Foreword

Yongwoo Lee

The Changing City Face

Though global capitalism and electronic democracy have contributed to the equal sharing of information, it is also true that these two modern advances have constantly provoked a crisis of identity. As noted by Felix Guattari, global capitalism has fostered a homogeneous society[1]—as opposed to a culturally diverse heterogeneous society—and such homogeneity has obliterated our sense of place: the sense of local community. Today, the world is faced with a chaos of values; globally uniform city structures, architectural designs, and cultural infrastructure. Urban living has been relegated to a cog in the market machine. The chaos of values stemming from the view that a city is a mere means to make profit, thereby remaking it as a tourist zone, has brought about the city's devastation.

The most extreme conflict arising from this rampant global capitalism is the tattering of public spaces in metropolitan cities. That is, public spaces are being increasingly privatized, commercialized, and standardized so that urban development has come into a head-on collision with the expansion of social, public spaces that local communities have always nourished. Market-development approaches tend to dominate or expel the revered, traditional, small-scale buildings, as well as the conventional markets, commercial spaces, and organically connected public spaces that are unified in concept and context. Furthermore, thematic developments—special financial zones, special tourism zones, special medical zones, and package developments created by voracious franchise businesses of the gigantic capital and leisure industry—violently clash with the beautiful identity that a city has built up over decades. The city has long been the theater of citizen's dreams, the theater of human rights and civil rights, indeed, the theater of a good quality of life and of consciousness. But this theater of dreams is being transformed into a stage for frenzied consumption and spectacles.

True urbanization should result in an enhanced quality of life with *reasons*. To this end, every building constructed or built environment that makes up a city should prove its *raison d'être*. In other words, in a city, small plays with reasons for being,

instead of gargantuan constructions on a blockbuster scale, should be central to defining the urban scene. In the end, the true power of capital is realized only when the reasons behind them are beautiful, rather than being judged on the amount of money spent.

The city we face daily is being transformed into an assortment of artificial environments so densely packed that do not allow even one inch of leeway. If the built environment were an artery, it would be clogged. Traffic, human or otherwise, can no longer flow around buildings or move through them in a continual and natural way. It is as if the sinews that make up the body of a healthy city are shrinking and diseased, overwhelmed by cancerous tissue. The city's cancer consists of self-contained units that only allow those with the means to pay to enter them. The vanishing physical environment directly reflects the shift to virtual environments and the high technology that supports electronic democracy and private pursuits, and the expansion of private information that cutting-edge technology makes possible: unlimited expansion of private, two-way reactions; private political spaces that exclude discussions; silent activism ruled by surveillance cameras; and instantaneously repeated crossings and exchanges via digital tools, which subsequently expel the public domain. The public overvalues electronic democracy for its immediate communication and multi-channel communications, but it desensitizes them to their immediate surroundings.

Communication systems across cyberspace have triggered explosive reactions from society and have made a revolution of mass participation possible through forms of "one-many" communication. Our endless Twitter feeds act as a channel of consciousness, which can be easily secured and used by the public, providing users with benefits of anonymity and interactive discourse. On the surface, such venues seem to be guarantees of a "cyber" democracy. But, unless communication involves organic participation arising from the culture of public spaces, citizens will be faced with constraints in the end. When freed from our illusions about cyber space, city people are forced to confront some neglected but painful issues such as social polarization, and the gaps between haves and have-nots, let alone pollution from toxins—and information.

People accept urbanization as a necessity while the urban landscape is seen as voluntary, even though urbanization depends on the city landscape. Some believe that urbanization guarantees a civilized quality of life, and that the urban landscape is optional. The urban landscape, however, is not subordinate to urbanization but complementary to it, reducing the toxins and entropy of the city. High-rise buildings are only a part of the whole cityscape, rather than the other way around. Although less visible, the more humble buildings are brought into harmony with nature so that beauty can shine through.

Though one's thoughts cannot be seen, by looking at what one does, others may see the thought process. Likewise, when looking at a city, we can read the

thoughts of the citizens that live there; when looking at the world, we can under-
stand what it means to be a human being. Thus, philosophy is invisible, but sci-
ence is the face of philosophy.

Architecture, then, is the face of a city. When taking a closer look at the urban
vista and architecture, we can distinguish the natural from artificial beauty. For
those who understand architecture as something that should be realized only
through human touch, "naturalistic architecture," that is, architecture informed by
nature, architecture imitating nature, may not make sense. High-rise buildings are
not modest constructions that save the earth but instead they colonize the small-
er, more beautiful structures, domineering above them alone in the sky.

The Gwangju Folly is an architecture project that is jointly created and produced
by the Gwangju Metropolitan City and the Gwangju Biennale Foundation. The
Follies were designed to address the exclusion of citizens from urban planning
processes. Our goal is to research and propose a reality-based practical urban
architecture, which serves the 1.5 million contemporary Gwangju citizens, rather
than speaking to past or future times. The aim of the project is to nurture public
spaces, realized on a human-scale: in fact, one could call it humanity-based archi-
tecture. It is also particularly designed to present alternatives for how to better
employ public spaces threatened by the pressures of globalization and global
capitalism as well as how to better connect civil society with the alternatives.

In the process of redeveloping urban residential areas in particular, the public has
been directed to think that "redevelopment is good" through awareness-raising
campaigns and policies. Furthermore, urban planning is largely the product of a
few politicians and architects in power. Therefore, the Folly project also aims to
reveal the wrong-headedness of such practices and show alternatives. Ultimately,
this means returning the city to the public. At the same time, gigantic urban plan-
ning projects have mostly focused on commercial areas by involving mainstream
architects who have mainly participated in such large-scale projects. In contrast,
the Folly project has excluded such architects, inviting architects who have stud-
ied and written about the post-colonization of architectural spaces.

The Gwangju Folly was launched in 2011. It was proposed jointly by the architect
H-Sang Seung (who was in charge of the 2011 Gwangju Design Biennale) and Ai
Weiwei (the Chinese human rights activist and artist). During the Gwangju Folly I
project, the two initiators selected participating artists and orchestrated the proj-
ect. And for the 2012 Folly project, German architect and curator Nikolaus Hirsch
was positioned as the General Artistic Director. But these two projects flow in a
continuum. The first round of follies aimed to realize the social role of architecture
and its historical restoration for citizens; modern architecture was constructed
alongside the *Gwangju Eupseong* (old fortress), which had been destroyed under

Japanese colonial rule, in order to revive the historical importance of *Eupseong* in the memory of citizens. It required a highly sophisticated symbolic system that metaphorically, as opposed to functionally, revives the fortress, which had been established in the pre-industrial era in the modern metropolitan city. Therefore, the fortress has become more a part of public observation and serves to highlight its historic nature than functioning as a construction.

Secondly, the first Folly project was to make use of small plots of land scattered throughout different neighborhoods in Gwangju in order to generate a public space, a concept which is often missing in typical functional constructions.

A total of eleven architects participated in the first round of the Folly project: Dominique Perrault, Alejandro Zaera-Polo, Sung-Yong Joh, Francisco Sanin, Yoshiharu Tsukamoto, Florian Beigel, Juan Herreros, H. Sang Seung, Nader Tehrani, S.H. Jung + S.J. Kim. The second round, unlike the first which included architects only, invited both architects and artists: Rem Koolhaas, David Adjaye, Raqs Media Collective, Superflex, Do Ho Suh, Ai Weiwei, and Eyal Weizman. Furthermore, these architects and artists often paired up with collaborators (Rem Koolhaas with the writer Ingo Niermann; David Adjaye with the writer Taiye Selasi; Do Ho Suh with his brother Eulho of Suh Architects; and Eyal Weizman with his colleague Samaneh Moafi).

During the two folly projects, a series of related events took place. For example, eight rounds of public hearings were attended by citizens; information sessions for residents were held, and symposiums were held to encourage citizens to participate in the process. But some civic groups and individuals felt that they were politically excluded in the process, pointing out what they thought was unfair. Hence, it took quite some time to review their complaints and rearrange the project plans. This nicely illustrates the importance of networking between the central host and surrounding organizations to achieve a democracy of information. That is, no matter how well a central organizer understands and captures the concepts of decentralization and power distribution, civil society does not easily yield political power that they deserve to enjoy. In this regard, Manuel Castells's description of a "networked society" is particularly apt here. He noted that a network society features advances in power and information decentralization, going beyond centralization. This note applies to ordinary enterprises as well as to political systems and social organizations, thereby resulting in a "network enterprise."[2]

Yongwoo Lee is the President of the Gwangju Biennale Foundation.

[1] Felix Guattari, *The Three Ecologies*, trans. Ian Pindar and Paul Sutton, Athlone Press (London, 2000) p. 57ff.
[2] Frank Webster, Reviews, notes and interviews, "Information, Urbanism and Identity: Perspectives on the Current Work of Manuel Castells," in *City*, Vol.2, ed. Bob Catterall, 1997, p.111.

Introduction

Nikolaus Hirsch
Philipp Misselwitz
Eui Young Chun

About
Follies and
Follying

Since the mid-seventeenth century, the folly has been employed as a detour into delirium: a critical medium oscillating between aesthetic autonomy and social-political potential. As an architectural entity, the folly can be understood as a rupture, a strategic site questioning the constraints of norms. This book is an inquiry into the status of the folly within a broad range of cultural practices such as architecture, arts, and literature.

It is next to impossible to locate the first folly in history. The etymological origin of the word can be found somewhere in the twelfth century when the Old French notion of *folie* is appropriated into the English language to describe a foolish or mad act. Yet, the understanding of folly as an intellectual concept is owed most to Erasmus's *In Praise of Folly*, printed in 1511. Purportedly, Erasmus conceived this oratory to foolishness on horseback while on a journey from Italy to England as diversion to his friend, the utopist Thomas More. His sharp satire on the conditions of his time uses the voice of the folly as a vehicle of critique and speculation on an alternative society.

The sixteenth-century grottoes in the gardens of Bomarzo (see Horst Bredekamp, pp. 20–23) could be described as anticipating architectural follies, but "folly" as an explicit spatial concept emerges much later in reference to the expansive pseudo-natural eighteenth-century English landscape gardens with artificially constructed ruins or architectural fragments placed as surprise vistas (see Barry Bergdoll, pp. 128–129). Around the same time, interestingly, in French, the word *fabriques* comes into fashion, for example, especially in reference to the famous Hameau de la Reine, a series of faked farm structures in the gardens of Versailles used for pleasure by Marie Antoinette and her courtiers (see April Lamm, pp. 80–81). Antony Vidler (pp. 14–19) argues that it was indeed in the age of enlightenment and reason when the notion of folly became a well-known potent feature of landscape design, architecture, and art. The folly came to represent the opposite of reason, progress, and faith—a "necessary evil," a reference to horror, terror, and destruction in the emerging bourgeois imagination.

In more recent history, the term folly re-entered cultural practice as a form of critique against modernist rationality, most humorously in Buster Keaton's famous 1920 film *One Week*—an early slapstick on industrialized prefabricated housing (see Stephen Squibb, pp. 60–61). In 1962, Philip Johnson built a small structure as an ironic attack on what he called "the William Morris–Walter Gropius cult of the useful" (see Felicity D. Scott, pp.100–103) anticipating by some twenty years the postmodern love affair with the folly (most poignantly evidenced by the exhibition catalogue *Follies: Architecture for the Late-Twentieth Century Landscape* edited by B.J. Archer in 1983). The concept of folly also guided the imagination of two of the most notable entries to the 1982 international competition to redesign the Parc de la Villette—a site of former slaughter houses in Paris. Bernard Tschumi won first prize with his thirty-five red steel follies arranged on a grid to become the distinct organizing feature of the park. He was inspired by and in collaboration with the deconstructionist philosopher Jacques Derrida, like Peter Eisenman, who remained unsuccessful in the competition. Eisenman also proposed follies and described their ambiguous status as "neither quite here or there, oscillating between use and uselessness." Reflecting on his co-operation with Peter Eisenman, Jacques Derrida begins "Point de Folie" with a desire to engage with a physical object/building: "What is the relationship between a particular place (a building), a particular time (the just *maintenant*), and an assembly of people (us)? Not quite a building, nor an autonomous art object, the folly is a physical object, an event that reshuffles, questions that triangle between place, time, and us."[1]

Derrida's "Point de Folie" may be attributed to a physical structure and immaterial statement alike—provided that they share similar intent: a calculated provocation and charged invitation to reflect and think otherwise. As tiny or ephemeral as these follies might be—they all share the possibility of becoming critical tools to test out the transformative potential of public space.

Public Space and Human Rights

These pointed considerations arose from the context of our work as curators for the Gwangju Folly II project, jointly created and produced by the Gwangju Metropolitan City and the Gwangju Biennale Foundation. They provided the conceptual environment and resources for our main venture: to develop a curatorial strategy for the construction of eight new follies in the public space of the Korean city, which are documented in this book. Like the text contributions of this fragmented lexicon, we consider the built follies as fodder for the global conversation on the meaning of folly in the twenty-first century. But there are also specific responses to the city of Gwangju, which, due to its unique past, has become a particular testing ground for the folly. We were particularly interested in the crucial role the negotiation of public space assumed in the democratization of South Korea—a movement which has won global recognition as a reference point and model of effective grassroots political mobilization. During the May 18 Democratic Uprising in 1980, the city became an urban stage for public demonstrations that eventually triggered the political transformation of the country from dictatorship to democracy. Today, a multitude of commemorative plaques, signs, and memorials mark these historical sites, and, in 2011, the uprising received global recognition through UNESCO, which included the records of the movement in the UNESCO Memory of the World Register.

Going beyond the question of preservation, we understood the Gwangju Folly II as an opportunity to examine the present-day constitution of public space as a political arena: to challenge questions of participation, rights, and transformative political action, thirty-three years after the uprising. Like all South Korean cities, Gwangju today has been radically transformed, especially if compared to 1980. It is a "normalized" city within the globalized political, cultural, and economic geographies that have increasingly eliminated difference and specificity. Gwangju certainly reflects on the ambivalence between the political fatigue typical to many well-functioning democratic systems in the context of growing economies, and a growing trend towards social re-mobilization and critique. Is public space in Gwangju today different from that of any other late-capitalist city around the globe?

It is this special agency of the folly—that of galvanizing the space between the everyday and the utopian—which provokes discourse. Hence the folly is not a neutral object but a "public thing," a *res publica*. A physical thing that functions as an assembly in the sense of Bruno Latour's neologism "Dingpolitik."[2] That is, in this trajectory from *Realpolitik to Dingpolitik* objects turn into things. They become active, they assemble, they are agents in their own right.

Transdisciplinarity

Linking the notion of the folly to an inquiry about public space in general led us to question the role models of authorship and professional expertise. Architects—the traditional and self-declared experts of public space—can no longer claim unique

knowledge and negotiation skills in an age where the geographies of publicness extend well beyond the physical, the local, the planned. And it was for this reason that we decided to stray from the straight and narrow to pursue a hybrid constellation of folly builders. Rem Koolhaas was invited to collaborate with the writer Ingo Niermann; the architect David Adjaye with the writer Taiye Selasi. We invited artist collectives such as Raqs Media Collective and Superflex; and also those whose work stretches across disciplines, such as the artist Do Ho Suh in collaboration with architect Eulho Suh; and the architect, writer, and human rights expert Eyal Weizmann with Australia-based Iranian architect Samaneh Moafi; and finally Ai Weiwei, an artist and activist who himself intervenes in the global political discourse through a multitude of media, be it writing, art, architecture, or blogging.

Site-specificity and Decontextualization

All of the invited teams bring to Gwangju the expertise and modes of working that connect to a global field of political and aesthetic discourse. Most visited Gwangju for the first time. To us, "outside" and "inside" perspectives were crucial for creating a constructive collision of perspectives between site-specificity and decontextualization, immanent to the notion of the folly itself. We carefully chose local sites key to the public life of Gwangju today—from the subway to public parks and shopping districts—and connected them to more global inquiries into political and cultural constitution of post-public space.

Eyal Weizman's folly, the Roundabout Revolution (in collaboration with Samaneh Moafi, see pp. 150–161), examines how traffic islands have become hosts to radical and transformative political action, thus establishing a connection between the 1980 Gwangju revolt and the revolutions that have rocked the Middle East since the "Arab Spring," which also often (and rather uncannily) took place in and around traffic circles. The roundabouts of Cairo, Ramallah, or Bahrain are registered as markings on the traffic intersection in front of the Gwangju station, creating a tension between everyday banality and the political, between a local tradition and history of protest and a continuing global phenomenon. The Roundabout Revolution folly includes an enclosed structure centered around a round table as a hint to the promises and contradictions of political protest that lead to lasting transformation.

Ai Weiwei's folly, the Cubic Meter Food Cart (pp. 48–53), was inspired by the function, economics, and specific history of Gwangju's *pojangmachas* (food carts or "tented wagons"), which had once also served the May 18 demonstrators. Today, these small and mobile structures are considered an aesthetic nuisance and are prohibited, or at best tolerated in a few restricted sites. Ai's folly is an interpretation of a new food cart constructed in Beijing and brought to Gwangju. It intervenes in a controversial debate about rights and control of public space in Gwangju.

The follies acknowledge that neither local specificity alone nor a purely abstract global perspective can sufficiently acknowledge the complexity of post-public

space. Discourse on citizens' rights today transgresses all temporal dimensions of past, present, and future and unfolds across complex spatial and political geographies and actor networks blurring local and global scales.

Useful and Useless

Constructing the follies in Gwangju meant navigating a complex field between diverse sets of expectations, which is already apparent in the difficulty of translating the word "folly," which has no direct equivalent in the Korean language. To some, follies are simply devices for the beautification of public space; to others, they should provide for the everyday needs of citizens. Follies in Gwangju, we were told, should be instruments for the regeneration of distressed parts of the city. Yet, as we have seen, the cultural tradition of the concept of the folly trespasses between use and uselessness and thrives in the ambivalent tension therein.

Rather than being an impediment, this difficulty of translation opened up a space of misunderstanding that became highly productive. All follies engage in the tension between expectations to serve the everyday needs of citizens in Gwangju by offering a new, hitherto missing practical public function such as improved public space, public facilities, public access, or improving on existing ones. Yet they also provide a sense of rupture, enigma, and ambiguity which provokes a multitude of links between past histories and myths and present-day discourses on issues of human rights and citizen participation in Gwangju and across the globe.

Raqs Media Collective's folly, the Autodidact's Transport (see pp. 24–33), exemplifies this tension. The Delhi-based artist collective transformed a subway train that is used by citizens in Gwangju on a daily basis. The artists undertook a conceptual re-invocation of Erasmus's sixteenth-century satire, *In Praise of the Folly*, on the Gwangju Metro as a way of extending the Folly project beyond the frame of static presence in built spaces. In a way, their work is a tribute to the transformative political potential of the folly, in the sense of a "rupture" and "madness" that ultimately make uprisings like May 18 possible.

An itinerant structure, the Korean artist Do Ho Suh collaborated with his brother Eulho (of Suh Architects) to create the In-between Hotel (pp. 86–95), a functional object both strange and familiar. It is based on a precise analysis of Gwangju's urban tissue and yet intentionally slips through the fabric of the city's public identity: a temporary dwelling unit activating aspects of Gwangju that have eluded the grand narratives.

David Adjaye and Taiye Selasi's Gwangju River Reading Room (pp. 64–75) is a highly personal, architectural reinterpretation of traditional Korean pavilion structures—an unusual landmark placed to provide a new access point to the lower, seasonally flooded Gwangju river bed. At the same time it houses a selected library on human rights literature.

a run-down public toilet near Gwangju Park with a replica of the toilets used by the Executive Board in the headquarters of UNESCO, Paris. While remaining a fully functioning public restroom, the Power Toilets is a subtly strange and disruptive insertion into the cityscape, which also offers another reading to address the complex relationship between UNESCO and the city of Gwangju.

Participation and Agency

Gwangju's May 18 heritage triggered a tradition of citizen participation. Without this, neither the impressive landscape of civil society organizations active in the city nor indeed the Gwangju Biennale and the Folly project would exist. Yet rather than focusing on tradition, which entails the danger of petrifying activism into an object of historic preservation, the Folly project became an opportunity for a contemporary debate on modes and practices of participation with the organizers and selected activists and NGO representatives which have formed our Advisory Board and were included in all key decisions.

Yet, what could participation really signify and how can it be sensed in contemporary public space? Rem Koolhaas and Ingo Niermann's folly, the Vote (pp. 174–185), takes the most obvious yet contested field of public participation and proposes a new form of infrastructure for this essential democratic process. Placed in the middle of a busy shopping and entertainment district that is mainly frequented by teenagers, the Vote folly divides the street into three lanes of choice, "Yes," "No," and "Maybe," so that pedestrians can vote on a weekly issue established by the local Youth Center. The votes are then counted via a digital system and tallies are placed online to create a new form of direct plebiscite.

While the notion of participation is often used as a battle cry for the democratization of public space and planning, for opening up and expanding its fields of practice, it also bears the danger of diffusing the agency of shaping space which requires skill and expertise (see Markus Miessen, pp. 120–123). The positive bias towards all those individuals, communities, and organizations that are not necessarily professional planners, but considered "victims" of planning can compromise spatial practice which remains partial as long as we do not include within it the agencies of spatial production itself, the objects' potential of estrangement, the sometimes uncanny capacity to ignore and overcome social-political norms. The agency of the Folly project hence reflects on the ambivalent field between the short moment of madness and revolution, on the one hand, and the long post-revolutionary phase of consensual pragmatism, or as Eyal Weizman's folly for Gwangju suggests, it draws a line from roundabout revolutions to round table politics.

[1] Jacques Derrida, "Point de folie-maintenant l'architecture," in *Rethinking Architecture: A Reader in Cultural Theory*, ed. Neil Leach (Taylor & Francis, 2005) p.308ff.

[2] Bruno Latour, *From Realpolitik to Dingpolitik or How to Make Things Public*, in: Bruno Latour, Peter Weibel (eds.), Making Things Public. Atmospheres of Democracy, MIT Press, Cambridge / Mass., 2005, p. 14-41.

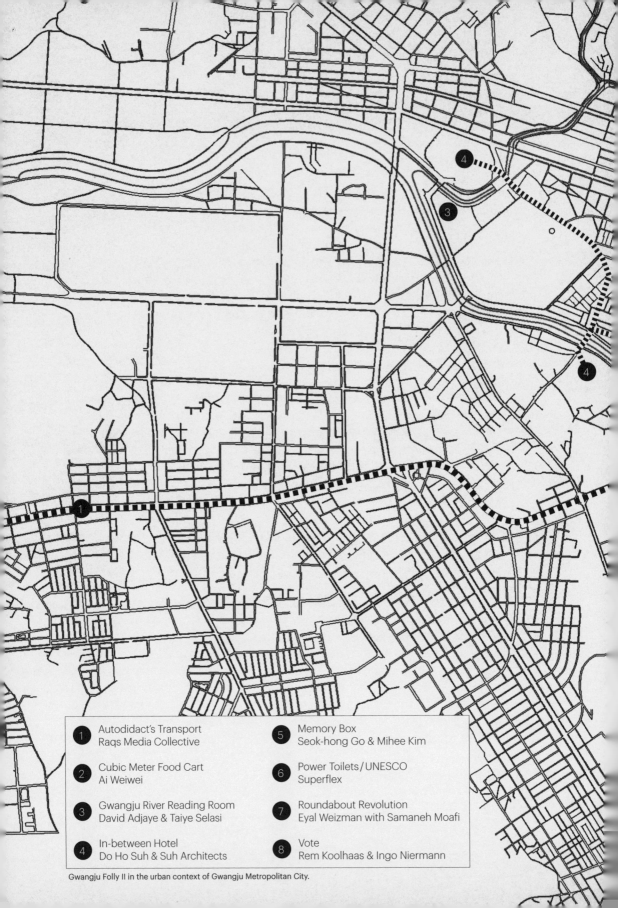

1. Autodidact's Transport
Raqs Media Collective

2. Cubic Meter Food Cart
Ai Weiwei

3. Gwangju River Reading Room
David Adjaye & Taiye Selasi

4. In-between Hotel
Do Ho Suh & Suh Architects

5. Memory Box
Seok-hong Go & Mihee Kim

6. Power Toilets / UNESCO
Superflex

7. Roundabout Revolution
Eyal Weizman with Samaneh Moafi

8. Vote
Rem Koolhaas & Ingo Niermann

Gwangju Folly II in the urban context of Gwangju Metropolitan City.

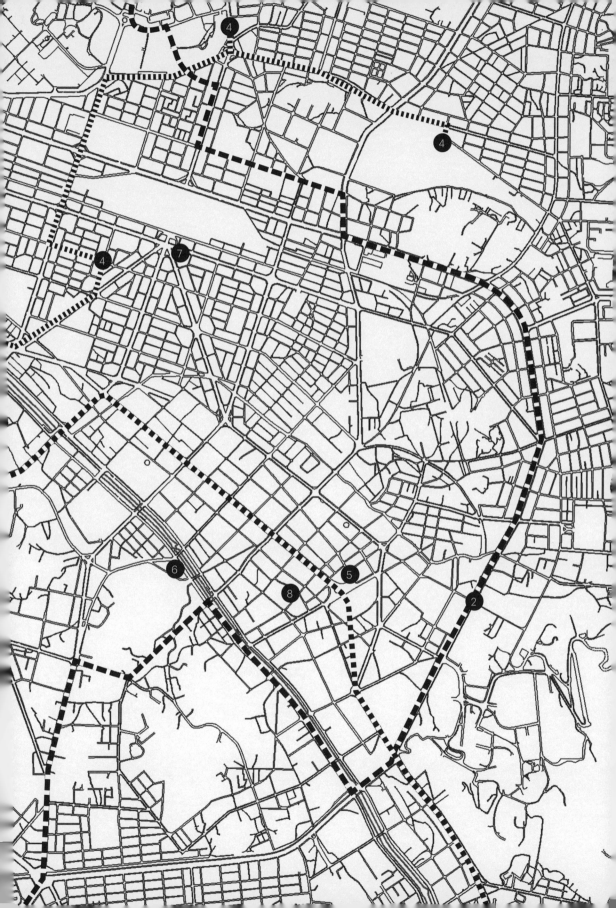

Antagonists

Anthony
Vidler

History of
the Folly

The folly, as both architectural design and figure of unreason, received its precise definition during the Enlightenment. Many eccentric builders in legend and in history have been referred to by their kind, gossipy neighbors as "inventors of follies"; but the cultural role of the folly was not realized until an age of reason had discovered its marvelous properties. As epitomizing a gamut of negative qualities, the folly took on the essential nature of the opposite pole, of extreme undesirability, of absolute contradiction. As the emblem of foolish luxury, it offered a warning to spendthrifts and unproductive investors; as totally without function, it provided a specter of emptiness and uselessness without which function itself was meaningless; as close to madness, it described a realm and embodied a visual metaphor that decorated and domesticated an otherwise awesome concept, one that was readily incarcerated behind nonsignifying walls; as a vehicle for all sorts of fashionable literary notions, from the sublime to the picturesque, the folly exhibited them in a kind of museum of meditative objects. Thus, within a tamed space, the folly closeted such difficult and nonbourgeois ideas as horror, terror, and decay. In every sense, the folly represented, in pictorial or figurative form, a necessary evil. Without the folly, rationalism, progress, and faith in a perfectible mankind would have been empty concepts—mere fictions of good without tangible antagonists with which to tangle.

The folly acted architecturally as *folie* acted mentally, to establish a state of calm and undisturbed reason. Thus, it took its place beside the madhouse, the zoo, the botanical garden, the physiognomist's cabinet of shrunken heads, and the phrenologist's shelf of skulls, as the tactile analogue to the nightmare, the monster, the savage, the criminal, and the insane. A garden of delights might contain a magician's cave, a hermit's hut, a giddying precipice, a horrifying grotto, an exotic, Oriental memory, even a skull-laden tomb without disturbing the overall Arcadian scene. Indeed, utopia was closer in contrast to its unspeakable opposite, its unnameable Other.

Characteristic Emblems

Beneath the expression of the inexpressible, of course, lurked the desire of the Enlightenment to say all, to name, and, thereby, to overcome, and to rationalize. "Every folly must have a name," noted Francis Coventry in his wicked satire on mid-eighteenth-century gardening; and accordingly, every folly should be emblematic, as unambiguous as possible of the quality or characteristic it exemplified. Follies, like species of plants or animals, should exhibit character—forms that, at a glance, would announce the object for what it was. The folly, as an extreme example, became in the eighteenth century the experimental object for architects who searched for an architectural parlance, a visual rhetoric that could be "read" like a book—and a moral book at that—by its viewer. Even as an older "garden of nature" was seen hieroglyphically, secreting in its hollows and shadows the wisdom of the Creator himself, so the eighteenth-century folly garden was seen as a sequence of emblems, giving rise, as the designer-theorist Robert Morris said, to a "Chain of Thought." The folly thus became a unit of language, a grapheme of philosophic discussion, an instrument in the didactic program of the enlightener. Almost all of the designs of Ledoux, of Boullée, and of Jean Jacques Lequeu have this quality: words in a persuasive dialogue about happiness that preferred to speak of unhappiness with so much force that the thought would be unbearable.

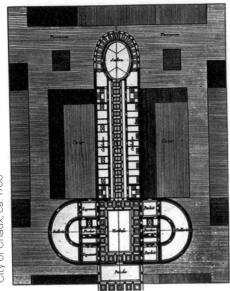

An example of Ledoux's "phallic planned brothels," the Oikema, an integral part of the Ideal City of Chaux, ca. 1780

Pornography

The ancient word *folle* was used primarily to refer to "lewd, unchaste, and wanton" behavior, and, while an obsolete term in the eighteenth century, the folly certainly held within it connotations of libertine eroticism and pornography. Here the folly became less an example of the bad than a not-so-secret harbinger of the impossible desired. What was not permitted in "serious" building was, by definition, permitted in the folly. A mere plaything, the folly could exhibit the dimensions of play. In fact, many follies were designed not only as the emblems of eroticism but also as its site, the "retreat" of lovers, allegorized as fauns, cupids, and nymphs, but nevertheless real. Fragonard depicted the scenes of love on the ceiling of Madame du Barry's pavilion in classical guise, and everyone knew for what purpose the little temple was to be used. Follies were a freedom not allowed in polite society; they were the spatial and sometimes—as in the case of Ledoux's phallic planned brothels, or Lequeu's monuments to Priapus—the figurative closets of not

just the "say all" but also of the "act all." The Marquis de Sade wrote the handbook of conduct for such interior liberty. In the environs of libertinage described in his *120 Days of Sodom*, act after act was seriously tabulated, as if in an encyclopedia to catalog and exhaust all acts. Similarly, every motif from past exotic architecture that could be broken off was used in the architecture of the folly.

Liberty in History

The folly as an emblem of the "invention of liberty" was also its closure. For while every monument of the past was fair game for copying, satirizing, fragmenting, and quoting—games well-known in our own day—this was, as many serious students of history recognized, an abyssal process. When the Comte de Volney meditated before the ruins of Carthage on the rise and fall of empires, he was melancholically conservative when speaking indirectly of the Revolution as a liberty taken, but also as a freedom bound for destruction. Follies as ruins, or as imitations of ruins, became the vehicles for such instant nostalgia encouraged by historicist regrets and supported by consumerist atavism. Here the Baroque cult of ruins was transformed from a simply relished fragmentation, a sense of the transience of history and the mortality of man into a "history lesson." The ruins of the monuments of France were laboriously carted from all parts of the realm to establish a Museum of French Monuments[1] that would, in precise chronological order, display the rise and fall of reign after reign to that time in 1795. In this temporal sequence, where every room was designed in period style to emulate the scene of an era, one could literally traverse the ages. In the museum, the folly indicated not only its ruined state but also its former or future state of completion; Michelet remembered being led by his mother's hand through the museum, and the effect of its cloistered history on his "chronologies" was incalculable. What had been taken as absolute liberty, of choice as well as play, was as legally binding as the rules of anatomy or crystallography when subjected to the stern laws of historicism.

Such a law-abiding fragment of the past, or even its imitation, was a prickly phenomenon in the eyes of the young Romantics of Germany. Friedrich Schlegel characterized the fragment—isolated and self-contained like a small work of art—as a hedgehog. The in-turned nature of an aphorism, of an unfinished poem, was seen to be analogous to the piece of history, complete in itself, never to be returned to its original wholeness, but always indicating its potential completion. Uncurled and slowly moving, the hedgehog might be going backward or forward, but was always historical; curled up, it was an impenetrable and hermetic harbinger of a truth. In this incarnation, the folly, an outsider in the Enlightenment, becomes the insider. Rather than impossible thought or unspeakable idea, it, *as* impossible or unspeakable, was a desirable object. The positive emblem of the greatest horror, of the most extreme cruelty, of the absolute decay, of the most decadent eroticism, of the furthest reaches of the exotic—these agonistic qualities were virtues to the Romantic imagination. Thus William Beckford[2] would build an unbuildable tower, more Gothic than the Gothic, which would fall down on completion; John Nash would construct a fantasy of the East, with palm-tree columns,

a caravanserai in Brighton, which gave the lie to serious attempts to reconstruct a history of Eastern architecture, but yet was essentially Eastern. The archetypal folly of Romanticism, both artifact and figure, was that of Frankenstein's unnamed monster. Unnamed because unnameable, the rival to the great namer himself, the monster is at once allegory of the reconstruction of history—the assembling of fragments from statue to statue, by Winckelmann and Quatremere de Quincy— and figure of the overcoming of imitation in art as well as science. With the monster, art will no longer have to strive to perfect nature in its representations; science will no longer have to work with the imperfect fabric of flesh and blood as given; the process of assembly is now unmasked and open to endless manipulation. What "monsters" might now be coldly and calmly assembled; to what ends might they be perfected and what power might be wielded by the artist-creator?

Modernity

After Frankenstein, modern-thinking artists have little need of follies: one might dream, figure the states of mind in the metropolis, vent one's spleen, but have no need to build the follies of imagination. Built objects, after all, are to be consumed, and while the folly-*fabriques* of the eighteenth century were certainly built to be consumed, they were in a real sense forbidden; in contrast the follies of the nineteenth century—especially from 1867 on—were made for the market. They were the proud exemplars

Ledoux's Quarters for the Rural Caretakers, with plans for three floors, ca. 1780

of industrial progress; the plundered forms of imperially dominated cultures; the packaged goods of exploration and the damaged goods of exploitation. The realm of the folly was the great exposition, the world exhibition, the trade fair. Grinning natives were exhibited in carefully constructed replicas of their homeland cabins; fantasies were elaborated on every style and building type in the Far East and Far West, adapting them to the needs of pleasure and leisure. In this world of marketable objects, the folly became subject not to liberty of permutation or creation, but to liberty of fabrication. What was once in one material was not pressed out of iron and forged out of steel, or molded in synthetic stone or plaster. All the careful historicisms of the materialists, from Pugin to Semper,[3] were undermined by a production process that simply provided a *replica*; all styles were hitherto without content derived from material and were transformed into imagery, pure and simple. What in the first place had been the role of the folly—to protect a form—now became a requirement to project an image.

The Unconscious

With the full flowering of the unconscious, the folly became once more again essential, but this time not as nonsense, but as sense itself, the reality of motivation and explanation. The folly of each individual became his truth and meaning; it was represented as an abstract structure of relationships and of interdependencies—a formal network, to be traced laboriously to its source by the techniques of a detective or an explorer. The greatest follies of Modernism are at the heart of darkness and can be lightly traced on the heel of a fleeing criminal. Watson is here the plodding force of reason, opposed to the unreasonable, but true, hypotheses of Sherlock Holmes—hypotheses which are plots and narratives, and which lead to impossible, but at least plausible, conclusions. If the world is not decipherable according to these rational means, then it makes no sense whatever—and this is insupportable.

The paradigmatic folly of this age is *Finnegan's Wake*, a language which is nonsense but, in a real way, decipherable; a plot which goes nowhere but which replaces all other kinds of plot; a speech which is audible, but can be spoken by no living person. History and memory are thereby collapsed into a single cipher; hieroglyphics take on the form of Artaud's screaming gestures; continuities become no more than a trace, lightly erased beneath elaborate discontinuities. In this world of the unfixed and of the desire for a transparent language of forms that will at once convey structure, substance, and feeling, follies retreat to the subliminal; they certainly have no overt place in the cold and abstract utopias of Modernism, unless it is by omission.

System of the Folly

The folly as defined in the eighteenth century, elaborated in the nineteenth century, and dissolved in the twentieth century has operated according to the following premises:

It has referred back to, or nostalgically alluded to, a short history of modern follies: it is solipsism.

It has acted as the asylum for the forbidden, for the repressed, for the denied, and the absolutely impossible.

It has, perversely, exhibited a discipline, a logic, a reason in itself, which, because withdrawn from the world, remains in a sense pure.

The folly, then, as a most unwelcome thing, has become the most sought-after guest. It is at best sublime and at worst frivolous, but still, despite the current tendency for imitating follies as if they were architecture, such extravagance demands attention. Follies have their place and their role, but only as long as reason is desired.

[1] Le Musée des monuments français, now in the northern wing of the Palais de Chaillot, Paris.
[2] *"So I am growing rich, and mean to build towers"* – William Beckford. [Ed. note]
[3] Augustus Welby Northmore Pugin (1812–1852) and Gottfried Semper (1803–1879).

Art Alone?

Horst
Bredekamp

Entering
Bomarzo

A visitor who came to see the garden at the time of its completion around 1580 first encountered the two-storied house, which leaned to the right at an alarming angle. As he approached, two sphinxes awaited him at an opening in a chest-high wall, and behind the off-kilter building, several herms and obelisks enlivened an open space whose theatrical architecture is still intact along the southwestern wall. Of the deep grotto along the adjoining short edge, by contrast, only the right half remains. From this entrance plateau, the visitor was led to an area featuring recesses, benches, female figures, and a boatlike fountain. Nearing the exit of this area, he stumbled over a truncated colum set askew, and a tangle of roots made of stone. A flight of stairs led him past the Pegasus fountain to the lowest point of the grounds, above which a female figure balanced on the shell of a gigantic tortoise; to the left and in front of it, a whalelike creature of the sea, its maw wide open, seemed to snap from the riverbed. A hardly less surprising revelation awaited him as he re-ascended: a spur of rock blocking his path turned out, upon closer inspection, to be a giant seen from behind. Another flight of stairs took the visitor to

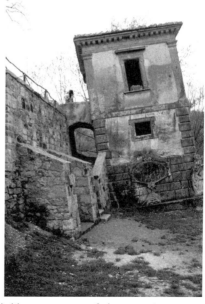

Leaning tower in the Garden of Bomarzo.
© Horst Bredekamp, 1985

the edge of a reservoir, from whose southern end the enormous face of a monster emerged, supporting a globe. The path returned to the overturned ruin and then tured left, toward the highest point of the garden, occupied by a temple. To the right of this building, a panorama platform offered a view of the low-lying plain framed by oversized cones. To the left, a three-headed dog guarded the entrance, and a larger-than-life seated woman and two erect bears faced each other at the short fronts, followed by a pair of lions between hybrid female creatures. The visitor descended a flight of stairs to reach the adjoining low-lying plain, where a bench, set forward, allowed him to survey the freestanding sculptures arranged on the ground level: a monumental vase, a ram, the battle between a dragon and a pair of lions, a life-sized war elephant, and an enormous animal mouth. Behind these figures followed a cordon of vases or urns surrounded by a seated giantess and her male counterpart, accompanied by a large fish. Passing the monstrous fish, the visitor reached a woman, also larger than life, stretched out on the ground and guarded by a dog; a few steps further on, a two-seated bench invited him to sit down and contemplate a gravelike cave beneath a brickwork tower rising above a massive rock. After returning to the double row of vases or urns, the visitor would cross a bridge to enter the upper floor of the leaning tower, and let himself be confused by the slanting walls, before descending a flight of stairs toward the entrance and looking back in bewilderment: an irregularly shaped path; abrupt transitions between intact architecture and forms that had lost their balance; fishes rising from the earth; a ship floating, as a fountain, on a rock; exotic animals; life-sized figures next to larger-than-life ones; an unspoiled temple and a ruin; female nymphs and monsters—an outlandish program, all in all, that initially left the beholder baffled: the work of a "determinedly perverse nature"? (Bredekamp pp. 3-4)

Once the visitor had perambulated the unenclosed garden at the feet of Bomarzo, crossed the brook, and, traversing the "copse" that shielded the park, had reached the entrance to the inner precinct, he encountered, beyond the gate,

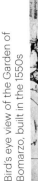
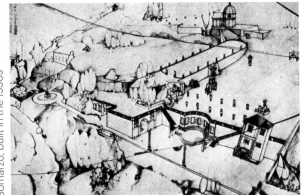

Bird's eye view of the Garden of Bomarzo, built in the 1550s

two sphinxes; the Egyptians, it was at that time assumed, had mounted these at the sacred sites to indicate "that divine knowledge must be enveloped in the shrouds of mystery and vieled by poesy." The sinister realization that passing these guardians meant entering another world must have aroused curiosity regarding the inscriptions on the sides of the pedastals: "You Who Enter Here Regard Part for Part and Then Tell Me Whether So Many Wonders Are the Work of Deception or of Art Alone." Strikingly, these lines

ask the entrant a question; any passably erudite visitor must have understood that what lay in wait for him here was the Greek counterpart of the Egyptian guardian of temples and tombs, the Theban sphinx, who was said to have lived on Mount Phikion, posing a riddle to all passing travelers and devouring those who failed to resolve it, until Oedipus finally broke her spell, whereupon she threw herself down a precipice. Her great cruelty notwithstanding, in this plunge to death she henceforth also represented a grim principle of wisdom and truth that imposes capital punishment for ignorance: lack of knowledge brings death, knowledge guarantees life. Even as he entered the "copse," the informed visitor had been warned that an otherworldly realm lay before him, in which he

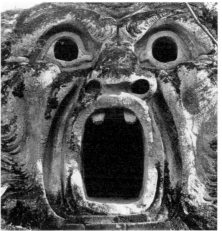

Orcus, god of the underworld, on whose upper lip is inscribed, "All thoughts fly," in the Garden of Bomarzo. © Horst Bredekamp, 1985

would have to prove his mettle and ultimately give an account of his life. The task was to determine, during a tour of the garden, whether the individual wonders were the products of *inganno*—(optical) deception—or of "Art Alone." By associating it with *arte*, Vicino[1] transposes *inganno* into a specific conceptual framework. This shift was supported by an important motif in the ancient as well as contemporary theory of art: in Ludovico Dolce's *Dialogo della pittura*, *ingannare* apppeared as evidence of the artist's ability to make works of painting appear consummately natural, to the point of utterly deceiving the senses. *Inganno* then functions as the distinguishing mark of an art whose mastery proves itself more grandiosely the less the beholder can tell that its product is a figment of art. Vicino, however, inverts the poles; by setting *inganno* in opposition to art, he displaces the latter term into nature. The forms of nature thus take on the role of art, as art for its part comes to occupy the position of nature: it is not art that creates the illusion of nature, but nature that feigns art. In this fashion, Vicino's ideas approach the no-less-famous theorem about art that nature herself, as a masterful artist, provides in her optical illusions the inexhaustible sources of inspiration. Yet Vicino does not simply adopt this other extreme either; as the question the sphinx raises leaves open whether it is the power of nature to inform art or art's ability to imitate nature that predominates in the garden, the inscription installs the mutual reversal of roles between the two as the guiding creative principle. (Bredekamp, pp. 76-77)

[1] The "Vicino" here is Duke Pierfranceso "Vicino" Orsini, who conceived of this garden, which he called a "Sacred Wood," on his own private estate in central Italy. Though himself an architect, he was called upon to finish St Peter's after the death of Michaelangelo, so he commissioned Pirro Ligorio to create this melancholic garden of wonders in homage to his recently deceased wife. [Ed. note]

Autodidact's Transport

Raqs Media Collective

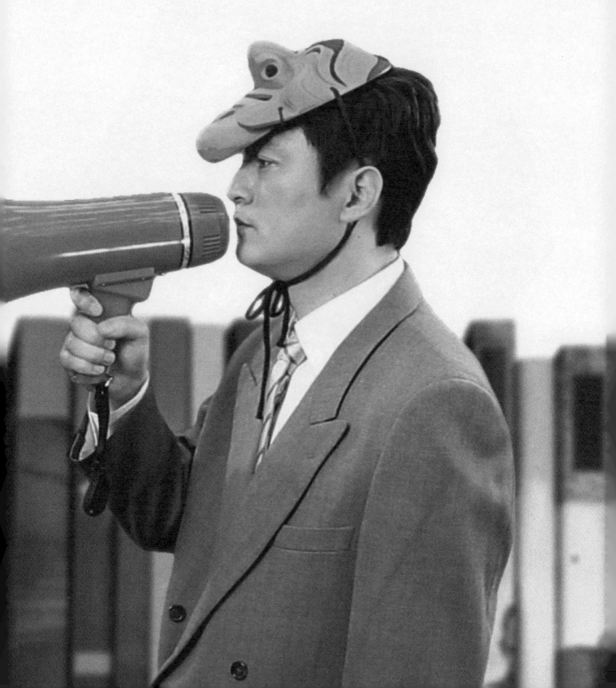

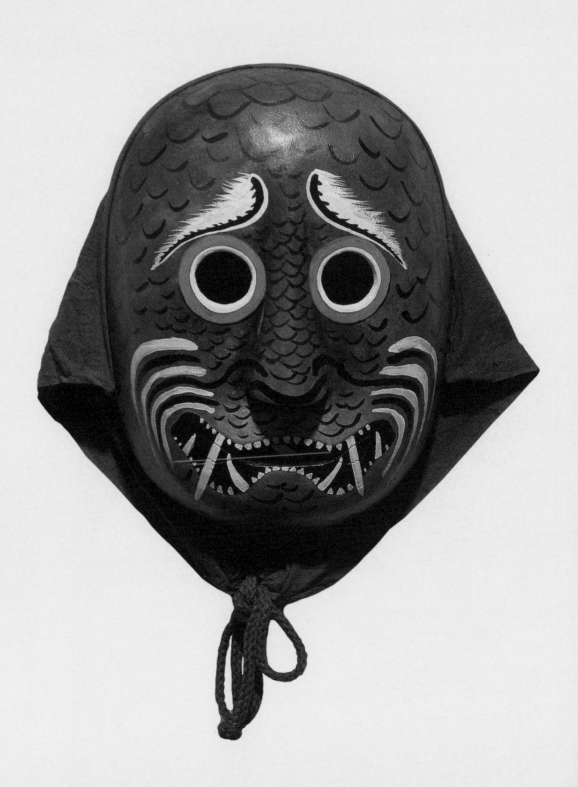

It can be said that a folly is an empty receptacle, a space void of purpose. We are interested in filling this space, in making it "go places"—like Erasmus, who used his *In Praise of Folly* as an allegorical vehicle. Our Autodidact's Transport extends the Gwangju Folly project beyond the static frame of the built world by taking it onto the subway cars of the Gwangju metro. After all, Erasmus's *Folly* was conceived in motion—as many of our best ideas are—on a journey from Italy to England, on horseback in 1509. (Samuel Beckett, too, once said that the best ideas came to him on his bike.)

Democracy cannot be seen simply as a static system of government—it is a set of values that privilege friendship, solidarity, equality, and freedom. We are interested in what it means for people in a democracy to occupy civic space, and what it is for strangers to come together and be drawn to one another for social and ethical reasons.

The Autodidact's Transport evokes for the viewer a strong sense of stepping into a completely unexpected space. When the traveller enters the subway car, it is as if they are being wrapped in a single image. This image is the result of a software program that has coded the "conversations" that our three computers have had with each other and the world. (Three computers, that is, as we are a collective of three). Each time our computers sent out a ping, downloaded data, or did a search, etc., it was translated into a line in the drawing.

So, we have taken the idea of silent conversations, which have taken place between computers, and layered the subway space, making loud what was once mute. As people step into the train, they step into a space that visualizes past and future conversations.

The lighting of this car has been transformed so that each light "orb" resembles a solar eclipse. The seats have been re-upholstered with headings, self-constituting roles. These roles are Critic, Agitator, Player, Pet, Prodigy, Prophet, Unknown, Missing, Hermit, Anonymous, Bard, Dissident, Star, Protagonist, Pirate, God, Keeper, and Crowd. Each of these roles speaks directly of the history of Gwangju as a site of political transformation and protest.

On a video monitor, one can see fragments of past "Orations" that have been performed by Gwangju actors wearing various *taichung* masks and carrying the red megaphone associated with protests in Korea. These traditional masks—historically used in socially critical dance performances—bring in a sense of the satire and parody associated with Erasmus's *Folly*. The text recited, as written by Raqs, address the paradoxes unfolding in the imagination of crowds: how democracy is largely dependent on a network of solidarity between strangers.

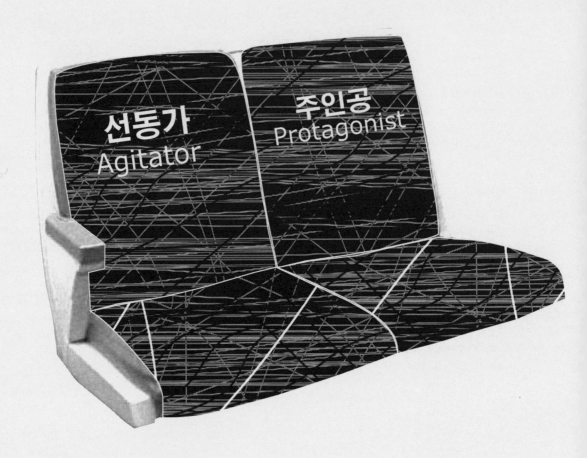

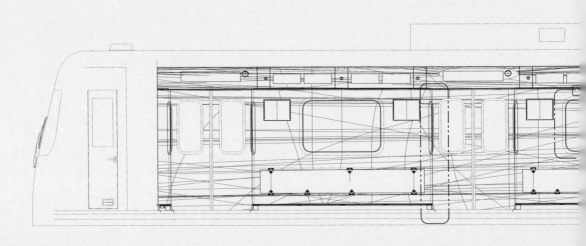

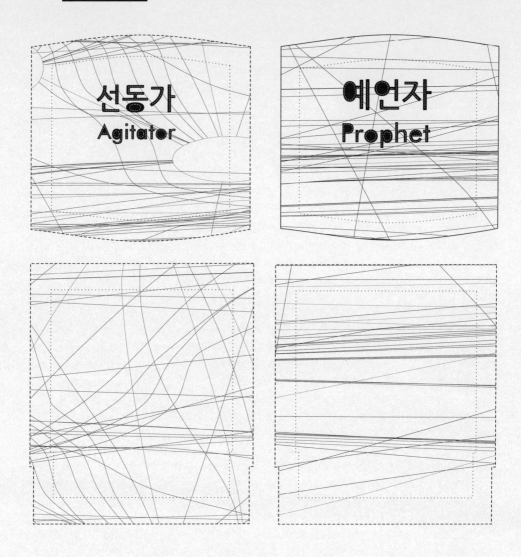

선동가
Agitator

예언자
Prophet

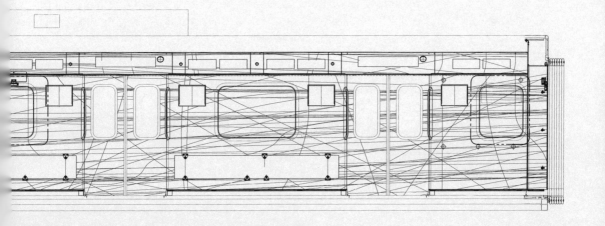

Oration

The Oration consists of a dramatic monologue on the virtues of democracy to be delivered by an actor, armed with a megaphone (the kind that is used in Korea so skillfully) and wearing a traditional performer's mask. The oration, of course, being read out loud on the Gwangju subway, has been translated into Korean.

Dear travelling companions,

I beg your forgiveness for intruding upon your precious time on this very special journey. I know you must all be going somewhere important. The journey is short, but life is long, and all I want—I, who have no destination, no final stop—is two minutes of your time. Indulge me, fellow citizens, be entertained by my folly.

Dear citizens of Gwangju: how many times have you heard that word "liberty" whistle past you, especially, but not only on the 18th of May? How many times you must have heard it said that the brave people of Gwangju stood up to tyranny and paved the way for freedom and democracy? Do you remember those two women who spoke to the town on megaphones from a moving van, telling citizens to stay the course even as the army was going to move in? Do you remember their voices, fleeting in the wind? How many times have you congratulated yourself on being the brother or sister or son or daughter or friend or wife or husband of someone who listened to them, and stood their ground? Perhaps there are those in this carriage who also stood up on the 18th of May. I salute you all. I am nothing. You are heroes. I am but a clown, and what value do the sentiments and salutations of a clown have? But still, bear with me, take my greetings, hear me, talk to me.

My task is to distract you while you travel, and so I will offer you some questions. Something like a crossword puzzle or a sudoku game for your conscience, to while away the time on your busy commute.

Can the liberty of one man be the prison of another?
Can the world be divided and free at the same time?
Can liberty be weighed, parceled, sold at a discount?
Can liberty wither if it is not watered?
Can liberty wax and wane like the moon, rise and fall like the sun, shine and fade like the stars?

Can liberty mean license, or leeway, or laxity?
Can liberty be earned or must liberty be won?
Can liberty include the ability to question liberty itself?
Can liberty sleep and dream or must she always stay awake?
Can liberty take a holiday? Can liberty grow up? Can liberty grow old?
Can liberty be loved or must she always be revered?
Can liberty be the freedom from one's own self?
Can liberty be hesitant, can liberty be gentle, can liberty whisper?
Can liberty keep secrets, can liberty laugh, can liberty cry?
Can liberty mourn the man who hangs with or without reason?
Can liberty change colors with the passage of days and the cycle of seasons?
Can liberty bleed, can liberty breed, can liberty be mother and daughter together?
Can liberty be liberty and not have to be disguised as a sovereign right or a solemn duty?

Good people, men and women of Gwangju, little children. I travel up and down this train, asking this question, being liberty's attendant, and all I receive are embarrassed stares, titters of laughter, and the sidelong glances of people who choose to look away. Do not bury yourself in your newspaper, leave your mobile aside for a while. I teach myself by looking at you, by being with you, everything I know, I betray all that I was taught, all my books and all my learning, and I ask myself.

Is the liberty of the magnate, the general, and the expert the same as the liberty of the agitator, the student, and the hermit?

I ask myself what happened to the liberty of the missing—of those who disappear or are made to disappear? Are they more free now than when we knew them and knew their every move?

I ask myself whether my pet has the liberty to keep me, because I know of one who owns me more than my cat. I wonder whether, if God exists, he is at liberty to change his own rules, or is he the prisoner of his own divinity? I wonder if prophets are at liberty to doubt their own faith? Whether a beast is more at liberty than man. Whether the keeper is the slave of the kept? I ask you if you know any liberty greater than that of the stranger, any liberty more constrained than that of the crowd. I ask you, if you will set me free?

Set me free, good people, set me free. Set me free of these questions that have been plaguing me since time immemorial. That weighs on my shoulders like a vampire, feeding off my conscience, my reason, my passions. Take each of my questions and turn them around in your heads, hold them up to light and mirrors, dust them and clean them and make them shine. Take them home and water them and feed them, let them live and let me be.

Li-ber-tyeeeeee!

Songjeong
Park

SangMu

Airport

Songjeongri

Kim Daejung
Convention Center
(Mareuk)

Dosan

Pyeongdong

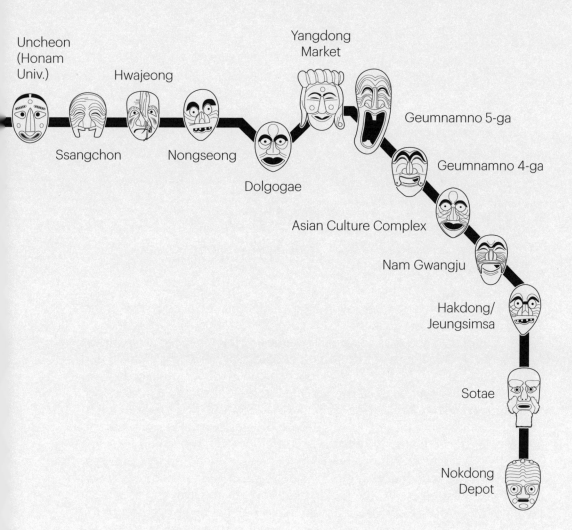

Uncheon
(Honam
Univ.)

Hwajeong

Ssangchon

Nongseong

Dolgogae

Yangdong
Market

Geumnamno 5-ga

Geumnamno 4-ga

Asian Culture Complex

Nam Gwangju

Hakdong/
Jeungsimsa

Sotae

Nokdong
Depot

Background Music

Joan Didion

Many Mansions

The new official residence for governors of California, unlandscaped, unfurnished, and unoccupied since the day construction stopped in 1975, stands on eleven acres of oaks and olives on a bluff overlooking the American River outside Sacramento. This is the twelve-thousand-square-foot house that Ronald and Nancy Reagan built. This is the sixteen-room house in which Jerry Brown declined to live. This is the vacant house which cost the State of California one-million-four, not including the property, which was purchased in 1969 and donated to the state by such friends of the Reagans as Leonard K. Firestone of Firestone Tire and Rubber and Taft Schreiber of the Music Corporation of America and Holmes Tuttle, the Los Angeles Ford dealer. All day at this empty house three maintenance men try to keep the bulletproof windows clean and the cobwebs swept and the wild grass green and the rattlesnakes down by the river and away from the thirty-five exterior wood and glass doors. All night at this empty house the lights stay on behind the eight-foot chain-link fence and the guard dogs lie at bay and the telephone, when it rings, startles by the fact that it works. "Governor's Residence," the guards answer, their voices laconic, matter-of-fact, quite as if there were some phantom governor to connect. Wild grass grows where the tennis court was to have been. Wild grass grows where the pool and sauna were to have been. The American is the river in which gold was discovered in 1848, and it once ran fast and full past here, but lately there have been upstream dams and

dry years. Much of the bed is exposed. The far bank has been dredged and graded. That the river is running low is of no real account, however, since one of the many peculiarities of the new Governor's Residence is that it is so situated as to have no clear view of the river.

It is an altogether curious structure, this one-story one-million-four dream house of Ronald and Nancy Reagan's. Were the house on the market (which it will probably not be, since, at the time it was costing a million-four, local real estate agents seemed to agree on $300,000 as the top price ever paid for a house in Sacramento County), the words used to describe it would be "open" and "contemporary," although technically it is neither. "Flow" is a word that crops up quite a bit when one is walking through the place, and so is "resemble." The walls "resemble" local adobe, but they are not: they are the same concrete blocks, plastered and painted a rather stale yellowed cream, used in so many supermarkets and housing projects and Coca-Cola bottling plants. The door frames and the exposed beams "resemble" native redwood, but they are not: they are construction-grade lumber of indeterminate quality, stained brown. If anyone ever moves in, the concrete floors will be carpeted, wall to wall. If anyone ever moves in, the thirty-five exterior wood and glass doors, possibly the single distinctive feature in the house, will be, according to plan, "draped." The bathrooms are small and standard. The family bedrooms open directly onto the nonexistent swimming pool, with all its potential for noise and distraction. To one side of the fireplace in the formal living room there is what is known in the trade as a "wet bar," a cabinet for bottles and glasses with a sink and a long vinyl-topped counter. (This vinyl "resembles" slate.) In the entire house there are only enough bookshelves for a set of the World Book and some Books of the Month, plus maybe three Royal Doulton figurines and a back file of *Connoisseur*, but there is $90,000 worth of other teak cabinetry, including the "refreshment center" in the "recreation room." There is that most ubiqitous of all "luxury features," a bidet in the master bathroom. There is one of those kitchens which seem designed exclusively for defrosting by microwave and compacting trash. It is a house built for a family of snackers.

And yet, appliances notwithstanding, it is hard to see where the million-four went. The place has been called, by Jerry Brown, a "Taj Mahal." It has been called a "white elephant," a "resort," a "monument to the colossal ego of our former governor." It is not exactly any of these things. It is simply and rather astonishingly an enlarged version of a very common kind of California tract house, a monument not to colossal ego but to a weird absence of ego, a case study in the architecture of limited possibilities, insistently and malevolently "democratic," flattened out, mediocre, and "open" as devoid of privacy or personal eccentricity as the lobby area in a Ramada Inn. It is the architecture of "background music," decorators, "good taste." I recall once interviewing Nancy Reagan, at a time when her husband was governor and the construction on this house had not yet begun. We drove down to the State Capitol Building that day, and Mrs. Reagan showed me how she had lightened and brightened offices there by replacing the old burnished leather on

the walls with a kind of beige burlap then favored in new office buildings. I mention this because it was on my mind as I walked through the empty house on the America River outside Sacramento.

From 1903 until Ronald Reagan, who lived in a rented house in Sacramento while he was governor ($1,200 a month, payable by the state to a group of Reagan's friends), the governors of California lived in a large white Victorian Gothic house at 16th and H Streets in Sacramento. This extremely individual house, three stories and a cupola and the face of Columbia the Gem of the Ocean worked into the molding over every door, was built in 1877 by a Sacramento hardware merchant named Albert Gallatin. The state paid $32,500 for it in 1903 and my father was born in a house a block away in 1908. This part of town has since run to seed and small businesses, the kind of place where both Squeaky Fromme and Patricia Hearst could and probably did go about their business unnoticed, but the Governor's Mansion, unoccupied and open to the public as State Historical Landmark Number 823, remains Sacramento's premier example of eccentric domestic architecture.

As it happens I used to go there once in a while, when Earl Warren was governor and his daughter Nina was a year ahead of me at C. K. McClatchy Senior High School. Nina was always called "Honey Bear" in the papers and in *Life* magazine but she was called "Nina" (or sometimes "Warren") at weekly meetings of the Mañana Club, a local institution to which we both belonged. I recall being initiated into the Mañana Club one night at the old Governor's Mansion, in a ceremony which involved being blindfolded and standing around Nina's bedroom in a state of high apprehension about secret rites which never materialized. It was the custom for the members to hurl mild insults at the initiates, and I remember being dumbfounded to hear Nina, by my fourteen-year-old lights the most glamorous and unapproachable fifteen-year-old in America, characterize me as "stuck on herself." There in the Governor's Mansion that night I learned for the first time that my face to the world was not necessarily the face in my mirror. "No smoking on the third floor," everyone kept saying. "Mrs. Warren *said*. No smoking on the third floor *or else*."

Firetrap or not, the old Governor's Mansion was at that time my favorite house in the world, and probably still is. The morning after I was shown the new "Residence" I visited the old "Mansion," took the public tour with a group of perhaps twenty people, none of whom seemed to find it as ideal as I did. "All those stairs," they murmured, as if stairs could no longer be tolerated by human physiology. "All those stairs," and "all that waste space." The old Governor's Mansion does have stairs and waste space, which is precisely why it remains the kind of house in which sixty adolescent girls might gather and never interrupt the real life of the household. The bedrooms are big and private and high-ceilinged and they do not open on the swimming pool and one can imagine reading in one of them, or writing a book, or closing the door and crying until dinner. The bathrooms are big and airy and they do not have bidets but they do have room for hampers, and dressing tables, and chairs on which to sit and read a story to a child in the bathtub. There

are hallways wide and narrow, stairs front and back, sewing rooms, ironing rooms, secret rooms. On the gilt mirror in the library there is worked a bust of Shakespeare, a pretty fancy for a hardware merchant in a California farm town in 1877. In the kitchen there is no trash compactor and there is no "island" with the appliances built in but there are two pantries, and a nice old table with a marble top for rolling out pastry and making divinity fudge and chocolate leaves. The morning I took the tour our guide asked if anyone could think why the old table had a marble top. There were a dozen or so other women in the group, each of an age to have cooked unnumbered meals, but not one of them could think of a single use for a slab of marble in the kitchen. It occurred to me that we had finally evolved a society in which knowledge of a pastry marble, like a taste for stairs and closed doors, could be construed as "elitist," and as I left the Governor's Mansion I felt very like the heroine of Mary McCarthy's *Birds of America*, the one who located America's moral decline in the disappearance of the first course.

A guard sleeps at night in the old mansion, which has been condemned as a dwelling by the state fire marshall. It costs about $85,000 a year to keep guards at the new official residence. Meanwhile, the current governor of California, Edmund G. Brown, Jr., sleeps on a mattress on the floor in the famous apartment for which he pays $275 a month out of his own $49,100 annual salary. This has considerable and potent symbolic value, as do the two empty houses themselves, most particularly the house the Reagans built on the river. It is a great point around the Capitol these days to have "never seen" the house on the river. The governor himself has "never seen" it. The governor's press secretary, Elisabeth Coleman, has "never seen" it. The governor's chief of staff, Gray Davis, admits to having seen it, but only once, when "Mary McGrory[1] wanted to see it." This unseen house on the river is, Jerry Brown has said, "not my style."

As a matter of fact this is precisely the point about the house on the river—the house is not Jerry Brown's style, and not Mary McGrory's style, *not our style*—and it is a point which presents a certain problem, since the house so clearly *is* the style not only of Jerry Brown's predecessor but of millions of Jerry Brown's constituents. Words are chosen carefully. Reasonable objections are framed. One hears about how the house is too far from the Capitol, too far from the Legislature. One hears about the folly of running such a lavish establishment for an unmarried governor and one hears about the governor's temperamental austerity. One hears every possible reason for not living in the house except the one that counts: it is the kind of house that has a refreshment center. It is the kind of house in which one does not live, but there is no way to say this without getting into touchy and evanescent and finally inadmissible questions of taste, and ultimately of class. I have seldom seen a house so evocative of the unspeakable.

[1] Mary McGrory won the Pulitzer Prize for Commentary in 1975 for her articles about the Watergate scandal. [Ed. note]

Backslash

April Lamm

Folly-fallen: David Hammons's *House of the Future*

This house is no house. It's an illusion; a rupture in the idea of a house. Ramshackle, slipshod, it's a foil of a house, a hoax. There's no room for life—no "living room," no running water or electricity—no room, actually, for much of anything between the four walls and roof placed just beyond the perimeter of a door. It is the crooked cousin of colonial Charleston's "single house," the prevailing style of all the houses on this otherwise posh peninsula. If you don't look closely, this idea of a house might seem fool-borne. What is that unlivable sliver?

It was conceived of by a man who has made wit his profession, a man who has sold snowballs to city slickers, a man who mounted a basketball hoop some thirty meters high on a telephone pole. In the parlance of his profession, David Hammons's house folly built in downtown Charleston, South Carolina, would be called an installation. He titled it the *House of the Future*, though you wouldn't know that by looking at it. No commemorative plaque announces it, unlike so many homes in the storied adjacent neighborhood, "Washington slept here"; or "… built by Col

William Rhett [who] captured the pirate Stede Bonnet in 1718"; or my favorite, at 56 Society Street, "…by the late 19th century the kitchen building was connected to the main house with a hyphen."

Hammons's *House of the Future* is sited askew, at a diagonal on a lot too big for it. It's more of a modern-day backslash: that is, when you stand on the corner of America and Reid Streets, it is placed at an angle like this: \. Backslashes are place-holders of mystery. Without a firm grip on the nitty-gritty of computer program-ming, you'd just think of them as lines that lean back, relaxed.

Hammons's folly leans too. And putting the house on a diagonal certainly sets it apart from all the other houses perpendicular to the street. As I approach the corner, parking the car curbside of the Chicken Plus, I see that Hammons's fol-ly had taken a beating, or at least acquired a few wrinkles. It has weathered since I last set eyes on it. But importantly, it still stands, un-like many of the other projects built for the 1991 Spoleto Festival. The grass of its gener-ous yard is a memory, the mud in its stead like toothpaste under my feet. This mud even has a particular name, I later learn, "pluff" mud, which not only prevented the build-ing of high rises on the peninsula, but also the high rise of upward mobility for quite a few.[1] Braving the rickety steps to the second floor, I feel as if I am being watched, playing the fool in mounting this house of cards. A fall seems imminent. But nothing happens. I straddle the landing of the mock "piazza"

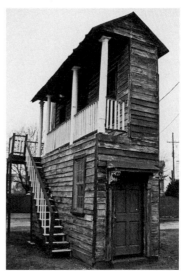

David Hammons's *House of the Future*.
© Sandy Lang, 2008

(Charlestonese for porch) and hear the vintage sound of someone popping open a can of soda. I imagine the refrigerator door being shut while someone watches me, sipping Coke from behind a screened window. Being white, surely my pres-ence in the neighborhood is not going unnoticed, let alone my foolhearted ascent of this folly. I watch a man with a cap and cane hobble by and see a young man greet him as "Mr Billy." It's a neighborhood where neighbors have names, I con-clude quickly. I peek into the upstairs windows looking for evidence of the build-ing's function, what happens here at day, what at night. According to *The New York Times*, it was once used as an artist's studio; no wider than a tenement hall, un-fathomable, truly, though I suppose it would fit a chair and a laptop, but no more. All I can see are a few broken boards. Evidence of nothing bad, nothing good. Up close you notice that its parts are labeled, like in an illustrated manual, "stucco," "siding," "shingles." It's a house you can "read," even if much of the page is blank. Its emptiness is less empty than bereft, yellowed. An emptiness emblematic of what happens in the other 300 empty houses in the neighborhood. Rather than a folly to liberty, a house for the libertine. At least it witnesses the libertine. America

Street is *the* street of the neighborhood with street cred, the one that makes it into the newspapers the most. Men drive by it slowly in sedans with all four windows rolled down, greeting men leaning against parked cars. Their dialogues are hushed. "No Trespassing,"Private Property" signs tacked to doors and taped to windows announce the obvious. The chain link fences marking off rented plots make sounds quite different from the iron gates and wooden picket fences of the "historic" houses nearby.

Nearly two-hundred-year-old barbed wire made of heavy iron spikes remains around windows and doors of the expensive houses in the neighborhood adjacent, the *chevaux-de-frieze* which had been installed to ward off the freed slaves who'd fueled the slave revolt of 1822.[2] That is to say, Hammons's folly is a backslash, bringing attention to the differences between a single house South of Broad, say, and a single house on the East Side. It's a backslash that heralds a shift in mentality. The kind of heat that slows a person's walk here fuels a hotbed of sedition. The single palmetto flanking the house is naked: its green open fan fronds plucked—it's a tree that looks more like a torch. And though the physiognomy of the house itself is apparent, its personality remains hidden. It could be read

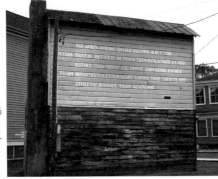

Back of the *House of the Future*.
© Sandy Lang, 2008

as a harbinger of what W.E.B. Du Bois called a "double consciousness," that is, seeing yourself through the eyes of others. It is a shrink-to-fit house fitting to the quote that graces its side like chalk on a blackboard, the graffiti of a dispirited teacher: "The Afro-American has become heir to the myth that it is better to be poor than rich, lower class than middle or upper, easygoing rather than industrious, extravagant rather than thrifty, and athletic rather than academic."[3] It's a skinny house, malnourished rather than slim.

In the antebellum South, Hammon's *House of the Future* would have found itself plopped down in the middle of a working-class community composed of German and Irish immigrants, and, significantly, the "Brown elite" (mulatto sons and daughters of plantation owners) alongside the more than 3000 free black carpenters, ironsmiths, tailors, barbers, and grocers, many of whom owned the property they lived on.[4] Perversely, the Civil War and the Emancipation Proclamation marked the downward trend of a once up-and-coming area. Over the years, the "Negro Codes"[5] had made life for the "free blacks" increasingly difficult, and many of this well-to-do set had fled the city in fear of being re-enslaved based on the draconian laws which required that "people of color" seek out year-long work contracts, or else be arrested for the criminal act of being unemployed ("vagrancy").[6] While those laws were eradicated, the invisible barriers of segregation remain very much erected around Charleston's East Side.

Ironically, Hammons's folly sets off a chain of thoughts about the prosperity it mocks, the prosperity beyond the invisible scrim. You can still hear the rustle of a hooped skirt, or the twirl of a parasol nearby, in the neighborhood adjacent, in the manses built as wedding presents, houses in which the "piazza" is tiered. Townhouses built by rebels, the signers of the Declaration of Independence, people who owned people. Hammons's folly is in a neighborhood which shares the air of Charleston's posh neighborhood with most of the houses dating back to the early eighteenth-century, "second" houses owned by golf partners, people with public relations liaisons, people who have lawyers, portfolio advisors, members of the Garden Club and the United Daughters of the Confederacy. They sit under cornices and medallions, on piano benches in cypress-paneled salons, behind damask draperies from which to view the cultivated ivy and jasmine. Wisteria and Spanish moss run wild, azaleas burst forth in spring. The horse carriages of tourists passing by make the cobblestones noisy. Tiny flags top piles of manure, heralding the need for hauling it off. Toy flags, it seemed at first—a little boy's joke.

You'd think that today Hammons's absurd prototype would be the ideal playhouse for kids on the block, a gathering point, an elaborate soapbox. Not a single house of Thoreauvian solitude, but a house of solidarity. A pretend house that prefaces and portends, in pursuit of negativity—for to live in a house this small would indicate a dire future—it negates its identity. In this sense, this house is what it is not.

[1] In the early eighteenth century, there was a strong rising class of free blacks who slowly lost footing. See footnote no 5.
[2] Denmark Vesey was a slave until he bought his freedom after winnning $1500 in a city lottery in 1799. After working as a carpenter for eighteen years, he co-founded a church, a hotbed of sedition in those days, which was shut down just one year after its opening, and then again two years later. On Bastille Day in 1822, four years after Vesey had founded that church, his plan was set in action to execute several slaveholders in Charleston and then make a quick escape on a ship bound for Haiti. 131 of these daring men were caught and convicted, many of them hanged, including Vesey.
[3] The quote painted on the windowless side of the house is from Ishmael Reed.
[4] The majority of whom were women, but that's another story. Notable well-to-dos include Robert Howard, "one of the wealthiest free men of color," and Richard Dereef and who owned several properties in the neighborhood. As such, he was a landlord to white renters, and he himself owned some forty slaves. See http://mulat-todiaries.wordpress.com/2010/03/25/richard-dereef/ and http://www.southernheritage411.com/emails2.php?me=1233.
[5] Enacted in reaction to the quickly quelled Stono Uprising of 1739 in which two white men guarding a general store were decapitated. The so-called Negro Codes restricted what clothing a negro could wear ("…blue linen, check linen… callicoes, checked cottons, or Scots plaids,"), prohibited blacks from carrying guns, and the death penalty for any slave who raised or attempted to raise an insurrection." See, Edward Ball, *Slaves in the Family* (New York, 1998), p 141. It also denied plantation owners the right to grant freedom to their slaves or their own children. Ibid, p. 187.
[6] The eventual dissolution of segregation came about through a series of lawsuits presided over by Judge J.Waties Waring, a Federal judge in Charleston, whose landmark decisions in the late 1940s set a precedent for cases tried years later such as Brown vs Board of Education, and eventually the revoking of the Jim Crow Laws in 1961.

Barricade

Naeem
Mohaiemen

*Janen na
din-kal kharap?*

A cup of tea. Temporary camp for highway construction. Phantom investor. New chairman. List of approved guests.

Shadows lengthen. A theorist talks about an architecture of occupation. But security presence in Asia is subtle. Suit, tie, coat, bideshi degree. Think tanks, seminars, conferences, talk shows, newspapers. Everyone has an opinion on the century's obsession.

They tell us, we know the answers. Facial hair, surname, skin hue, city of birth—the spectrum of motivation recognition.

Dhaka is inside a security cocoon. The genius of elections came and went, steel wire barricades and midnight checks remained intact.

On the day after the state of emergency was lifted, I saw a homeless woman on Dhanmondi Bridge, drying her family clothes on that same wire barricade. A sweet, fleeting moment.

But a few days later, the barricades were back in action. The sudden stop and search, a demand for identification, the rummaging inside your camera bag, the interrogation.

Eto raat e beriyechen keno? Janen na din-kal kharap? (Why have you come out so late? Don't you know these days are bad?)

I feel a searing nostalgia for open space, a time before these "temporary" structures. Temporary camps that never leave. It is all to make you safe and secure. Safe from what?

A long pause.

Yourself, your weaker side, your politics, your affiliations, your nightmares, your ideology, your rights, your friends and neighbors.

Your dreams.

Street barricade in Dakha, Bangladesh

Cannibalism

Sam
Jacob

Dumb and Dumber:
In Praise of Follies

Off-season, the Scheveningen boardwalk is a very lonely place. All of its seaside resort jollity is blasted by North Sea winds leaving desolate prospects. Even the blow-up gorilla sitting astride the roof of a fun pub seems to hum, "Come Armageddon, come," and the giant neon parrot at the end of the pier looks like it would rather be blinking in a neon jungle far, far away.

Street folly
© Athar Abidi

From the miasma of blur-grey sea mist, a startling figure pulls into focus. Bright and so full of verve, it seems to bound towards us, despite its rigid figure. "Hi!" it says without speaking, "I'm a cone full of chips." Face bursting with excitement, perky legs sprout from its carton body, chips poking up for hair. One arm is raised in greeting while the other reaches up to the top of its head—no doubt feeling for a chip. Its eyes bulge in anticipation of the taste of fried potato. In fact, so much pleasure emanates from this figure that it seems deliriously innocent of its own imminent self-cannibalism. Its mouth hung open, its tongue swells, lolls out, its teeth are all arrayed in preparation to chomp down on its own body. Ecstatic about its own deliciousness, totally absorbed in its self-ingestion.

The demented fellow seems a poor encouragement for fried food. Its body without organs instead seems to carry another message.

Os Filhos de Pindorama. Cannibalism in Brazil in 1557 as described by Hans Staden

It smiles at us with a knowing smile. "Don't we all eat ourselves?" it seems to say. "Don't you, like me, swallow yourself up in self-absorbed pleasure?" Standing as a glowing embodiment of consumption, it is even a symbol of consumption devouring itself.

And while it says these things, it offers a hole in its hollow body as a receptacle for our trash. Just like Brett Anderson, it offers us some kind of redemptive consolation in its (and by extension, our own) lowliness: "We're tra-a-ash, you and me."

We encounter these kinds of fiberglass follies in streets, parks, and other touristic locations, the kinds of places wrapped up in absent-minded consumerism. They might be giant sculpted ice creams the size of an adolescent, whipped tops dripping with sauce, their cones sculpted into an exaggerated waffled texture. Or neon pizza slices, each neon mushroom a swiggle of calligraphy. But they aren't quite signs. They don't explicitly encourage us to buy, they don't offer us deals. They remain wordless objects in the landscape. Stupid objects in the stupidest parts of our modern landscape. Not so much advertisements but desire made GRP real, popped as much out of our greedy minds as from the moulds that form them. These are objects of the shallow imagination, idiotic follies of an animal desire for fat, sugar, and flavorings. But they are follies, nonetheless. And as follies they spring from a grand tradition.

According to Erasmus of Rotterdam, Folly was born to the young and intoxicated god Plutus and "the loveliest of all the nymphs and the gayest" Youth. Folly was nursed by Drunkenness and Ignorance. Her followers include Self-love, Pleasure, Flattery, and Sound Sleep. We might not know much about Renaissance culture or the Catholic Church in the 15th century that Erasmus was apparently addressing, but those character traits sound very familiar, the very same things we wring our own hands about. Erasmus's text, *In Praise of Folly* (1511), might be a piece of 500-year-old esoterica but it might help us understand the contemporary significance of a self-devouring bag of chips. Erasmus mobilizes Folly as a form of sarcasm, as a voice able to say things that we can't say in our own voice. Like the court jester, Folly performs an exceptional role. Its idiocy grants it license to speak the kinds of truths others can't. Our friendly bag of chips is Folly herself. It talks in Folly's voice directly to our own self-love, our own empty, trash-filled hearts, and it does so with Folly's goofy grin and goggley eyes of idiocy.

According to Adolf Loos, "Only a very small part of architecture belongs to art: the tomb and the monument. Everything else that fulfills a function is to be excluded

from the domain of art." Follies too are architecture eviscerated of practical func-tion. Perhaps this makes them art as well. All three forms of construction share a single characteristic: their primary purpose is to embody, transmit, and represent an idea, to petrify narrative into stone or fiberglass. Aren't tombs just follies minus the fun? And monuments are surely just joyless follies of state. That also means that follies are far more than simple entertainment. They may be playful, but their playfulness is as serious as the grave.

We can trace the architectural folly's role as idea-made-real to its origins in the 16th and 17th century. Follies operated as decorative objects in the aristocratic land-scape that acted as tangible symbols for ideas and ideals. Often taking the anti-quated form of Egyptian structures, Greek temples, ruined gothic abbeys, and so on, they summoned up cultural references to make them stony flesh. By summon-ing up idealized cultural images, they made the imaginary world of their builders real. Follies are equal parts thing and idea, bound together in a way that is impos-sible to untangle.

Nowhere is this compound of ideology and folly more fulfilled than Stowe, the family seat of the Temple-Granvilles. Richard Temple, 1st Viscount Cobham, was both a soldier and a politician who acted as a mentor to William Pitt. Disillusioned with active politics he retired and took to redesigning Stowe's gardens. Rather than a retreat from ideology though, the gardens became a vehicle for his political concerns. The very ground was ploughed and reshaped by his political beliefs. Designed with Capability Brown and John Vanbrugh, Stowe was choreographed as a landscaped manifesto, as satire and as a legible political proposition. Struc-tures such as the Temple of Ancient Virtue embodied those virtues Viscount Cob-ham saw as lacking in his political opponents, while the Temple of Friendship was dedicated to his group of opposition Whigs. The Temple of British Worthies set out an agenda of good and honorable qualities through its selection of poets, philosophers, scientists, monarchs, statesmen, and soldiers. We can read Stowe as a 400-acre ideologically narrative landscape.

Of course, we don't build landscapes like Stowe anymore. But we do build follies, even if we call them something else. Even if they are simply giant GRP ice creams. And when we do, consciously or not, we also cite the cultural heritage of the folly. In its ridiculous stupidity it operates like Erasmus's Folly, as the voice of a deranged self-indulgent truth. In its uselessness, it gains Adolf Loos's amplified essentiality. In its figural representation, it gains Stowe's narrative ability.

Follies then, whether we like it or not, are serious, sarcastic, and ideological mani-festations. The more stupid they are, the more serious they become. The more facile, the clearer their ideology. Follies are ourselves reflected back at us in a magnifying mirror. They are our desires and dreams, our logic and reason made friendly-grotesque, hanging out on street corners ready to wink at us knowingly and smile with that gurning expression of self-recognition.

Cubic Meter Food Cart

Ai Weiwei

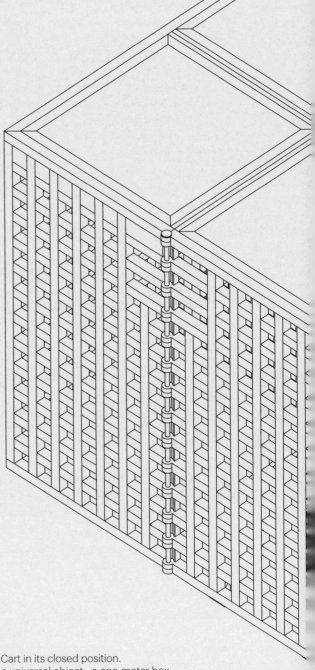

Concept drawing of Ai Weiwei's Cubic Meter Food Cart in its closed position.
Ai Weiwei's Cubic Meter Food Cart is conceived as a universal object—a one-meter box.
Materials, wood, glass, and brass

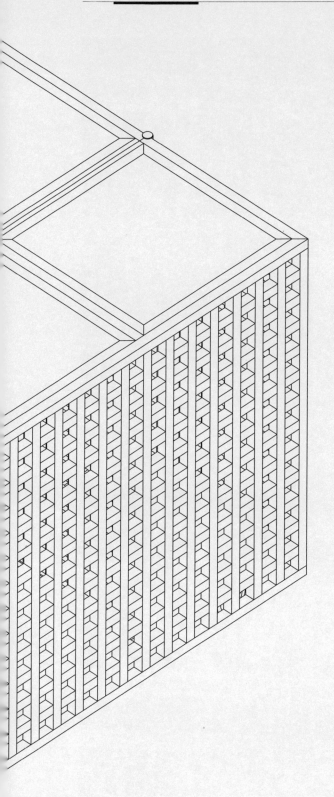

Setting up *pojangmachas* in Gwangju Park.

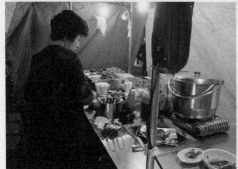

This vendor has worked nearly 30 years at her current location in Gwangju's downtown.

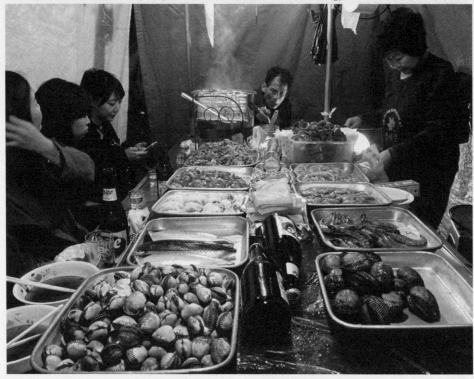

Food carts have an ambiguous and declining social role in cities today, operating in restricted locations and within limited hours. Nonetheless, they embody a persistent, if not subversive, freedom. Inspired by the function, economics, and history of Gwangju's *pojangmacha* or "tented wagon," whose vendors provided food to protestors during the uprising, the Cubic Meter Food Cart reflects on the role they played in significantly changing Korea's political landscape.

In its expanded form, the Cubic Meter Food Cart accommodates the necessary functions of the *pojangmacha* experience: cooking, storage, lighting, display, and table surfaces. It is a mobile modular object occupying a modest space—a discreet container of consumption, conversation, and culture. The act of opening and closing the Food Cart should instigate discussions about public space and private enterprise. How does the city reconcile restricting these small, temporary, and useful structures while allowing the construction of massive buildings or even "follies," which, by definition are permanent, fanciful, and useless?

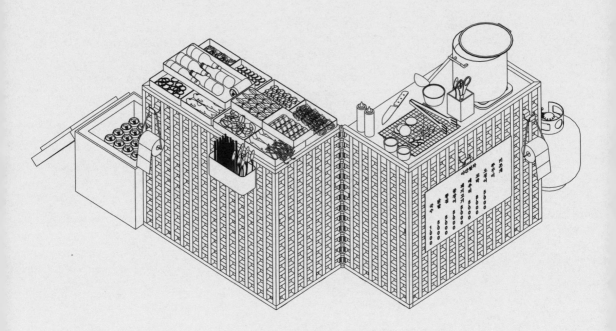

Concept drawing of Ai Weiwei's Cubic Meter Food Cart in use. Exterior view.

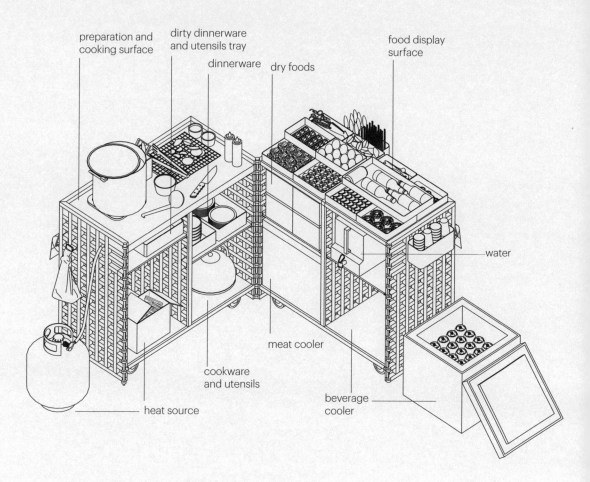

preparation and
cooking surface

dirty dinnerware
and utensils tray

dinnerware

dry foods

food display
surface

water

meat cooler

cookware
and utensils

beverage
cooler

heat source

Concept drawing of Ai Weiwei's Cubic Meter Food Cart in use. Interior view. The cart provides space
for the basic functions of a typical food cart and accommodates different types of cuisines.
Its gridded structure allows for flexible use and some transparency.

Disaster

Hu
Fang

The Century's
Talents Expo

When I finally fall, I might descend into a cool midnight in early summer. Over there, I will still find bold, heroic-like questions awaiting answers, and through them, I will take another step into exploring the labyrinth of life.

Test (please indicate an "×" next to your selection)

It is a cool midnight in early summer, well-suited for an earlier slumber. Imagine you are the story's protagonist. Select the manner in which your dream will develop:

1. In your dream, you are a very popular pop idol. In fact, you have a secret—you are currently seeing a young successful (male or female) singer. However, such a situation is considered an absolute taboo for two idols. Will you:

 ☐ retire from the pop scene and focus on your relationship with him/her
 ☐ give up on the love affair and continue being an idol

2. The scene suddenly changes. You are now sitting for an examination for the diplomatic service. Which country do you hope to go to?

 ☐ Australia, with its wide expanse of land
 ☐ Italy, with its rich arts scene ancient ruins

3. This time, you have become an administrator in an advertising company. The client is going to launch a new healthy beverage. What would you call it?

 ☐ Vitality Vitamin A
 ☐ Beautiful C Component

4. Next, you become the secretary of a director in a large firm. Although the director is not particularly friendly, he is rather concerned about you. You discover that the other directors in the company are discussing an evil scheme to force your director to step down. Now that you know the truth, what will you do?

 ☐ feel sorry for your director and tell him about the plan immediately
 ☐ remain as fierce as the director and not let on about the plan

5. Now, you are the deputy of the National People's Congress. A few of your constituents hope that you can build a golf course to boost the tourism in-dustry. However, doing so could possibly result in pollution from pesticides. You are stuck between a rock and a hard place. What will you do?

 ☐ For the sake of the future in the long term, you refuse to build the golf course.
 ☐ For the sake of resolving the current economic problem, you endeavor to make the golf course a reality.

6. This time, you have become an enthusiastic new film director. What subject matter do you think your first film will have?

 ☐ a romantic love story
 ☐ an imaginative science fiction story

7. Now, you are an astronaut being sent to Mars with a companion to fulfil your mission. What is your preoccupation for this particular mission?

 ☐ a sense of boredom over the fact that you will have to eat rather bland foodstuff made for space
 ☐ a sense of worry that you may not return successfully to the Earth you love

This test indicates the career path that you are most suited for. By discovering what career you are suited for, you will be able to have extraordinary developments for your talents.

Hence, after passing through the metal grill and walking past the green that early summer night, two young men dressed in camouflage green suits took me to a "place where dreams come true": the site of the Century's Talents Expo. This was the world that everyone was fighting tooth and nail to squeeze into because it was replete with opportunities leading into the future. It is only when they arrived here that people realized that this place was once a disaster site creatively developed based on its geographical conditions. It was constructed within a depression formed after a mudslide and an earthquake. After working tirelessly night and day, and subsequently with the space covered with astroturf, the landscape architects had constructed a system that presented the space in an outstanding theatrical manner. In particular, when lights were cast on the man-made landscape at night, the whole atmosphere was especially stirring.

Or should we say: this time, the scene of the Century's Talents Expo and the reconstruction of the disaster site were organically melded together, resulting in the city's largest real estate project in its history. The Expo stood out from other exhibitions in that it not only imposed strict criteria for participants, but also incorporated professionals such as psychiatric therapists, food nutritionists, glaziers, front-runners, recycling-data experts, magicians, plastic surgeons, dictionary editors, bloggers, LED technicians, hungry artists, palmists, gardeners, etc.—all in a bid to become the grandest gathering in this country's history where talents attracted and delegated.

When the disaster took place, I remember how we were anxious to be part of the rescue effort. Everyone was talking on and on, asking Sensei where we should go. Sensei just smiled and let us meander round and round in our search, until we were finally dizzy and no longer able to hold our ground. Where we fell became where we wanted to head towards to assist with the emergency rescue.

In the end, I fell towards the east. I moved through the entire city and finally arrived here.

At this point in time, those people who were faced with the disaster at hand bore no traces of panic on their faces. On the contrary, a rare sense of harmony permeated the city. There must have been something or other that was supporting the thousands of inhabitants of this city, as they made their journeys on the road diligently. I suddenly thought of how those who had been unemployed for a long time may well find love amongst the ruins.

Dogged

Caruso St John &
Thomas Demand

Nail
House

Wu Ping and Yang Wu's house in Chongqing, China, in 2007. © EyePress, Hong Kong

A "nail house" is a Chinese neologism for homes belonging to people who refuse to leave, like that last nail in the wall that refuses to be pounded down. The most famous case is the one of Wu Ping and Yang Wu who declined to sell their two-story brick house to the developers of a shopping mall under construction in Chongqing. The developers cut their power and water, and excavated a ten-meter deep pit around their home. For two years, Wu Ping and Yang Wu's house became a fortress of resistance: a folly in its obstinacy, its refusal to be defeated.

In 2008, Thomas Demand and Caruso St John collaborated on a "Nail House" to be constructed as restaurant under a viaduct in Zurich West, a former industrial area undergoing dramatic changes. The house would have taken on the semblance of an archaeological fragment, a simulacrum carefully tailored to fit the precise topography of the heavy concrete overpass, the Hardbrücke. It would have appeared like stubborn leftover from a lost city district, a bizarre fragment of China

Illustration by Martin Mörck of the Nagelhaus, an aborted project for Escher Wyss Platz, Zurich, by Thomas Demand and Caruso St. John. © Martin Mörck

Town. The "Nail House" won first prize in the city-sponsored competition but the project was nipped in the bud by a plebiscite ignited by the right-wing populist SVP. Zurich West, the new frontier would host no ruins of a Chinese district, fictive or otherwise.

Emancipation

Stephen Squibb

Let a Thousand Follies Bloom

In the 1920 film *One Week*, newlywed Buster Keaton sets out to build a house according to a set of directions. Today, we would call this an example of *coproduction* wherein the consumer is recruited to assist in the production of their own goods. Instead of buying the finished product, one buys elements and instructions. In the film, as in life, this sets the stage for the follies that follow. In fact, it is difficult to imagine recognizing a folly as a folly without there being some plan, concept or idea to provide the standards according to which it falls short. Great follies are distinguished by the vast canyon separating their aspirations from their actuality. In the case of the film, the raw materials are intentionally mislabeled by an adversary to further compound the difficulty of assembling the house. The plan is useless in the face of this deceit. The resulting house is unlivable.

Unlivability is usually what we mean by architectural folly, not that things didn't go according to plan. On the contrary, a proper architectural folly is a structure built

perfectly to plan that is, nevertheless, unlivable. If one were to speak of the "folly of Brutalist architecture," for example, one would not be speaking of a consistent inability to assemble these structures correctly. Folly, in this case, refers less to the process of production, and less to the plans themselves, than to the ambitions that gave birth to the plans in the first place. It was folly, we would say, to imagine that one could build a structure that could succeed by the terms of the idea. Or worse, that it was folly to have an idea in the first place, for the space between the building and the idea is the background against which the folly falls into relief. No idea, no space in between, no folly.

May 18, 1981
© 5.18 Memorial Foundation

Architecture would then be the place where the tension between the realm of the idea and the lived experience of the life-world (*Lebenswelt*) is most powerfully rehearsed. Far from securing the *participation* of the idea *within* the social fabric, architecture secures instead the *history* of ideas *as the social fabric itself*. Architecture thus preserves the distance between the present and the past; such is the function of the plan, which selects one moment in the history of an idea and installs it permanently in the social landscape. This is folly.

The danger of a social architecture thus lies in doing the work of the future with the tools of the past. Regimenting the possibility delimited by history, the politics of architecture consist in constructing the line that divides the old from the new. Old is what is reflected in the architecture, the new, what is not. We are accustomed to celebrating the new; the unplanned, which, so long as it remains unbuilt, can never be considered folly. *To use a space otherwise than what it was designed for* is a surefire way to avoid embarrassment by the terms of history. One risks nothing when one builds nothing.

The Gwangju Commune lasted for six days. During which time the spontaneous emergence of popular democracy, the pursuit of armed resistance from below, the vanishing of criminal behavior in the city, the revelation of genuine solidarity and cooperation among the citizenry, and the suspension of hierarchies of class, power, and status provided a blueprint for the future. Of course, it was folly to imagine that freedom can persist against mercenary para-

May 18, 1981
© 5.18 Memorial Foundation

troopers and helicopter gunships. On May 27th 1980, one hundred and nine years to the day after the destruction of the Paris Commune, Gwangju was similarly overrun by the international forces of reaction. Their victory, as always, was short-lived, for the memory of rebellion is the architecture of freedom as surely as the edifice of emancipation is the evidence of folly.

Form, Follies, Function

Hans
Hollein

Holly
Folly

Original graphic from Hans Hollein, 1983

Gwangju River Reading Room

David Adjaye &
Taiye Selasi

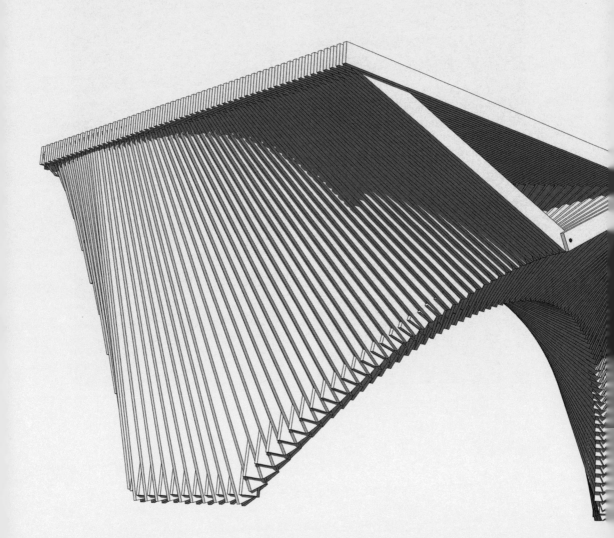

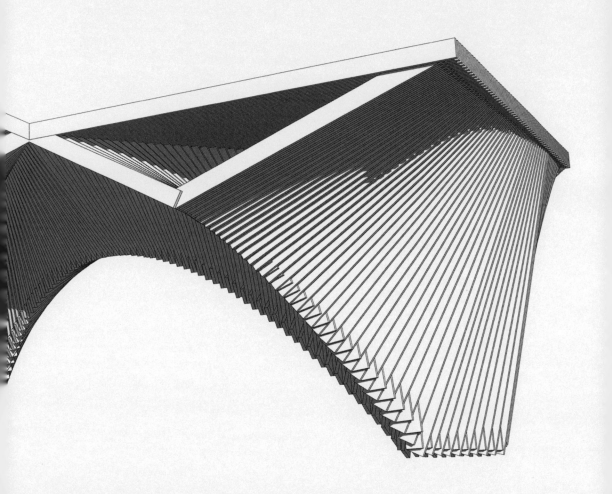

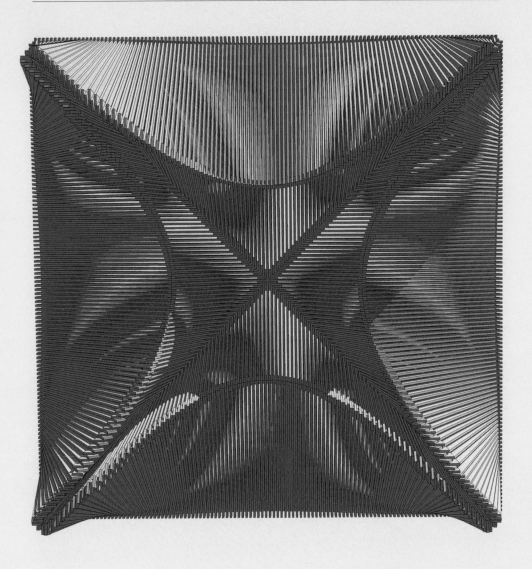

On a sunny Monday morning in the middle of spring, some two hundred students stood, angry. They'd gathered at the gate of Chonnam National University in defiance of its closing. Five months prior General Chun Doo Hwan had taken control of their country, summarily expelling both students and professors from universities for pro-democracy activities. With the beginning of the new semester in March, many of the expelled had returned. By 9:30 AM on this bright mid-May morning, two hundred such had assembled.

See them.

A dark Mudeung Mountain looms calm in the distance, outlined in light by the mid-morning sun: that stunning exemplar of the elegance of nature that had given rise to gasa poetry four centuries before. Thirty paratroopers in the service of Chun look anxiously upon their assembly. They aren't much older than the students themselves, with families and friends of their own. Were it not for their uniforms, weapons, and scowls, they might not stand out from the gathering crowd. But their minds have been molded by orders, not ideas, their lives by bayonets, not books. For thirty-odd minutes, with the crowd growing bigger, the sun growing brighter, the soldiers growing bitter, a peaceful demonstration takes place at the gate. At 10:00 AM, the soldiers charge.

See this.

The brutality exhibited in the next nine days would stun the world and rock the country. The defiance exhibited by the citizens of Gwangju would forever change Korea. When we think of the Gwangju Democratization Movement, we think of them, these citizens. We think of the two thousand murdered, unarmed, of the triumph of the will of the demos. The City of Light, like its picturesque Mudeung Mountain, has become iconic: both an embodiment of the sanctity and of the cost of human rights.

Which is a problem.

The trouble with icons is that, much like mountains, we tend to place them at a distance, so that they appear immobile, unchangeable, frozen, unrelated to actual life. Three decades later, the events of May 18 1980 could not be less so: they are acutely related to the actual life of a global contemporary polis. As students and soldiers in the primes of their lives—in Libya, Syria, Russia, Egypt—re-enact the events of May 18 on their own city streets, we are compelled to remember Gwangju. This question of memory is neither purely local nor sentimental. Within Korea and without, the need to remember is urgent. The question is how? How to memorialize a human rights movement without trapping it, freezing it, making it "past"? How to remember death in ways that don't drain memory of life? They are critical questions for the sculptor, the architect, the creator of public memorials, yes, but also for the writer, the poet, the photographer: the chronicler of human experience.

"Human rights" is a funny term, as it rings with the immensity of global imperatives. Its meaning seems as clear as day, and yet it tends to obscure its subject. The human possessor of "human rights" is, after all, individual. If humans are to express and to experience their rights, they must do so within their experience. The mere idea that all humans have the right to food security, for example, does me no good if I am hungry. Human rights are realized in the singular experience of the individual. If "human rights," that most global of terms, speaks in fact of human experience, then to memorialize a human rights movement we must turn our attention to the same. What were the names of the two hundred students who went marching that morning down bright, tree-lined paths? What were their stories, their fears, hopes, sins, dreams? Who were those human beings? What are the human narratives of the two thousand who died that week? Of the millions who died before them in pursuit of the same rights? Of the thousands dying now in squares, at gates, on fields, in city streets? What are the stories of the human beings who struggle for human rights? They exist: in books, both fiction and non-fiction, an unfrozen form of memorial, an investigation not only of what happened, where and when, but to whom. Still, we undertake these investigations of human experience in silence, in private. Such is the nature of reading a book; our minds can hold whole worlds. To shift the experience to the public sphere—where political movement occurs—requires a public space designed for that most intimate of memorials: the book.

Of course, "public space," like "human rights," suffers from the elasticity of the term's abstraction and the imprecision of its application. Its mythology is more about fiery speeches and huge audiences than about the solitary act of reading. We know public space when we see it—or think we do—but the shades of what we label "public" resist a firm correspondence between this classification of space and any particular built form. The street, the plaza, the park; these are easy. The market, the temple, the bus; these are a little more tricky. The contemporary spaces we hold in common with our fellow citizens are riddled with questions of who pays for them, who benefits, who is excluded, who determines their use. Again,

the human capacity to be a part of a crowd elevates the categorical at the expense of the individual. Yet, when Giambattista Nolli made his famous map of Rome (1736-1748), distilling all urban space into the black and white of public and private, the distinction was not—as many think—between open-to-the-sky or closed-in-by-ceiling, volumes versus voids, figure and ground. Rather, the definitional difference was between what a commoner could walk through and what he could not. Thus, the interior space of the duomo becomes as public as the street; the Pantheon is rendered as a piazza. The possibility of public assembly takes the same forms as the capacity for private reflection in the company of strangers.

More recently, the encroachment of private capital into the commons dissolves any simple binary. And the political potential of making the multitudes visible brooks neither dissent nor nuance. Mass protest has a way of assigning a particular meaning to where it takes place. Therefore, Tlatelolco, Tiananmen, and Tahrir become metonyms for massacres or rebellions. The symbolism of the horde is broadcast as a monolithic symbol. The quantity of people gathered serves only to amplify the unitary voice and to stifle individual voices, lost in the crowd. Public space, fetishized by urbanists and revolutionaries alike, begins to lose its most powerful attribute: the collective container for being alone together.

The Gwangju River Reading Room, a riverside pavilion for exploring human story, attempts to restore power both to human rights and the public space. In giving form to human memory, the Reading Room becomes a living space, an open-air memorial to the lived past and living present. Indeed, the steppingstones that cross the river just below the Reading Room suggest the bridge between past and present that literature and memory erect. Citizens are encouraged to come to enjoy their daily papers, to sit in reflection, to read, to witness one another and their city. Indeed, located at a scenic point along the Gwangju River, the Reading Room encourages public exchange in the ever-rare act of being present. The pavilion will hold 200 books selected around the theme of human rights and intended to be read within the Reading Room itself. If a visitor chooses to take a book, he must leave a book behind, such that the number of books always remains 200. Finally, the number 200 asks us to remember the brave human beings who assembled that May morning, to reflect on the lives in which rights are expressed and the deaths by which rights are too often won.

Taiye Selasi with Cassim Shepard

Reading List
- Adichie, Chimamanda Ngozi, *Half of a Yellow Sun*
- Adnan, Etel, *Sitt Marie Rose: A Novel*
- Agamben, Giorgio, *Homo Sacer: Sovereign Power and Bare Life*
- Alegría, Fernando, *Allende: A Novel*
- Allende, Isabel, *Of Love and Shadows*
- Alvarez, Julia, *In the Time of the Butterflies*
- Anand, Mulk Raj, *Untouchable*
- Anderson, Benedict, *Imagined Communities*
- Angle and Svenson, *The Chinese Human Rights Reader: Documents and*

Commentary 1900 to 2000

- Appelfeld, Aharon, *To the Land of the Cattails*
- Arenas, Reinaldo, *The Assault*
- Arendt, Hannah, *The Human Condition*
- Argueta, Manlio, *One Day of Life*
- Asturias, Miguel Ángel, *The President*
- Atwood, Margaret, *The Handmaid's Tale*
- Atwood, Margaret, *Cat's Eye*
- Bache, Ellyn, *The Activist's Daughter*
- Baldwin, James, *Giovanni's Room*
- Barowski, Tadeusz, *This Way for the Gas, Ladies and Gentleman*
- Bassani, Giorgio, *The Garden of the Finzi-Continis*
- Beecher Stowe, Harriet, *Uncle Tom's Cabin*
- Bellow, Saul, *Herzog*
- Benedict, *The Chrysanthemum and the Sword*
- Benjamin, Walter, *Arcades Project*
- Benjamin, Walter, *Illuminations*
- Berman, Marshall, *All that is Solid Melts into Air*
- Boo, Katherine, *Behind the Beautiful Forevers*
- Bradbury, Ray, *Fahrenheit 451*
- Bulgakov, *The Master and Margarita*
- Burgess, Anthony, *A Clockwork Orange*
- Caldwell, Erskine, *Tobacco Road*
- Camus, Albert, *The Plague*
- Carey, *Plaza of Sacrifices: Gender, Power and Terror in 1968 Mexico*
- Carpintier, Alejo, *Reasons of State*
- Carpintier, Alejo, *The Kingdom of this World*
- Carson, Rachel, *Silent Spring*
- Casey, Edward, *The Fate of Place*
- Castells, Manuel, *The Urban Question*
- Castells, Manuel, *The Internet Galaxy*
- Coetzee, J M, *Life and Times of Michael K*
- Compenstine, Ying Chang, *Revolution is Not a Dinner Party*
- Cortazar, Julio, *Hopscotch*
- Dabydeen, David, *The Counting House*
- Danticat, Edwidge, *The Farming of Bones*
- de Certeau, Michel, *The Practice of Everyday Life*
- Debord, Guy, *The Society of the Spectacle*
- Dee, Jonathan, *The Liberty Campaign*
- deLillo, Don, *Mao II*
- Deutsche, Rosalyn, *Evictions*
- Dickens, Charles, *A Tale of Two Cities*
- Didion, Joan, *Play it as it Lays*
- Doane, Michael, *City of Light: A Novel*
- Donoso, José, *Curfew*
- Dorfman, Ariel, *The Resistance Trilogy*
- Dos Passos, John, *USA Trilogy*
- Dreiser, Theodore, *Sister Carrie*
- Dreiser, Theodore, *An American Tragedy*
- Eggers, Dave, *What Is the What: The Autobiography of Valentino Achak Deng*

- El Saadawi, Nawal, *God Dies by the Nile*
- Eliot, George, *Felix Holt by*
- Eliot, George, *Middlemarch*
- Ellison, Ralph, *Invisible Man*
- Englander, Nathan, *The Ministry of Special Cases*
- Fanon, Frantz, *Black Skin, White Masks*
- Farivar, Cyrus, *The Internet of Elsehwere*
- Febvre and Martin, *The Coming of the Book*
- Flaubert, Gustave, *Madame Bovary*
- Folman, Ari and Polonsky, David, *Waltz with Bashir: A Lebanon War Story*
- Forster, E.M., *The Machine Stops*
- Forster, E.M., *Maurice*
- Foucault, Michel, *Discipline and Punish*
- Galeano, Eduardo, *Days and Nights of Love and War*
- Gandhi, Mohandas Karamchand (Mahatma), *The Story of My Experiments with Truth*
- Gangopadhyay, Sunil, *Arjun*
- García Márquez, Gabriel, *Autumn of the Patriarch*
- Geddes, Patrick, *Cities in Evolution*
- Geertz, *The Interpretation of Cultures*
- Gide, Andres, *The Immoralist*
- Glaeser, Edward, *The Triumph of the City*
- Gleick, James, *The Information*
- Gordimer, Nadine, *July's People*
- Gourevitch, Philip, *We wish to inform you that tomorrow you will be killed with your families*
- Grass, Gunter, *The Tin Drum*
- Greene, Graham, *Our Man in Havana*
- Guevarra, Che, *The African Dream: The Diaries of the Revolutionary War in the Congo*
- Habermas, Jurgen, *The Structural Transformation of the Public Sphere*
- Hagedorn, Jessica, *Dogeaters*
- Harvey, David, *Social Justice and the City*
- Hemingway, Ernest, *To Have and Have Not*
- Hosain, Attia, *Sunlight on a Broken Column*
- Hosseini, Khaled, *A Thousand Splendid Suns*
- Hugo, Victor, *Les Miserables*
- Huxley, Aldous, *Brave New World*
- Huxtable, Ada Louise, *Kicked a Building Lately?*
- Jackson, J B, *The Necessity For Ruins*
- Jackson, J B, *A Sense of Place, a Sense of Time*
- Jacobo Timmerman, *Prisoner Without a Name, Cell Without a Number*
- Jacobs, Jane, *Death and Life of Great American Cities*
- Jensen, Kim, *The Woman I Left Behind*
- Kafka, Franz, *The Trial*
- Kafka, Franz, *The Castle*
- Kapu_ci_ski, Ryszard, *The Emperor*
- Kasarda and Lindsey, *Aerotropolis*
- Kherdian, David, *The Road from Home:*

The Story of an Armenian Girl Beech Tree Books, 1996
- Kogawa, Joy, *Obasan*
- Koolhaas, Rem, *Delirious New York*
- Kourama, Ahmadou, *Allah Is Not Obliged*
- Kunzru, Hari, *Transmission*
- Lampedusa, *The Leopard*
- Lanier, Jaron, *You Are Not a Gadget*
- Larkin, Philip, *A Girl in Winter*
- Lefebvre, Henri, *The Social Production of Space*
- Lessig, Lawrence, *Remix: Making Art and Commerce Thrive in the Hybrid Economy*
- London, Jack, *The Iron Heel by Jack London (1907)*
- Lynch, Kevin, *The Image of the City*
- Macfarquhar, Roderick, *Towards a New World Order*
- Mahfouz, Naguib, *Palace Walk*
- Malan, Rian, *My Traitor's Heart*
- Mann, Thomas, *The Magic Mountain*
- Maron, Monika, *Flight of Ashes*
- Matynia, Elzibieta, *Performative Democracy*
- Mehta, Suketu, *Maximum City*
- Mengitse, Maaza, *Beneath the Lion's Gaze*
- Merrill, Jean, *The Pushcart War*
- Miller-Lachmann, Lyn, *Gringolandia*
- Mooney, Bell, *Voices of Silence*
- Mouffe, Chantal, *The Democratic Paradox*
- Mumford, Lewis, *The City in History*
- Mumford, Lewis, *The culture of Cities*
- Nabokov, Vladimir, *Bend Sinister*
- O'Brien, Tim, *The Things They Carried*
- Ondaatje, Michael, *Anil's Ghost*
- Orwell, George, *Animal Farm*
- Paasi, Anssi, *Territories, Boundaries, Counsciousness*
- Palangyo, Peter, *Dying in the Sun*
- Paton, Alan, *Cry, The Beloved Country*
- Pavic, Milorad, *Dictionary of the Khazars*
- Philoctète, René, *Massacre River*
- Piglia, Ricardo, *The Absent City*
- Power, Samantha, *Chasing the Flame*
- Prose, Francine, *Guided Tours of Hell: Novellas*
- Puig, Manuel, *Kiss of the Spider Woman*
- Roa Bastos, Augusto, *I, the Supreme*
- Roy, Arundhati, *The God of Small Things*
- Rudofsky, Bernard, *Architecture without Architects*
- Rushdie, Salman, *Midnight's Children*
- Ruskin, John, *Unto This Last*
- Said, Edward, *Orientalism*
- Salih, Tayeb, A Season of Migration to the North
- Sassen, Saskia, *The Global City*
- Sassen, Saskia, *Territories, Authories, Rights*
- Sebald, W G, *Austerlitz*
- Sembené, Ousmane, *God's Bits of Wood*
- Sennet (ed), *Classic Essays on the Culture of Cities*
- Sennett, Richard, *The Fall of Public Man*
- Sennett, Richard, *Flesh and Stone*
- She, Lao, *Rickshaw Boy*
- Shirow, Masamune, *The Ghost in the Shell*
- Silone, Ignazio, *Bread and Wine*
- Sinclair, Iain, *Liquid City*
- Sinclair, Upton, *The Jungle*
- Singer, *Prelude to Revolution: France in May 1968*
- Skármeta, Antonio, *Burning patience*
- Smith, *Gorky Park*
- Soja, Edward, *Thirdspace*
- Solhenitsyn, Alexander, *One Day in the Life of Ivan Denisovitch*
- Sorkin, Michael, *Variations on a Theme Park*
- Steinbeck, John, *The Grapes of Wrath*
- Stone, Sarah, *The True Sources of the Nile: A Novel*
- Strejilevich, Nora, *A Single Numberless Death*
- Stuart, David E, *The Ecuador Effect*
- Styron, William, *The Confessions of Nat Turner*
- Sunstein, Cass, *Republic.com*
- Swift, Jonathan, *A Modest Proposal*
- Tabio, Paco Ignacio, *Four Hands*
- Tagore, Rabindranath, *The Home and the World*
- Taylor, Mildred D, *Roll of Thunder, Hear My Cry*
- Thornton, Lawrence, *Imagining Argentina*
- Toer, Pramoedya Ananta, *House of Glass*
- Tolstoy, Leo, *War and Peace*
- Traba, Marta, *Mothers and Shadows*
- Tsukamato, Yoshiharu, *Bow Wow from Post-City Bubble*
- Twain, Mark, *The Adventures of Huckleberry Finn*
- Uchida, Yoshiko, *Journey to Topaz*
- Vargas Llosa, Mario, *The Feast of the Goat*
- Vassilikos, Vassilis, *Z*
- Vonnegut, Kurt, *Mother Night*
- Wang Gang, *English*
- Weber, Max, *Economy and Society*
- Weil, Simone, *The Need for Roots*
- Weiss, Peter, *The Aesthetics of Resistance*
- West, Morris, *Proteus*
- Whyte, William, *The Social Life of Small Urban Spaces*
- Wollstonecraft, Mary, *A Vindication of the Rights of Women*
- Wright, Richard, *Native Son*
- X, Malcolm, *The Autobiography of Malcolm X*
- Yoder, James D, *Lucy of the Trail of Tears*
- Zola, Emile, *Germinal*
- Zwi, Rose, *The Umbrella Tree*

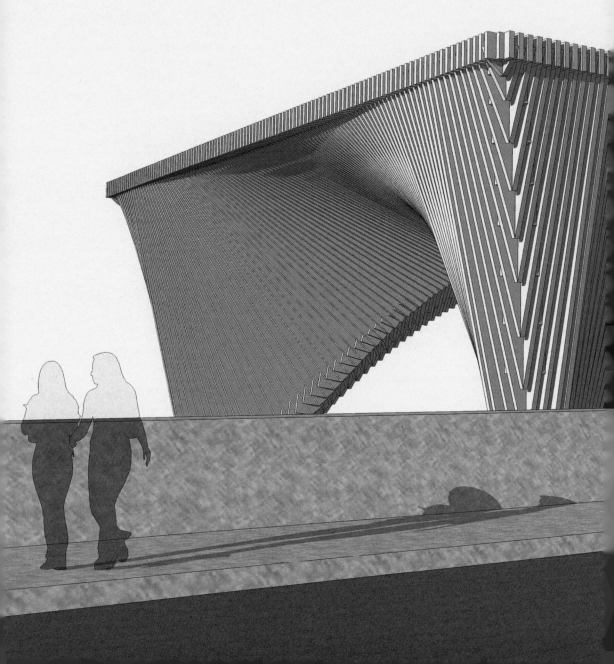

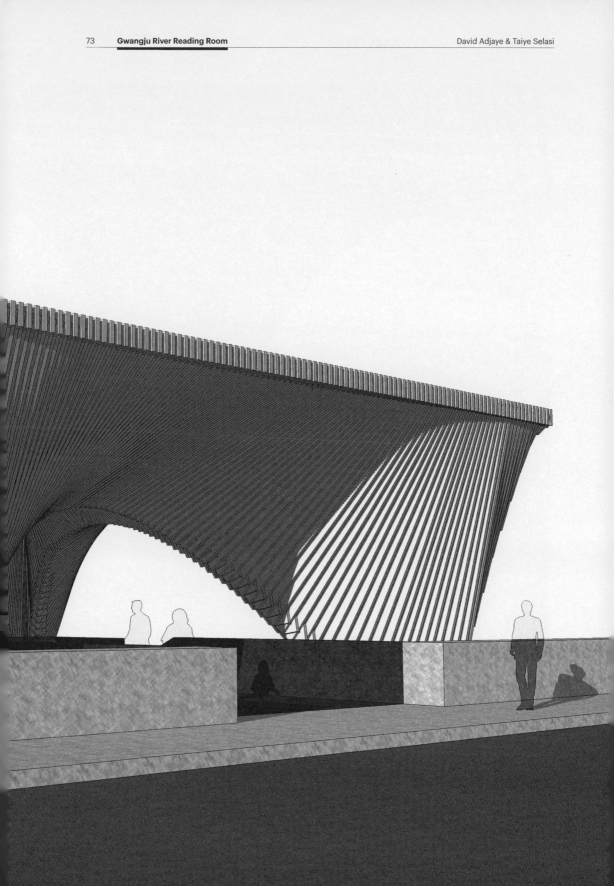

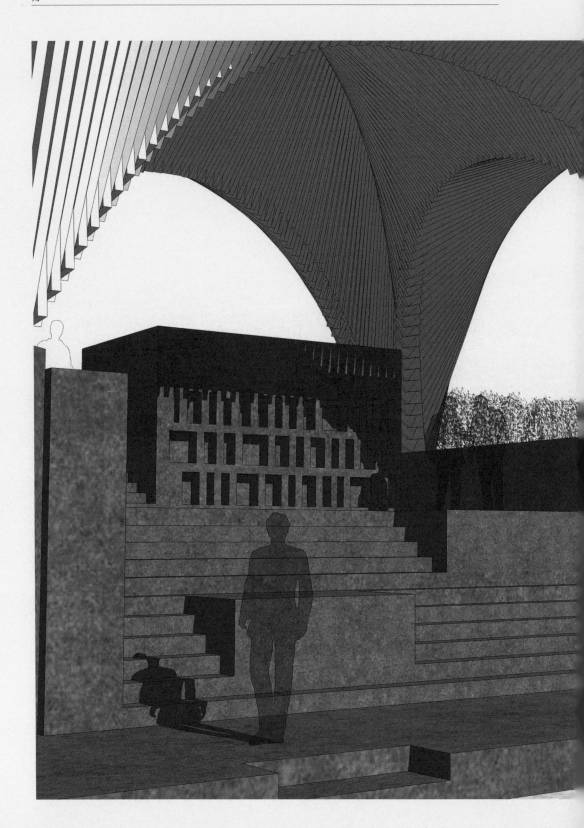

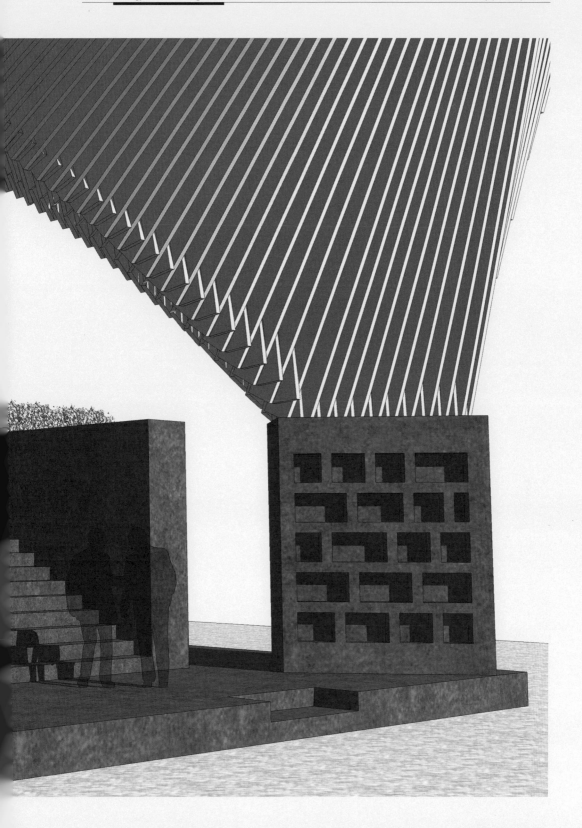

Haircut vs Wig

Marion von
Osten

Folly
Flowers

It is well known that the British were always obsessed with gardening and invented important garden concepts. Famous are the landscape garden designs by William Kent or Lancelot "Capability" Brown, who wanted to peal all potentials out of pure earthly nature. Villages were erased for these enterprises and hills and valleys dug out to create the illusion that the garden would continue endlessly. Only some "through-views" were developed out of the designed landscape that are called Ha-Ha's. These were deep ditches that enabled unexpected vistas into the un-designed surroundings that would surprise the eye upon coming near and make the walker, as the gardeners believed, laugh aloud, Ha! Ha!

English landscape gardens display nature as nature, celebrating naturalism against theatricality, authenticity against artificiality. They were counter-statements to the Baroque gardens of the seventeeth century, a period in which theater had become the most important art form, consisting of illusionistic stage design and special-effects machinery like pyrotechnics, lightning flashes, growling thunders, and swinging clouds. Baroque gardens were orchestrated like theaters. They followed the rules of an Euclidean optic, an underlying grid as an all-over geometry. Nature here was transformed into a sign, a symbol. By moving the body through the garden and the laws of its optical viewpoints, the fragility of the representational system, perception, and cognition were put on display. This constructed environment was staged with grottos, caves, mountains, speaking statues, sound automats, water clocks, rainbow machines, sundials, surprise fountains, perspective paintings, and small theater-automats. A central perspective created by trees and bushes cut in difficult forms, green theaters built of hedges, ornamental flowerbeds, and the newly developed garden machinery in its technical perfection, represented a microcosm and model of the centrality of the king and its royal household.

In opposition, a landscape garden was not to be discovered from a central viewpoint, as every bush and every curve opened up new perspectives into seemingly unknown terrains. Here a small group of trees on the meadows, there a series of busts portraying well-known Worthies. The loopy paths cross woody bridges and end at ruins or small temples of Honor, Philosophy or Virtue. These temples are built—as Dan Graham once expressed—"as ruins from the past seen from its future." But one could also find Chinese temples, Egyptian pyramids, ruined abbeys, or Tatar tents. All these follies looked like usable buildings, but never were. Only some exceptions were to be found—when it was a rustic village, a mill or a

cottage that sometimes not just symbolized rural virtues, but was also used to educate the farmers of the region with new planting techniques, such as to be found in the famous Wörlitz Garden in Dessau. Thus, on the one hand, the garden functions as an open-air theater of moral allegories, on the other, as a pedagogical device.

To generate diverse experiences for the individual stroller was at the core of landscape garden scenography. Alone, the individual was no longer ordered in relation to one hegemonic center. Unfolding a series of spiritual conditions and insights within an established framework, a constant process of self-reflexion was put into motion. The multiplication of perspectives encouraged the walker to understand his or her enlightened subjectivity.

Thus, one can see how the new liberal social order expresses itself in the aesthetic regime of the garden: a promenade turns into an intellectual experience, into an education project with elastic bands. Free will becomes the veritable truth. Instead of a dramaturgy based on a central axis that represents the absolute sovereign, the invisible hand of the market economy proclaimed by Adam Smith guides the individual on the unpredictable ground of the ever-arriving future. Where once had been the wig, is now the proper haircut.

How to make ships or galleys seem to move over the sea

Figure 65.

This was the political dimension of these new aesthetics inhabited by artificial ruins and many other architecture follies, a compression of the technological and sociological status quo that does not care about the society as a whole, but only for taxes. The garden debate became a battlefield between the French Monarchy and the English Liberal Empire. The debates about naturalness and realness were contentions about which form a liberal State should take.

L'Année dernière à Marienbad, directed in 1961 by the French director Alain Resnais and based on a screenplay by Alain Robbe-Grillet, relates to both of the abovementioned traditions of landscape design and societal order. Most of the scenes were shot in the baroque ensembles near Munich. On the one hand, the film depicts a gathering at a château with its baroque garden architecture, in which the actors are placed artificially like objects or designer plants into the spatial arrangements. Relations seem empty, masque like, communication skirts along the surface, underlying social or political problems cannot be expressed here. Past and present remain unclear but, likewise, obvious. Modern elite society finds its limits in representational forms and attitudes: they walk and talk in schemes. Their rela-

tionships are as abstract as the geometry of the garden architecture. Here the liberal subject is trapped in its novelties and exclusiveness. It is cut off from society as it is only able to represent forms of societal attitude, but cannot represent society at all. The present is stuck in antiquity and the past remains in what is imagined to be the past if only to legitimize existing power relations in history. This is also mirrored in the relation between a man and a woman. A dystopic relation which makes it difficult to discern if the couple indeed knew each other from last year in Marienbad or have never met before. Their unpredictable past is an investment into a predictable future that can never step out of the given framework. This incredible film that haunts the viewer with its surrealist anti-plot was a great success in its time, won several prizes. It was a milestone for a postwar generation that had had enough of the stiff rituals and old-fashioned values of their fathers' generations. Societal form itself had become fully folly. It represented itself as real, but was not (anymore). Alain Resnais said in an interview: "I was making this film at a time when I think, rightly, that one could not make a film, in France, without speaking about the Algerian war. Indeed I wonder whether the closed and stifling atmosphere of *L'Année* does not result from those contradictions."

1961 marks not only the brutality of the Algerian war but also the decline of the French Empire and also other European colonial powers—that also opened up the way to what we know as Cold War Imperialism. That is to say, the nineteen sixties changed geopolitical relations on the whole and also the concept of the "public" in Europe and the US. Since then, in a way, the public has been defined by social movements. Deviance of life style is performed against starchy societal norm: a practice that also informed commodity production in late-capitalist consumer society. It was also in 1961 that Henri Lefebvre
became professor of sociology at the University of Strasbourg, before joining the faculty at the new university at Nanterre near Paris, not very far away from Versailles. His concepts of the "Critique of the Everyday" and "The Right to the City" analysed (and influenced) the May 1968 students revolt. *The Survival of Capitalism* (1973) and *La Production de l'espace* (1974) are today well-known milestones for the production of space, as well as his claim: "Change life! Change Society! … new social relations demand a new space, and vice-versa."

But for sure, there are other ways to think about public space beyond this telos that can also be learned from garden architecture follies. They are the perfect sites for making dates, for reading and relaxing on a bench nearby, for letting the eyes wander around or for sleeping in a meadow. They can be used for hiding behind bushes, kissing or weeping; they are important landmarks for cruising, drug using, for unpredictable events. But only, one has to say, if they are publicly accessible…

This essay is informed by the collaborative research for the video work: *The Park—Investigation in a Post-Productive Cluster* (2006) shot in the Lakeside Science & Technology Park Klagenfurt, Austria. Directed by Peter Spillmann, Katja Reichard, and myself.

Hameau

April Lamm

A Rendezvous with Repetition: on Marie Antoinette's Hamlet at Versailles

At this mannered recess, at the Hameau de la Reine in a corner of the vast park of Versailles, Marie Antoinette emulated a life most distant from her own: that of a peasant. It was a class masquerade, a flippant rejection of Dionysian life in the big house. The *hameau* was the place, after all, where a promenade became a walk, where the cornucopia was filled with bucolic pleasures, such as getting down on your hands and knees to pick strawberries or hopscotching around piles of chicken poop. It was the place to perform *la vie champêtre*, the elegant country life.

A *tableau vivant* depicting life at the *hameau* would have included the vision of a queen ham-handed with the tasks of a *laiterie*, but certainly at home in a *laiterie d'agrément*, what the English called an "ornamental dairy." This *hameau*, constructed between 1782–83, is a prime example of the built world at one degree of

remove: a village, yes, but more importantly, a village theater. In this sense, it is one of the world's greatest follies of all time, intended largely as political theater in a milieu of crisis. Life in the countryside was seen as more pure. The class of women who were wont to retire to the chaise lounge for a little debaucherous reading just after rising from bed were meant to be instructed in the ways of industrious femininity. It was the ultimate camp: "converting the serious into the frivolous," as Susan Sontag would have it.

The architect Richard Mique's rustic final touches, the *trompe l'oeil* cracks, the faux-crumbling façades, the comic reality of having to lift a milk jug made of marble or use a butter churn out made of porcelain… only Marie-Antoinette's hair could rival his creations—in the form of a three-foot *pouf* à *la jardiniere* (the product, I imagine, of her well-employed Mistress of the Hair).

Such simulacrum are rare today, but in the eighteenth century, these *laiteries d'agrément* were quite common. It was of the belief that drinking milk exemplified healthy life, and the milk cure was a new form of *wellness*. It was Catherine de Medici, however, who was the pioneer of the pleasure dairy, in search of childhood memories with Grandfather Lorenzo the Magnificent whose *cascina* she would remake at Fountainbleau. The message broadcast, however, from Marie Antoinette's georgic *hameau*, some two centuries later, was negligible and did nothing to save her from being placed on the list (the "List of the 286 heads that have to fall in order to effect the necessary Reforms"). Indeed, the pleasures of the subjunctive, *if I were a farmer's wife*, created a *tableau vivant*, to be sure, of ideals extolled by Rousseau. But the transformative powers of the *terroire* remained beyond reach, *la vie champetre* would never became *la vie de la campagne*. But any structure, after all, has a purpose: any folly can be seen as an excuse to "take the air."

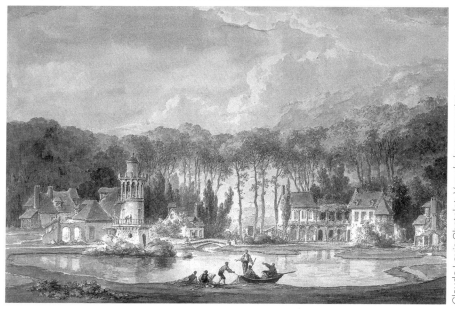

Claude Louis Chatelet, *Vue du hameau prise en avant de l'étang*, 1786

Horizon

Philip
Ursprung

Follies Under
Pressure:
Gordon
Matta-Clark

Despite the economic crisis that has brought construction sites in Southern Europe and the United States to a standstill, architecture still behaves as if the boom of the 1980s never ended. The prestige of large-scale iconic buildings in metropolitan areas continues to expand, while the appeal of utopias, critical manifestoes, and follies is diminishing. The built results of architecture attract more and more attention, it seems, as the interest in unrealized ideas and experiments declines. In the shadow of star architecture, the folly cannot grow.

Under such conditions, one might ask: has the centuries-old role of the folly as a device of playful experimentation and provocation been taken over by art? Is it art, or, more precisely, the performative projects related to architectural and urban issues that were prospering during the 1970s that function as a mirror for theoretical architectural practice? Is the interest of today's architects for artists such as Gordon Matta-Clark, Robert Smithson, Vito Acconci, Trisha Brown, Dan Graham, on the one hand, and utopian architectural projects such as those of Yona Friedman and Cedric Price, on the other, a compensation for the theory absent in the realm of architecture?

Gordon Matta-Clark
Tree Dance, Vassar College, 1971

The work of Gordon Matta-Clark is well suited to follow the hypothesis that art offers a substitute for architecture's shrinking theoretical horizon—and, indeed, that art has taken over the function of the folly. After studying architecture, Matta-Clark moved to the field of art in 1969, stating that he and "professional architects" were at "opposite ends of the pole."[1] In fact, his oeuvre mainly deals with architectural and urban issues, and many of his architectural performances and interventions outside the museum walls can be interpreted as follies. For *Tree Dance*, which took place in 1971, he and other perform-

ers lived in ephemeral structures of cloth and rope, high above the ground in the trees on the campus of Vassar College. These temporary dwellings resembled utopian constructions in constant movement, a space without walls, floors, and windows. Matta-Clark described the performance as an "aerial dance during which I

Gordon Matta-Clark
Open House, New York, 1972

overcome the discomfort of empty space by installing a resting place in which my body will be supported aloft."[2] In 1972, he and his colleagues performed *Open House* in a container in front of 112 Greene Street. Like *Tree Dance*, the performance was about turning the inside of a space outside. The floor plan of the open container resembled that of an apartment without a roof. The performers moved freely from room to room, opening and closing doors, walking through the space, or dancing on the edge of the container, their actions visible from above. Again, the performance (and the container itself) can be interpreted as a folly, which reflects on the relation between private and public space. For *Splitting*, performed in 1974, he sawed an entire wood house in half, by cutting the stone foundations and lowering half of the house until a gap opened. The intervention turned an inhabitable home to a sculptural work of art. *Splitting* opened a usually closed space and symbolically freed the inhabitants. But, at the same moment, it destroyed the house and made it useless as a home.

Splitting made Matta-Clark famous both in the realm of art and of architecture. Due to this success, Peter Eisenman invited Matta-Clark to participate in the exhibition "Idea as Model," which took place at the Institute of Architecture and Urban Studies, New York, in the winter of 1976. He probably expected Matta-Clark to build a folly. In fact, Matta-Clark originally intended to cut an existing space, namely a windowless, white box, which served as a seminar room, into two-by-two-foot squares, and stack the pieces

Gordon Matta-Clark
Splitting, Englewood, 1974

in the exhibition space. Afterwards, he wanted to rebuild the room, adding windows. However, Matta-Clark changed his plans. He placed photographs of houses with broken windows between the real windows of the exhibition, and shot holes into these windows with a BB gun. Instead of building a folly in the guise of an object, he made a performance, which radically questioned the role of the institution and criticized its separation from the outside world. The non-documented work of art was immediately removed from the exhibition. However, under the title *Window Blowout* it acquired legendary status soon after Matta-Clark's untimely death in 1978.

Window Blowout stands at the core of both Matta-Clark's demonization as a violent artist in the 1970s and his posthumous hero-ization. The performance is emblematic for Matta-Clark's critique of architecture's claim of exclusivity and autonomy. For Matta-Clark, the autonomy of architecture and the heritage of Modernism were not sacred values to be preserved but rather symptoms of enclosure. In opposition to this, his art is characterized by pragmatic action and theatrical mimesis. And this is what hurt the architects of his time most. As long as his performances took place in the realm of art, they could be seen as harmless comments *about* architecture. As long as the follies were symbolic, they could be cherished as exceptions. But as soon as he performed in the context of an architectural exhibition, which was supposed to deal with ideas, his act became a problem. Instead of obeying the dominant representational economy, instead of dealing with ideas and plans, instead of realizing a constructive critique—as would have been his project for a literal folly by deconstructing and reconstructing the seminar room—he mimicked the act traditionally reserved for "real" architects, namely, that of touching (and even harming) the very body of a building.

Window Blow-Out implies a spatial, temporal, economical, and emotional continuity between what happens inside and outside the gallery. When the architects were confronted with his performance, they probably became aware of the fact that they, like their models, were standing at the sidelines of the real transformation of the city in the 1970s—autonomous, but impotent. Matta-Clark, their fellow architect who had become an artist, used his artistic freedom to enact what was actually happening in the city. In articulating, by the means of art, the rawness of gentrification, the brutal process of transformation of value, and the production of new value within abandoned sites, he literally put his finger at a point, which must have deeply hurt architects such as Peter Eisenman: namely, the fact that they were unprepared to deal with the problem of transformation of the cities in the phase of urban blight in the 1970s.

By the end of the decade, the economy had started to recover, and architecture returned to center stage. By the 1980s, Matta-Clark's performances had become models for a formalistic approach to architecture under the label of "deconstructivism." But the fact that his performances still challenge the practice of architects today proves that the problem they represent remains unresolved. As long as Matta-Clark's work stands outside the architectural canon, it is admired. However, its integration into the canon would lead to a fundamental change of the canon itself. This shows both the impotence and the power of the folly.

[1] Gordon Matta-Clark, "Interview with Donald Wall," manuscript, Archive Matta-Clark, n.d. (ca. 1976). A shortened version (not including the quote) is published in: Donald Wall, "Gordon Matta-Clark's Building Dissections," *Arts Magazine*, March 1976, pp. 74–79, reprinted in: *Gordon Matta-Clark*, exh. cat. ICC Internationaal Cultureel Centrum, (Antwerpen, 1977), pp. 35–44.

[2] Gordon Matta-Clark, letter to Mary, n.d. (ca. April 1971), Estate of Gordon Matta-Clark on deposit at the Canadian Centre for Architecture, Montreal.

In-between Hotel

Do Ho Suh &
Suh Architects

Journeying within
the Spaces
and Histories of
Gwangju

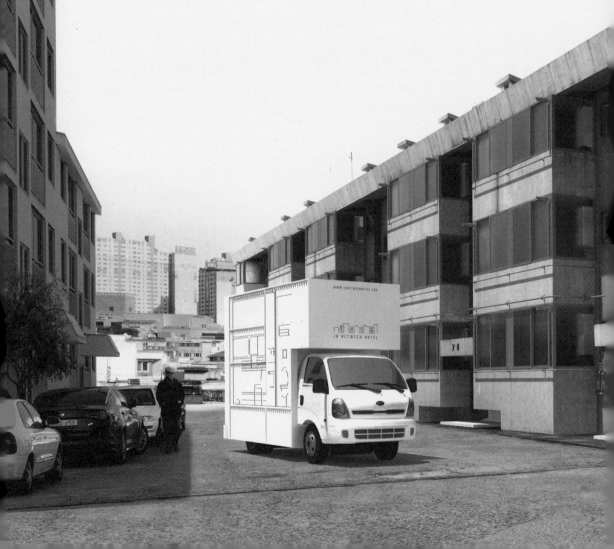

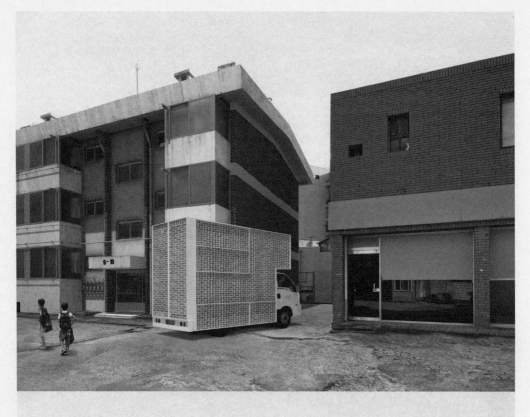

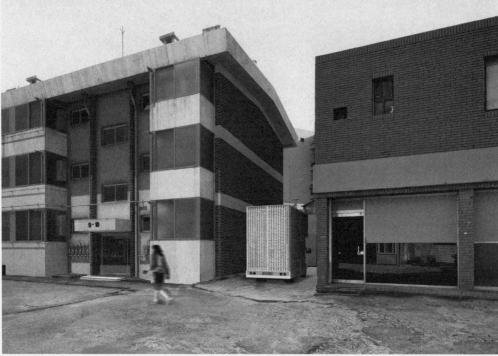

The In-between Hotel is an insider and outsider. It observes the life of the city—its memories and histories that sometimes escape being encountered by those coming into contact with it for the first time. It is more concerned with the possibility, perhaps, that a city may not even be visible to those inhabiting it. This is the life of the In-between Hotel: a temporary dwelling unit activating aspects of Gwangju that have eluded the grand narratives.

An itinerant structure, the In-between Hotel is both strange and familiar. It slips through the fabric of Gwangju's public identity. Underscoring how this fabric is woven from neglected experiences, the project explores Gwangju's facade as a surface of invisibilities—experiences that slip past the scrutiny of history, politics, or culture. Like all fabrics, only the surface is seen. Even the inhabitants of such a place seldom realize their roles within the life of their neighborhood or city at large. In this way, rather than describing aspects of Gwangju or searching for traces of its history in landmarks, the In-between Hotel occupies neglected spaces to make it more present to visitors and citizens alike in its complexity and ambiguity.

The In-between Hotel also makes visible the processes inherent in the functioning of complex entities that extend beyond the context of Gwangju to illustrate how the project itself emerged. In fact, this project entered into operation right at the point of the initial development of the concept. From the survey and categorization of available locations for the hotel, to considerations concerning the structure's architectural, functional, and civic characteristics, the project embodies a complex dynamics of collaborations and negotiations. For this hotel, the "in-between" refers to the space between two existing buildings. But specifically, it is derived from knowledge about a particularity of the South Korean architectural zoning system that requires all buildings to be constructed within a given distance from the outer limit of the property line.

Indeed, the notion of "in-between" would have remained vague without a thorough understanding of the type of spaces available in Gwangju. The parameters that further specified relevant spaces resulted from the coordination of different findings and consultations carried out by numerous collaborators. Crucial collaborators included Suh Architects, whose interpretation of the function and functioning of the hotel unit is reflected in the design of the interior and exterior of the hotel as well as in the graphics and logo developed for the project. Studio Wy and Urbanindex.Lab were also fundamental in their invaluable research and categorization of the different types of sites in Gwangju. Of similar importance was the contribution made by Imagebakery, which produced the video and multimedia material and made the necessary contacts to secure locations, as well as designing and managing the information kiosk through which guests and hosts could exchange experiences.

Working in parallel, these collaborations have cross-referenced different layers of the city. For example, by juxtaposing the minimum size of the truck that would transport the hotel with the multiple categories of available spaces, the survey team narrowed down over 250 dead-end spaces (that could be used without blocking any pedestrian or vehicular access) to approximately 60 viable spaces. Furthermore, the team proposed the idea of integrating urban amenities to provide services for hotel guests. Adding another layer to the notion of a "contextual hotel," this suggestion investigates the criteria of how a hotel is defined and imagines an urban hotel that, through its itinerancy and reliance on neighboring amenities, moves like a living cell in the city.

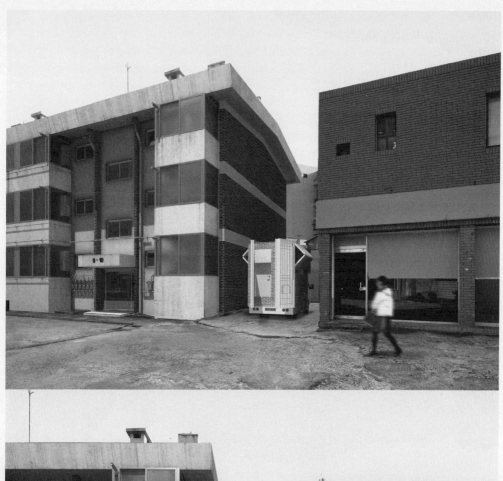

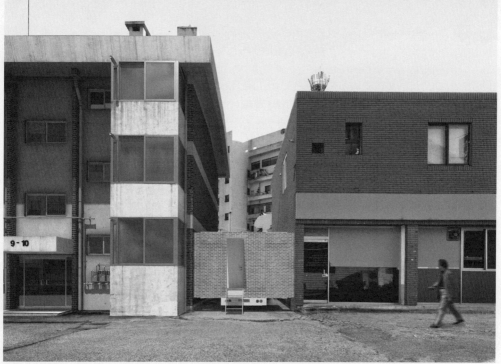

In this way, the In-between Hotel aims to present a new face of the city to those already living there. When inhabitants learn that a single-room hotel might occupy an empty lot next to their house, they might begin to see these neglected spaces in a new light. When the hotel room in a truck drives into the lot, the site is transformed into a completely new space that is, both physically and psychologically, the hotel. Its interior, however, is no different from an ordinary hotel room—with a bed, a TV, and a toilet. But because the In-between Hotel is camouflaged by patterns of bricks and slates, it quietly merges into the surrounding neighborhood— it does not pretend to be a landmark. Each in-between space that hosts the hotel is made unique by the interactions shared between the local inhabitants and the guest, and the memories these interactions produce. With each new location, the space is changed—it holds new memories.

From this perspective, the In-between Hotel is not just a tiny hotel room on a truck. Houses or shops become part of the greater hotel, as does the hospitality of Gwangju's citizens, who become an important part of the artwork itself.

The In-between Hotel has the ability to locate itself precisely within a specific context and shift appearance depending on the time and space of the contexts it occupies or even the psychological context of its participants. It resists becoming a monument that is independent of its surroundings, immutably permanent. Instead, with its mobility and ability to attract citizens' participation, it operates as an anti-monument that invites participants inside the work while simultaneously leaving the boundaries of the work undefined.

The In-between Hotel also challenges traditional monumentality by being a fully functional architectural structure. This means that it requires a distinct type of care that relies on the interactions of all the people involved. Proposing a new notion of a "permanent" artwork, it relies on the hospitality of not only the citizens of Gwangju but also of all the people involved in keeping the project in good working order, from the architects and mechanics to the staff in charge of the room-reservations system.

Relying on the energy of all its collaborators, its hosts, and its guests, the In-between Hotel is an inclusive project that extends beyond the instances of conception and actualization. Over time, as memories settle, the way the project approaches the physicality and identity of the city, without fixing it to any one site, may effect its transformation from anti-monument into something new, making visible the continuous actualization of the different networks that constitute a city. It is in this sense that this public art project makes present contexts that otherwise remain invisible to most of us: the energy or connections between all things; the memories that either enable or challenge our ability to adapt to new environments; and even the in-between condition characteristic of those contexts that have undergone too many attempts at adaptation.

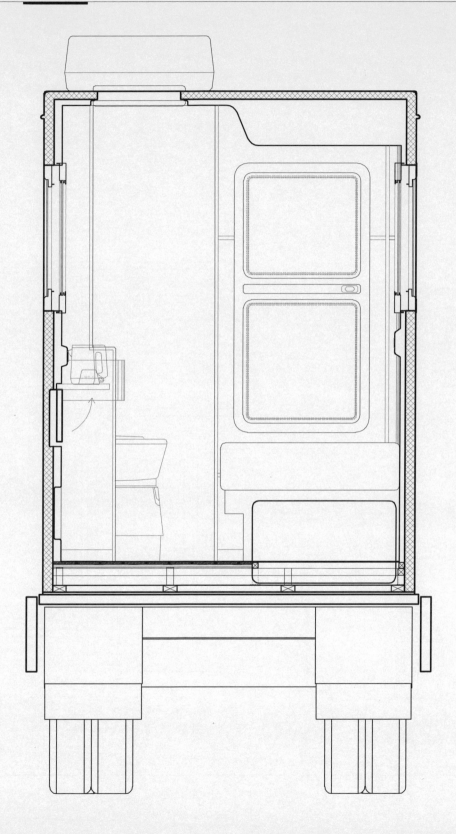

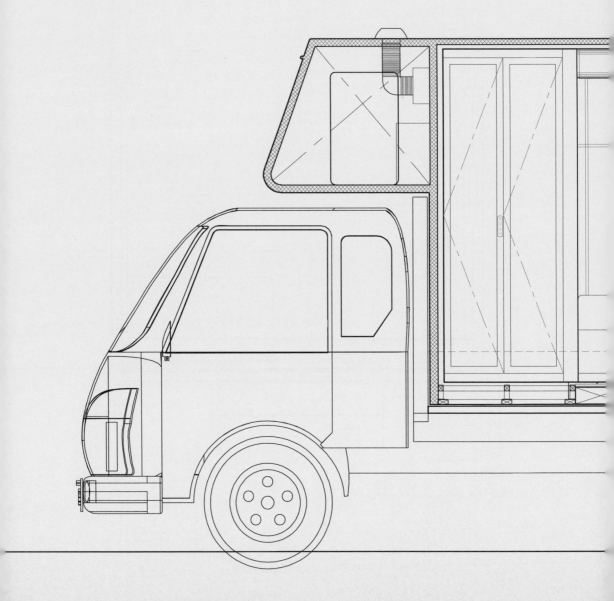

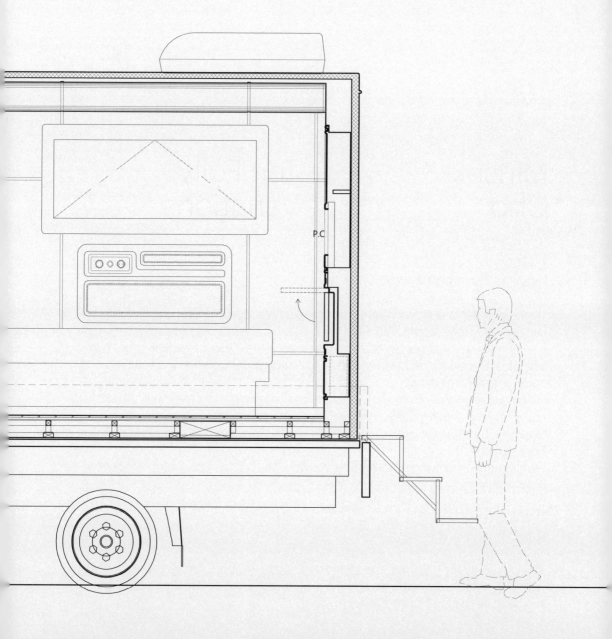

P.C

Instant Monuments

Minsuk Cho

Ten Folly Variations

1. Drop
Party Pad, New York City, 2003

Three days after the United States dropped the first bomb on Iraq, an email invitation arrives for the MoMA/PS1 summer pavilion competition.
Are we *really* in the mood to design a party structure? Should we just "drop" giant inflatable objects made in Korea on the PS1 courtyard? Considering the time and budget, it only makes sense to outsource the production in Korea. Though will everyone be OK with such party decorations delivered from Asia? Will the public accept a SARS-ridden border crossing in such a tense, post-911 atmosphere?
One question from a juror at the presentation: "You are from South Korea, not North, right?"
We did not win. It was rumored that we were the runner up, despite of our suicidal scheme.

2. Waste
Ring Dome, New York City, 2007

Joseph Grima (at the time, the Director of Storefront for Art and Architecture) visits the office, discovers a small rapid prototype model, and makes a proposition for the Storefront's 25th anniversary event…

Me: "Joseph, I'm glad you like that dusty old model, but you know, that model was a rejected scheme for something else. It seems unlikely that you can build it three times larger with one third of the budget. It shouldn't be about intricate digital fabrication as originally intended. What about a bunch of hula hoops held together with zip ties?"

The hula hoops were then re-distributed after twenty-six days, the duration of the event.

3. Engagement
Ring Dome Junior, Kitakyushu, 2007

Joseph conducts a workshop with local elementary school children to build a mini Ring Dome in just two days!

Me: "Either it is the easiest system on earth buildable even by the tiny hands of children, or the exploitation of child labor is not really an issue in Japan. I hope the former…"

4. Art
Ring Dome, Yokohama, 2008

Joseph introduces the hula hoop structure to the Yokohama Art Triennale.

Me: "Does it mean that now the Ring Dome is an art piece? It's an interesting turn of the work, but I would insist on planning programs that conjure some social activities within it, rather than it sitting pretty on the lawn."

5. Dropped
Air Forest, Denver, 2008

In response to a request from Seth Goldberg, the curator for Dialog:City, a cultural event held during the 2008 Democratic National Convention.

Me: "Seth, I'd rather not create any waste for this week-long event. I don't think another Ring Dome is suitable for this vast park, which demands something much larger—at least ten times. Are we really only allowed three days for construction?"

Time and space constraints helped resurrect "Drop" architecture, for its efficiency and scale. The "Drop" architecture was "dropped" in Colorado, just as it had been in the 1960s.

Welcome (back) to Dialog:Drop:City.

6. Nothing
Knot House, Ordos, 2008

No context, only the number "57" written in white chalk powder on a lot in the vast Mongolian desert indicating our site, out of 100 lots that make up Ordos. 99 other architects were in a similar frenzy, bombarded by the media, as if on a reality show. Are we designing villas or follies on a moonscape?

Ai Weiwei mysteriously emerges from the sand dune and shares his wisdom: "What you are assigned to do is NOTHING compared to what is happening in China now. Like dust. So relax."
The Knot House model is currently collecting dust. The client of the Ordos100 Project has vanished into thin air.

7. Pragmatic
Art Trap, New York City, 2009

Invited along with 200 artists, designers, and architects to propose a dream installation/exhibition for the 50th anniversary of the Guggenheim Museum.
At our in-house meeting we asked ourselves: "What are the problems of the museum?"
Too dangerous because the handrails are low and makes the visitors feel vertigo; too many tourists who do not care much for art; too crowded; too much movement; and with only a few places to pause along the sloped ramps, a relentless dynamism…
What if the low handrails could "trap" the visitors? Forcing them to pause and choose between the ramp and the void? Will those that choose the void become celestial bodies? Will the art goers and the non-art-lover type tourists be somewhat integrated while being trapped?

8. Alchemy
Open Pavilion, Anyang, 2010

After building several follies that had very limited life spans, we are commissioned to build something more lasting, in an indefinite temporal condition…
Finally, we get to design a "permanent" folly! Great. The Ring Dome structure has always provided a space for gathering, but required standard folding chairs, or random chairs to be brought in for various events. We should integrate seating within a rigid, braided chain-like structure for this new pavilion.
The Ring Dome meets the Art Trap?

9. Opportunity
Vacant House, Gwangju, 2011

Five Korean architects gathered for the Parkscape project at Sajik Park, Gwangju.
Architect A: "Let's not call this another folly project. Lots of Gwangju folks are fearful of the "100 Follies Plan" after the first ten. This park is already great. There are more things to eliminate than to add. We should all make discreet improvements, staying closer to the ground…"
Architect B: "At least some of us should be iconic and shameless. Otherwise, they will think that everything has been done by landscape designers. The problem of the existing dilapidated pergolas could be the task."
Me: "I will try to make something both discreet and iconic."

10. Intensify
Flower Cushion, Bucheon, 2012

At the Bucheon Technopark Art Factory meeting
Me: "With a challenging budget of only $20,000, maybe we should make something useful, for example, ping pong tables or benches for the factory workers?"
Workers' Leader: "Well, we want something more 'art-like' from you, though."
Choi, Jeong Hwa (artist): "I will make a big white magnolia out of metal waste created from this high-rise factory."
Me: "Jeong Hwa, what if we combine yours and mine? Maybe I can make a pedestal for your flower sculpture, which can be used as a bench so that the workers can hang out under your flower pedals?"

The projects listed above, which we call "Instant Monuments for Collective Intimacy," have kept us mentally stimulated, motivated, and perhaps even helped maintain our sanity, much like a form of therapy. "Collective Intimacy" is a term that Mass Studies has been using to describe our practices relating to public space. We view pubic space not as an antonym of private space, but as a collection of many intimate spaces of individuals. These spaces, which manifest this collective intimacy, are particularly prevalent in Asia, i.e. *jjimjilbangs* (large public bathhouses) and the Red Devil hooligans occupying plazas in Korea, not unlike the middle-age women wearing their pajamas in the streets of Shanghai.

Minsuk Cho's *Flower Cushion* in Bucheon, Korea.
© Kyungsub Shin, 2012

Although, by definition, follies are not about pragmatics, they come from the most pragmatic concerns because, consistently, in every case, these tasks have been given to us to deliver maximum effects with minimum means. Follies in the Asian context—especially in Korea—tend to defy the original functionless typology: they actively seek out a certain level of functionality. If follies were originally extravagant markers and functionless ornamentation, Asian (or, more specifically, Korean) follies often add extra-extravagance to an already extravagant context. Despite its own complications, we hope that our efforts stand apart from the urban context as fragmented moments and spaces, as pop-ups of time-specific architecture, celebrating the processes of production—as spatial objects that are both systematically complete and independent. We believe that these attempts will someday expand towards projects with more substantial public ambitions.

Interrogation

Felicity D. Scott

A Costly Madness

In 1962 Philip Johnson built a small precast concrete pavilion replete with what he called "whimsical" arches at the edge of a recently constructed artificial pond, picturesquely sited within the garden of his Glass House Estate in New Canaan, Connecticut. The following year Johnson published a brief, characteristically witty (and media-savvy) article on the diminutive pavilion in the short-lived *Show* magazine, including a picture of what appeared to be his over-scaled persona peering out from amidst one of its intersecting arcades. Entitled "Full Scale False Scale," his account explained that while the design was avowedly a folly it was nevertheless "serious architecture."[1] The folly's scale was, however, he conceded, "'right' only for four-foot-high people," a formal and perceptual conceit not only serving as an allegory of Johnson's looming presence within the field but also prompting the architectural historian and critic John Jacobus to rather indelicately refer to it as a "dwarf-scaled pavilion" when telling the story of Johnson's departure from his earlier Miesian idiom.[2] Johnson himself referred to the structure as a grown-up playhouse, noting that he "wanted deliberately to fly in the face of the 'modern' tradition of functionalist architecture by tying on to an older, nobler tradition of garden architecture." "The William Morris–Walter Gropius cult of the useful must be overthrown," he announced, alluding to a familiar (if, for Johnson, less-noble) narrative of the emergence of architectural modernism in Europe. In its place would be celebrated the more elevated "art of architecture."

Expanding on the distinction between architecture conceived as useful versus that which might be beautiful, Johnson turned to an analogy with shoes:
Usefulness as a criterion condemns our art to a mere technological scheme to cover ourselves from the weather, much as to say that shoes should be practical, not hurtful and handsome. Actually, there exist shoes designed just for comfort and we all know them for the hideously ugly monstrosities they are. But somehow the idea has come about that mere functional (cheap) buildings are good enough for Americanst But I say, just as in footwear, we need beautiful, in addition to mildly useful buildings. My pavilion I should wish to be compared to high-style, high-heel evening slippers, preferably satin—a pleasure giving object, designed for beauty and the enhancement of human, preferably blonde, beauty.

Philip Johnson peering out from his "dwarf-scaled pavilion" in the garden of the Glass House estate in New Canaan, Connecticut. © Saul Leiter, 1963

Identifying with the "art of architecture" (and even more ominously, given his flirtation with German Fascism during the later 1930s, with the "blonde beauty") was not, of course, a new gesture new for Johnson. He had privileged a dedication to formal and aesthetic questions over those of function as early as 1932, when he co-curated with Henry-Russell Hitchcock the legendary "Modern Architecture: International Exhibition" for New York's Museum of Modern Art.[3] In the case of his New Canaan folly three decades later, the suspension of architecture's use-value in favor of its exhibition value, however, had taken place not within the institutional framing of an art museum but in the perhaps equally rarefied milieu of his New Canaan Estate. Indeed, in contrast to the large audience gained via circulation within the media, Johnson's experience of the pavilion was to take place in an even more circumscribed, more private realm than a museum, "isolated from the world on a small island in a pond."[4]

In a short editorial note accompanying the re-publication of "Full Scale False Scale" in a 1979 anthology of Johnson's writings, Robert A. M. Stern, long-time champion of the architect, felt it necessary to distance himself from the pavilion. He noted that for many critics the "garden folly" stood as a low-point in Johnson's career, that it "mark[ed] the nadir of his 'ballet school' phase."[5] Although, as Stern continued, the text itself could be considered a testament to Johnson's art and intelligence, the folly was neither "frivolous" nor "rich" enough since it used "earnest pre-cast concrete where only either lath and plaster or marble would do." In this Stern was, of course, in a large part correct. A properly aristocratic genre that emerged within the life of the court in seventeenth-century France and flourished within the landscape gardens of eighteenth-century England as a means of entertainment, even of stemming boredom, a good folly at the time was supposed to be beautiful, useless, and expensive. Architecture, however, can change.

Fifteen years after Johnson celebrated the "art" of his architectural folly, on the occasion of an exhibition entitled "Architecture I" at the Leo Castelli Gallery in New York, Ada Louise Huxtable noted a rising "interest in architecture on the popular high-art circuit" and with it practices of collecting architectural documents like other artistic media. Reviewing the show under the title "Architectural Drawings as Gallery Art," she explained, "Architecture is being perceived as an important art form now, equal to and intricately connected with painting and sculpture, sharing with those arts much of the troubled philosophy and arcane esthetic of our time."[6] The architects included—Raimund Abraham, Emilio Ambasz, Richard Meier, Walter Pichler, Aldo Rossi, James Stirling, and Venturi & Rauch—were, she stressed, "not new to exhibition," having presented work at MoMA, the Institute for Architecture and Urban Studies, or Cooper Union. Although paying attention to distinctions among the participants, she cast the exhibition as exemplary of an architectural paradigm that in its celebration of aesthetics "breaks with the constraints of doctrinaire modernism." After citing the comments of guest curator Pierre Apraxine, Huxtable went on to indicate that the contributions had created their own form of isolation from the world, not unlike Johnson's small island: it was "very personal, metaphysical work, rather than a primary concern for functional purposes. For most of these architects, anything as restrictive as environment, or context, does not exist. They created their own images; in fact, they create their own worlds." Pointing to a more general contemporary tendency towards breaking down traditional divisions among the arts, she declared of the "purely esthetic" works on show at Castelli Gallery, "art and architecture have come closer than at any time in history. In these examples, they merge and dissolve."

I introduce Huxtable's review here not only for her recognition of the manner in which, as in Johnson's pavilion, conventional notions of architecture's use-value could be superseded by exhibition value, and her reading of this work as "almost a new art form." In addition, and perhaps more importantly, she raised a rather ambiguous point in concluding: "The question one asks is how much of this is obsessive self-indulgence, and how much is the opening of new architectural frontiers. It is a mark of our time, of course, that the two are not mutually exclusive." Huxtable's remark about the mutual entwinement of work uncoupled from conventional mandates and what she calls "architectural frontiers" might serve to remind us that to lament the loss of function or even of context as simply a sign of self-indulgence—as though such characteristics were foundational to architecture's definition, as though without them architecture proper would come to an end—would be to misrecognize the complex institutional, discursive, and media environments within which architecture operates as a discipline. My point is not identical to Huxtable's, but I want to suggest that she had identified in those antinomies opportunities for a structural redefinition, ways in which the discipline might open towards other futures. Such a suspension, deferral, or incompleteness often emerges in, and characterizes, the very act of exhibiting architecture. The question remains, and it appears to be key to the Gwangju Folly II project: to what ends might such operations be deployed other than those of Johnson's aesthetic

games? Hence, in this context, we might ask what other roles follies can play beyond that of helping overcome the boredom of aristocratic solitude? Can suspensions of normative functionality allow architectural follies to function otherwise, even to raise more difficult and political questions about the very constitution of the field and its limits? In other words, at stake is not whether architecture *can* have something important to say once freed from traditional functions, but rather *what* it has to say, how an exhibit or folly mobilizes such an opportunity to function critically, to more politically interesting ends.

Reiterating that his pavilion in New Canaan was conceived within a particular genealogy of functional deferral—landscape or "garden architecture"—Johnson contended, "Follies in gardens—or arbors—or pavilions—or teahouses or summerhouses (as they were apologetically called in my Edwardian youth) must go on." Follies indeed have gone on, to many ends and with many purposes, some informed by Johnson's over-scaled persona, claiming discursive space as "serious architecture." What I want to stress in concluding is not that follies might come to an end but rather that a contemporary architectural folly might also be conceived as an archaism with a distinct contemporary function (with a nod to Gilles Deleuze), that the genre might be mobilized or remobilized within the public sphere as a politicized device through which to open the discipline to alterity. This was not, of course, Johnson's ambition in seeking to uncouple aesthetics from utility or program, the legacy of which remains within the field in many guises, not least thanks to Johnson's financial largesse in sponsoring such a paradigm on so many institutional fronts. But at this point in history, a period *after* Johnson, we might declare the pavilion a memorial to purely aesthetic and formal concerns, or even put this aspect of his legacy to rest. To reiterate, and as will hopefully be demonstrated in this new installment of follies: architectural follies might serve to interrogate the discipline's structural exclusions, to facilitate the voicing of *other* questions, *other* concerns.

[1] This and all other citations of Philip Johnson are from "Full Scale, False Scale," *Show*, June 1963, 72-75, reprinted in *Philip Johnson Writings* (New York: Oxford University Press, 1979): 251-52.
[2] John Jacobus, *Twentieth-Century Architecture, 1940-65* (London: Thames and Hudson, 1966), 177.
[3] See, for instance, Henry-Russell and Philip Johnson Hitchcock, Lewis Mumford, *Modern Architecture—International Exhibition* (New York: Museum of Modern Art and W.W. Norton and Co., 1932). On Johnson's political tendencies see Michael Sorkin, "Where Was Philip?," *Spy*, 1988, reprinted in Michael Sorkin, *Exquisite Corpse: Writing on Building* (New York: Verso, 1991), 307-11.

[4] Johnson, "Full Scale, False Scale," 251.
[5] Robert A. M. Stern, editorial note in *Philip Johnson Writings*, 250.
[6] This and all other citations of Ada Louise Huxtable are from "Architectural Drawings as Art Gallery Art," *New York Times*, October 23, 1977, D-27. She noted later in the review: "Much of this work is transitional—somewhere between architecture and the other arts. It is testing the meanings and boundaries of architecture, as those boundaries have been tested in painting and sculpture. There are tints of Marxist philosophy and tinges of angst and despair, echoes of conceptual art, minimal sculpture, and earthworks, among its debts and credits."

Lunacy

Franco "Bifo"
Berardi

Mantra and
Madness

The Psychic Collapse of the Economy

Semiocapital—or cognitive capitalism—is based on the application of nervous energy, as the technical system of the digital network intensifies the transmission of stimuli to individual brains.

In the neoliberal context that emphasizes competition as the only possible form of relation in the social sphere, intensification becomes a pathogenic acceleration investing the conscious and sensitive organism. Therefore, the rhythm of social vibration becomes a source of a sort of psychopathology leading to panic syndrome, attention disorders, and, finally, depression.

Until a few years ago, psychiatrists hardly recognized panic as a symptom. Panic was rather linked to the Romantic literary imagination associated with the feeling of being overwhelmed by the infinite richness of natural forms, by the unlimited power of the cosmos. Today panic has lost its romantic aura; instead, it has become a pathology frequently denounced as a painful symptom—the physical sensation of having relinquished governing one's own body, an acceleration of the heart rate, a shortness of breath that can lead to fainting and paralysis.

Attention disorders are increasingly widespread: millions of children are being treated for the incapacity to concentrate on an object for more than a few seconds. Indeed, the constant excitement of the mind by a neuro-stimulating flux leads the collective brain to a pathological state of saturation. Semiotic flows are accelerated according to an extra-semiotic principle of economic competition and maximum exploitation.

Being essentially connected to the brain as a psychovirus or pathogenic agent, Semiocapitalism accelerates pulsations until they become tremors, spasms, and, finally, reach the point of collapse.

During the 1990s, the culture of Prozac was inseparable from the culture of the new economy. Hundreds of thousands of operators, directors, and managers of the Western economy have taken innumerable decisions in a state of chemical euphoria and psychopharmacological lightheadedness. Eventually the organism of cognitive workers and of semiotic consumers has caved in, unable to support indefinitely the chemical euphoria that had sustained competitive enthusiasm and productivist fanaticism.

Just as a cyclothymic organism or a patient affected by bipolar disorder, the financial euphoria of the 1990s was followed by irrational exuberance—and then it fell into depression. The present financial crisis is jeopardizing the social sphere worldwide: it has lead to widespread impoverishment as a consequence of the nervous breakdown that has affected the connected mind. This, in turn, has opened up the way to a financial dictatorship which is destroying democracy and the very foundations of social civilization.

The Healing Mantra of the Uprising
Social life needs an uprising. This will not be a political uprising. The rational activity of the social mind is out of order, and craziness acts as a short-circuit in the wired economy of Semiocapital.

We need an upheaval of the body, a schizo-insurrection of desire and of laziness. A downtempo folly.

We need a global mantra to re-activate the social respiration and the body.

Upheaval, uprising, insurrection, and riots: these words should not be intended in a military way. A violent action of the anti-capitalist movement would not be smart nowadays, as violence is a pathological demonstration of impotence. Nevertheless, we'll no doubt witness further massive explosions of precarious rage and violence—like in Tottenham, Peckham, and other neighborhoods in London and Birmingham in August 2011, or like in Athens and Rome during the last two years. The uprising will frequently give way to phenomena of psychopathic violence. We should not be surprised, we should not condemn these acts as criminal.

For too long, a financial dictatorship has compressed the social body, and cynicism of the ruling class has become too repugnant for the moral sentiment of the majority of young people. This is why we should not be surprised when violent explosions happen.

The uprising is a therapy for this kind of psychopathology. The uprising is not judging, but healing. And healing is only made possible by a mantra that rises, stronger and stronger, as solidarity re-surfaces in daily life.

It's useless to preach to those who can only express their resistance in a violent way. They are crazy, but craziness is everywhere, and only a schizo-therapy can heal this kind of malady. The medic does not judge, he heals; and the task of the movement of uprising is to act as a medic, not as a judge.

What we should be able to communicate to the rioters, the looters, the black bloc and the *casseurs* (vandals) is a truth that we must build together and disseminate: only a collective mantra, a verbal folly, chanted by millions will tear down the walls of the financial fortress that is destroying our future.

Magnet

Hans Ulrich Obrist

Follies Can Be Serious but Not Really Serious

Flexibility, responsiveness, transience, relativity, joy. Championing these as the principles of urban design, the freeing of the human within the structure, in opposition to the engrained doctrine of unyielding, static, constrictive architecture has earned Cedric Price iconic status not only among contemporary architects, but also artists and thinkers alike.

Cedric Price's major work in the 1990s was the Magnet Project. This comprises a series of short-life structures that happen "in between" urban spaces: stairways, walkways, elevators, arcades, and piers that function as "urban triggers." The idea of these interventions is not to occupy space, but to trigger relations and social spaces, stimulate new patterns and situations of urban movement in the city.

"Magnets offer us," Price once said, "a series of inherently changeable public amenities which take ease of access, sanctuary, information, and delight as their starting point."

In the year 2000, I curated an exhibition called "Retrace your Steps: Remember Tomorrow" at the architect Sir John Soane's home, quite an unusual museum in London, and at that time, J.G. Ballard's sister, Margaret Richardson was its director. As a part of that show, Cedric Price gave us a lecture from the kitchen: a magnet space, in any case, for conversation. Here are a few excerpts:

Perspective sketch: Magnet by Cedric Price. © Canadian Centre for Architecture Collection, 1995

The business about follies, which again is a very English thing, I know it in some other countries, but as far as I'm concerned it is very English. The business about follies is that they don't have to be too serious, you don't say, "Oh, that's a really serious folly!" The true folly reaps the harvest of a silent eye, suspending truth itself in a delightful way. Lone contemplation is essential if only for a split second. The folly distorts time, space and place and in so doing mixes magic with mystery, fun and fantasy, now with then. Humor is essential, in its creator and wit a bonus. In effect, the successful folly encourages the observer to suspend with alacrity any belief in the rational. The element of surprise is usually confined to the single or visually isolated folly. Wonderment replaces surprise when a series of follies can be enjoyed by the viewer. However, even in these circumstances the visual enjoyment remains, in a particularly English way, a series of incidences rather than a sequential experience. To understand this, the viewer should compare the forty or so follies still to be found in the enormous gardens and parkland of Stowe in Buckinghamshire.

Folly viewing is an outdoor activity. The folly should not be contemplated through glass. Never approach a folly by an easy route and try not to get too near. If you have to be near, see the detail but never touch it. Do not try to determine the actual size, it does not exist. Never make comparisons. Under no circumstances try to draw or photograph one.

Many of Cedric's friends were present, including his partner, the actress Eleanor Bron, and sculptor Eduardo Paolozzi, and after the lecture, his friend Fergus Henderson prepared us all a meal. There was another form of magnets that Cedric did for that show, conversation pieces attached to the lapels of the men in charge of watching over that great house of curiosities. Cedric had had conversations with all the museum guards and made drawings out of the stories they told him, and then turned this little notebook of drawings into badges.

Misplaced

Kyong
Park

Nomadic
House

24260: The "Nomadic House," a project by Kyong Park, is an abandoned house from Detroit, cut up so that it could be re-assembled anywhere in the world. It was once called a "fugitive house," on the lam from the city of Detroit, where more than two hundred thousand homes were burned or destroyed in the last fifty years.

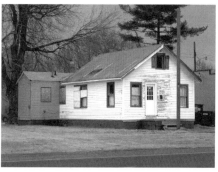

"Nomadic House" in Detroit, 2000

24620 desperately extended its existence by travelling. Its first journey was made in April 2001, crossing the Atlantic Ocean to be reconstructed in the third annu-

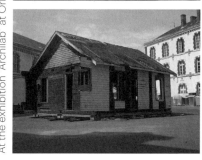

At the exhibition "Archilab" at Orléan, France, 2001

al Archilab exhibition in Orléans, France. It went on to make stops in five other European cities. In 2008, on its last legs, it made its way back across the ocean, its dying breaths in San Diego. Ever since, Park has been dismembering it into individual pieces that are placed into coffins which are soon to be making their return journey, piecemeal, to Detroit with several stops and ceremonial "funerals" along the way. Thereafter, the house will be resurrected in the form of a "Nomadic Pavilion" which will then tour the same cities it visited in coffins, eventually planting its feet in San Diego.

With its pieces misplaced and their incisions permanent, the house and pavilion replicate the condition of a dysfunctional city in the violence of dismembered spaces. Wherever it may go, it takes the ideals and failures of modernism with it, an aberrant displacement in which meaning is inscribed by its perpetual reiterations.

Memory Box

Seok-hong Go &
Mihee Kim

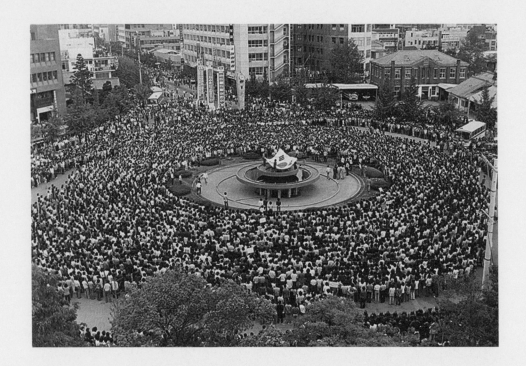

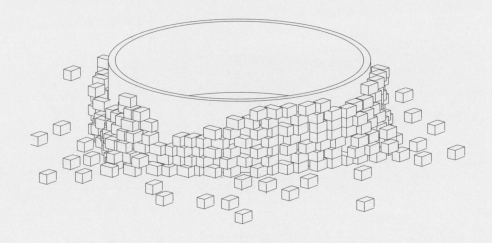

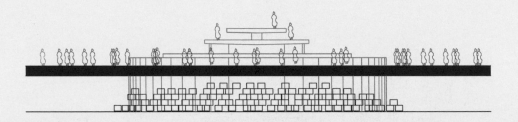

Public lockers are a frequent feature in public spaces around Gwangju. Here citizens can rent small compartments to discreetly store individual belongings for a short period of time.

Seok-hong Go and Mihee Kim have designed a new wall of lockers which, through its shape, also invites passersby to sit and rest. Some of these function as ordinary rentable lockers. But the locker doors have been replaced by transparent doors revealing the contents for one and all to see: an ordinary locker is thus transformed into a Memory Box.

Activated through a website and public call for participation, Gwangju citizens have been invited to store and display private objects and memorabilia on public view.

The Memory Box is installed in an underground passage of the Gwangju Fountain metro. Thus, it is placed right underneath one of the most prominent commemoration sites to the student protests of 1980. A vertical tension is thereby created between radically different approaches to memory: one representing the official political "memory" and the other a dynamic archive representing a multitude of highly personal memories. The installation questions the boundaries between the public and the intimate, between the static and dynamic facets of the history of the city.

Seok-hong Go and Mihee Kim's folly won first prize of the competition open to young Korean architects launched by the Gwangju Biennale Foundation in May 2012.

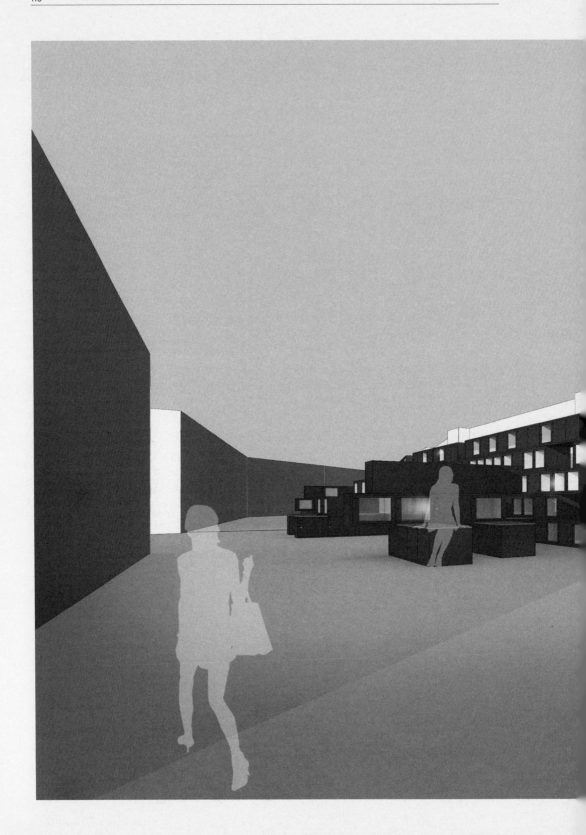

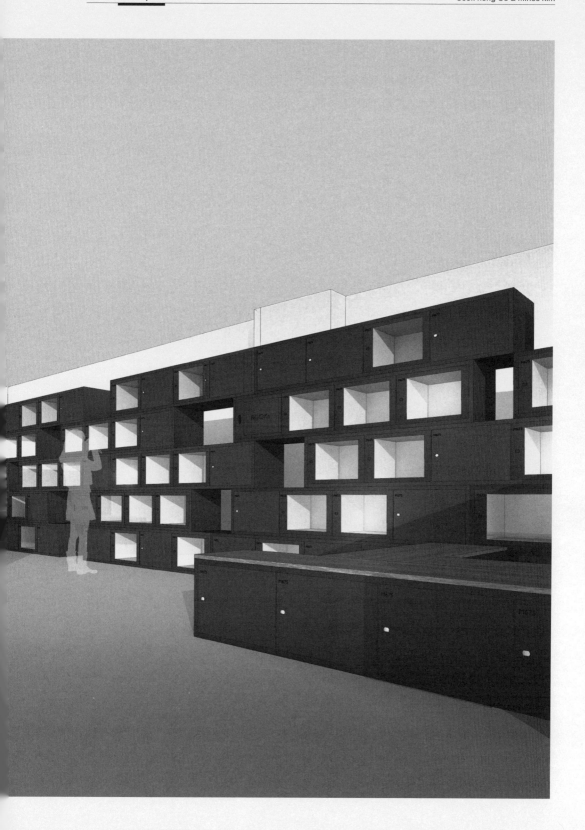

Parade

Etcetera

The Name
of Victory in
the Language
of Children:
One Act
Operetta

During June and July of 2010, we were invited to Turkey for a residency to work in a neighborhood that covered an entire hillside, a dense tapestry which had acquired urban complexity and distinct local identity. The Gülsuyu-Gülensu neighborhood (called a *Gecekondu*, Turkish for "shack") was established informally when immigrant groups from eastern Anatolia arrived in the early 1960s. Since the

Etcetera, Parade, Cultural Agencies Residency, Istanbul, 2010

1970s, local activism and solidarity networks created a unique social tissue. But the municipality is currently planning to exploit the prime real estate value of the area, located within an earthquake-safe zone and offering unique panoramic views. If

Etcetera, Parade, Cultural Agencies Residency, Istanbul, 2010

plans are realized, the neighborhood will be replaced with new up-market housing and most inhabitants will be displaced. Two collective activities were organized and developed together with neighborhood residents. "The Name of the Victory in the Language of Children" was performed as a social readymade in the public space—a poetic action to give voice to the real estate speculation and to denounce potential displacements; a parade that played on stereotypes created by the mass media.

The project was made possible by Cultural Agencies, curated by Nikolaus Hirsch, Philipp Misselwitz, and Oda Projesi (Özge Açıkkol, Güneş Savaş, Seçil Yersel).

Participation

Markus Miessen

Crossbenching & the Outsider in Urban Practice

A folly serves as a form of content camouflage. Superficially, it could be described as a form of decoration, a surface, a pastiche. It transcends the normative notion of ornament as a decorative function of the building to which it belongs. In many ways a folly is a state of exception. It produces a sovereign framework that actively divests itself from societal norms and the necessity to perform in a presupposed manner. By default, the folly is not the norm.

In many ways, the folly is a MacGuffin. A MacGuffin is a plot device, in which a protagonist or antagonist is consciously introduced into a given context in order to pursue a particular goal. Although its real driving force may come across as nebulous, the MacGuffin serves as a force of motivation to the key characters. In other words: it serves as a stealth driver. In the context of terrorism, we would call the MacGuffin a Sleeper.

It is precisely this character that produces its potential. Not only for alternative forms and formats of (spatial) critique, but—moreover—the possibility of placing an outsider, a spatial irritant, into a given context: a "thing" that turns the homogeneous into a state moving towards heterogeneity.

This leads us to ask: what embodies contemporary forms of the folly when it comes to spatial practice? One can think of the notion of the outsider in two ways: as a social as well as a spatial construct. When considering the spatial, the outsider can be understood as a parasitical object (violently or otherwise) forced into a given context. When it comes to social dynamics, the role of the outsider could be described as a crossbencher. In the British House of Lords, the crossbencher is someone who does not align him- or herself with a given party structure and, hence, consciously avoids an a priori consensual agreement within a given framework and reality. Consequently, the role of the crossbencher is one of autonomy: decisions or propositions are based on personal belief, a code of morals or a particular set of knowledge.

When observing many global urban realities today, one can sense an alarming move towards processes that are seemingly based on the democratization of both public space and the public sphere at large. We are meant to believe that the citizen—as *citoyen*—has been reintroduced into urban political discourse. Such grassroots political mobilization, although important, has been obscured by the recent tendencies of state, city, or other powers to strategically introduce counterfeit forms of participatory structures. Decisions are outsourced in order to withdraw from their personal responsibilities as elected representatives. These forms and formats of participation have turned into a sedative: the new opium for the people.

Occupy Frankfurt, Armin Linke, 2011

What does this mean when it comes to contemporary public space? Is participation supposed to be understood as a form of harmony? Many recent forms of urban development are gearing towards a certain homogenization of the public sphere—not only in regard to programmatic decision making, but also in the way in which functions are understood as pedigree singularities that leave little room for unexpected encounters and cross-pollinated forms of urban coexistence. Moments of rupture have become rare.

Even when we observe necessary bottom-up urban activities—such as the Occupy movement—it is evident that those activities are favored by policy makers, as they produce a controllable reality, one that is based on a specific and delin-

eated territory. Grotesquely, this is similar to the way in which sterile environments for drug users have been introduced to cities: making sure that a particular urban crowd, a phenomenon, or usergroup are being being restricted and bound to a specific territory in order to be controlled. Welcome to Harmonistan!

It is precisely for this reason that the role of the outsider becomes more and more relevant and necessary. What we need today are individuals and spaces that do not conform to the idea of a homogenized harmony, but reintroduce forms of friction. This form of homogenized harmony has also infiltrated the art world, in which ideas around participation and social involvement have become the new status quo. Supported by a nostalgic veneer of worthiness, phony solidarity, and political correctness, participation has become the buzzword for success: a success that comfortably outsources individual responsibility and seemingly creates a platform to be involved.

Participation, as a term and practice, needs to be turned upside down. We should no longer feel obliged to answer to an invited participatory structure, but instead to authorize ourselves to our own participation. Such practices of the free radical would therefore not proclaim a form of passive participation that awaits the kind gesture of invitation—to assemble at a round table and establish consensus—but to proactively assume responsibility as a single person, a subject with a conscience.

Instead of understanding public space and social complexity as a question of perpetuated and micro-bourgeois preservation, today's urban spatial practices should assume a criticality that supersedes the harmonious notion of togetherness. By introducing forms of radical and decentralized friction, new urban complexities can begin to nestle. The folly, in this sense, can be understood as a singularity that is being strategically moved in from the outside: a spatial form of crossbenching. One that is many.

Pedestal

Can Altay

The Empty
Pedestal,
or Folly as
Experience

The Excess

Historically, a folly provides us with an architecture of excess. The folly is a building that doesn't care, that doesn't necessarily provide shelter; it appears adrift from the principles of architecture, its initiation is pure play.

However, this excess also reveals a possibility of beyond; the folly offers a potentiality to be used and appropriated beyond a pre-determined function, utility, or even meaning. Now, "excess" presents political potential. And it is because of such an inherent excess that architecture can be reconfigured through use and production of meaning.[1]

And if it is reconfiguration of space and meaning we are after, we need not necessarily begin with a folly. But it is a valuable trigger, which remains within the boundaries of architectural discourse. Otherwise, any simple element of architecture, even the most minor ones, hold such inherent excess. My work around the *minibar* phenomenon mainly revolved around this potential, and how certain actions reveal this excess to shift meaning in the urban realm.[2] In Ankara, the *minibar*, as it is anonymously named, consists of young people's temporary utilization of existing urban elements around and between buildings for the sake of socializing and nightlife. The triggers of the *minibar* were not primarily architectural—it was rather the sidewalks, the low masonry garden walls, and the spaces in between buildings that played more of a supporting role. Nevertheless, these architectural elements that were actually about maintaining boundaries, also made the *minibar* possible, by providing those surfaces and gaps as the "setting." The economic suspension of the service sector and the politics of the everyday transformed a casual "hanging out" into an act of significance. Negotiations were made, publics were produced, conflicts prevailed, meaning shifted, and those streets were never the same again.

The Grounds

Follies are mentioned among a set of features traditionally associated with gardens. It is amusing to observe that these set of features are, in terms of form and experience, where sculpture and installation in the twentieth century has brought us. The pavilion, the grotto, and the like bear a certain resemblance to the spaces artists have created. The significance of artistic work lies in the political side of "excess," where the artworks address the production of meaning and open up fields of possibility, for us, the subjects.

One of the questions tackled most throughout the twentieth century, in my opinion, was the question of display, i.e., what to do with the frame and the pedestal in a context where art deals mostly with the "pain of showing."[3] The motif can be traced throughout the works of many artists, working from sundry positions and places. The historical verdict seems to be on the side of those who dropped the frame and the pedestal completely. But if "showing the pain of showing" is "joy itself" for "art after the end of art," how is it that so few artists have pursued the potentialities offered by the frame and the pedestal? I am reminded of artists such as the Belgian Didier Vermeiren, who tackled the issue in the 1980s; though the problem remained as his work was ultimately about making a sculpture out of the pedestal.[4] The political potential of the inherent excess in the pedestal or the frame (two items whose existence are about limiting and defining "views"), the kind of potentiality as discussed for the folly, has been hardly explored or challenged.[5]

The History

This brings us to a sense of political history. A political history where artistic production in the sense used here is mostly dominated by the production of artefacts. The end of the twentieth century actually witnessed not so much the abandonment of the pedestal, but rather the destruction of what had been standing on top of it—especially in public spaces all over the former East and the Soviet Union, followed later on by spots in the Middle East. This was the removal process of many sculptures and former monuments, due to their monumentalization of former regimes. Suddenly there was an abundance of empty pedestals in the world!

Let's focus on the "empty pedestal." The empty pedestal provides us with a duality. It is at once a "promise" of something and a "question" of whether something has been removed. It points to the potentiality, but it also most likely points to a violent act of removal. We do not necessarily know, and depending on our position, we can either sail into the horizon it provides; or we can look back in anger, wrapped in memory or nostalgia; or, as in the case of the empty pedestal within the Kulturalna, the Palace of Culture and Science in Warsaw, we can embrace it as

The exedra of Protogenes, Kaunos. © Cengiz Isik

it is, somewhere in between, both the horizon and the past entangled, and have a sit on it while it lasts.[6]

An even older architectural feature, older than the folly and its excessiveness, is the exedra. The exedra, in architecture, is a semicircular recess, or niche, in a building. In ancient Greece and Rome, it was also an outdoor bench used as a place for discussions. The exedra where the ancient Greek painter and philosopher Protogenes taught, located in the city Kaunos, is peculiar as it is not only a bench, but also the pedestal for a series of sculptures that surround and frame the gathering. These sculptures were figures about the philosopher's background and influenc-

es (teacher, father, fellow). The sculptures are long gone; in their stead are foot-prints.[7] The exedra as incorporating a framing of ideas whilst being the site for the "taking-place" of ideas and discussion is thought provoking. It draws out a support in the sense that it provides the "foundation" but it also frames and "bounds" the very discussion with the existence of heavy references hovering over the lecture or the discussion. The references here are the sculptures: they are representative forms, and their presence can be challenged, if not neglected. We cannot begin to fathom what actually might have happened in the exedra of Protogenes, but its ruin provides us with a horizon that also incorporates its past.

The Action

When talking about artistic activity, Felix Guattari mentions "techniques of rupture and suture that are aesthetic in their nature," meaning an act of opening up, re-vealing a field of possibility; and an act of sewing back together, allowing singu-larization. "So how might a [Folly] be made to come alive like an artwork?"[8] This lies in acknowledging its inherent excess, and allowing it to be acted upon. It lies in forming and positioning the folly as a trigger and as experience, preferably beyond a preconceived set of performances, allowing a "grasping of existence" on the part of the subjects whose actions will reveal the folly's excess.

[1] A contemporary re-introduction of the folly into architectural discourse was through Ber-nard Tschumi's *Parc de la Vilette* (1984-87). I would like to believe this excess to be the reason why Tschumi placed follies as the central yet dispersed feature of the Park.

[2] For more insight on the minibar, see: Altay,C. and D.Altay "Counter-Spatialization (of Power) (in İstanbul)" in Guidi, E. (ed.) *Urban Makers: Parallel Narratives on Grassroots Structures and Ten-sions* (Berlin, 2008); Altay, D. "Urban Spaces Re-Defined in Daily Practices—Minibar, Ankara" in Frers, L. and L. Meier (eds.) *Encountering Urban Places: Visual And Material Performances in the City* (Ashgate, 2007); and Vergara, L. and C. Altay *No Bar, Just Bottles* (Bilbao, 2006).

[3] The full quote from Philippe Lacoue-Labarthe goes as: "Art after the end of art shows the pain of showing. That might be joy itself." See Lacoue-Labarthe, P. *La Poésie comme experience* (Paris, 1986). The translation I am referring to is by Da-vid Macey, cited in Badiou, A. *Pocket Pantheon: Figures of Postwar Philosophy* (London, 2009).

[4] As early as 1974, Vermeiren began making pedestals. One work worthy of mention would be *Un bloc de pierre de 80 x 80 x 20 cm sur un bloc de polyuréthane de 80 x 80 x 20 cm*, 1985. The work of minimal artists from the 1960s, such as Carl Andre, could as well be mentioned; but perhaps the one most worthy of our attention is Robert Morris's 1971 Tate exhibition "Exhibition of

Works"; the accompanying film *Neo Classic*, 1971; and the later reworked version *Bodyspac-emotionthings*, 2009. In the case of this work, the problem of the "pre-dictated movement" still bounds us, but this shouldn't undermine the field of possibilities it opens up within art.

[5] I have been personally in pursuit of making the frame and the pedestal "the work" itself, with consideration of such excess, for the last five to six years mainly in the context of the "setting a setting" series. For further discussion on settings see: Altay, C. "Setting and Remaking" in Hirsch, N. and Sarda, S. (eds.) *Cybermohalla Hub*. (Berlin, 2012).

[6] For more information on the Palace of Cul-ture and Science, which, to this day, is the larg-est building in Poland and built as a gift from Stalin, see the work of anthropologist Michal Murawski who focuses on the Kulturalna and its presence in Warsaw. His accounts of the remov-al of the sculpture by Alina Szapocznikow were helpful in constructing my ideas on the "empty pedestal."

[7] I am indebted to archaeologist Prof. Cengiz Işik's research work in Kaunos and his accounts on the exedra of Protogenes.

[8] Guattari, F. *Chaosmose* (Paris, 1992). The translation I am referring to is by Haun Saussy from Guattari, F. "The Object of Ecosophy" in Marras, A. (ed.) *ECO-TEC: Architecture of the In-Between* (New York, 1999).

Picturesque

Barry
Bergdoll

The
Picturesque
and the
Landscape
Garden

The English natural landscape movement underwent significant change in the decades between 1719, when the poet Alexander Pope and the architect John Vanbrugh both employed "picturesque" to advocate creating landscapes like paintings, thus substituting pictorial for architectural criteria in laying out gardens, and 1794, when Richard Payne Knight (1750–1824) and Uvedale Price (1747–1829) argued that the "picturesque" was a distinct category of aesthetic experience with its own formal laws and emotive effects. From the first, this embracing of "simple" or natural nature over the highly formal and geometric "artifice" of the gardens of Versailles—which enjoyed Europe-wide prestige for over a century—was celebrated as a distinctly English invention, one which paralleled, endorsed even, the quest for a society founded on natural law, liberty, and tolerance. Shaftesbury, who like Locke before him, argued that given freedom man would seek the good, used the wilderness as a symbol of nature in its primitive state and thus a symbol of universal order. The landscape garden became something of a utopia, a place where humanity's own natural morality rejoined the natural realm of which it was a part. Indeed, many of the most spectacular English picturesque gardens were created by and for members of the Whig aristocracy, whose political position was built on this philosophical foundation. Most notable of these were the famous gardens at Stowe in Buckinghamshire, where, for the leading Whig Sir Richard Temple, Charles Bridgeman's grand formal layout of 1719–20 was deliberately eroded over the 1730s and 1740s as a program of garden pavilions and natural tableaux was created by William Kent and, later, James Gibbs. A pointed commentary on British political liberties and artistic achievement was achieved by the introduction of garden buildings, which carried a range of emblematic and associative meanings. By the time Rousseau visited Stowe in the 1750s, it included some thirty-eight miniature monuments—a veritable museum of architecture to complement the full palette of natural effects in settings such as Kent's "Grecian Vale," meant to transpose the visitor to the purity of an ancient Arcadia. "All times as well as places have been united in this superb solitude with a magnificence that transcends the human," Rousseau noted in admiration of Stowe in *La Nouvelle Héloïse* (1761).

Palladian bridge, Stowe gardens.
© John Hubble, 2012

Power Toilets / UNESCO

Superflex

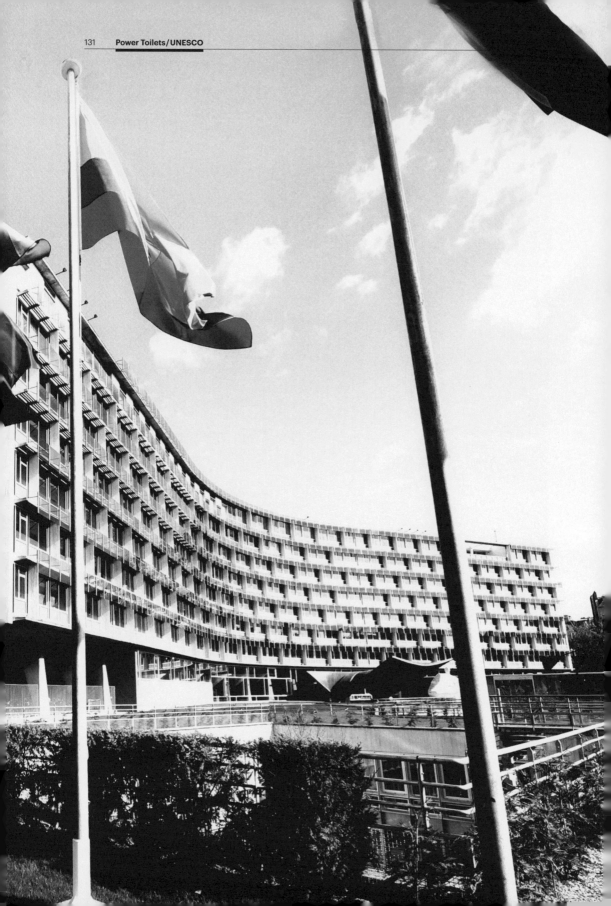

In 2011, the Gwangju Democratic Uprising received global recognition through UNESCO. Thus, the archives documenting the student-led protests were included in the UNESCO Memory of the World Register.

This decision had a profound and immediate effect as it became the cornerstone of the city re-branding campaign: at the airport or the main railway stations, visitors are now welcomed to the "City of Human Rights." Numerous plaques, signs, and memorials mark out the historic sites of the uprising—even an entire underground station has been devoted to the theme of human rights.

The Power Toilets address the complex relationship between UNESCO and the city of Gwangju. Superflex have replaced a run-down public toilet in Gwangju with a new toilet which—in its interior—is an exact copy of the exclusive toilet used by the Executive Board of the UNESCO headquarters in Paris. While maintaining the semblance of a normal public toilet, the structure also engages its users in questioning the relationship between original and copy, exclusivity and inclusivity, and, ultimately, the infrastructures of power and everyday banalities.

The Power Toilets also incorporate a personal aspect: the facilities are managed by a citizen who witnessed the 1980 uprising firsthand. That is, he lived in a house with a front-row view onto the protests. Later, this house, among others, was demolished and a park was created in its stead. The original public toilet facility found in this park was managed by him, as is Superflex's new structure.

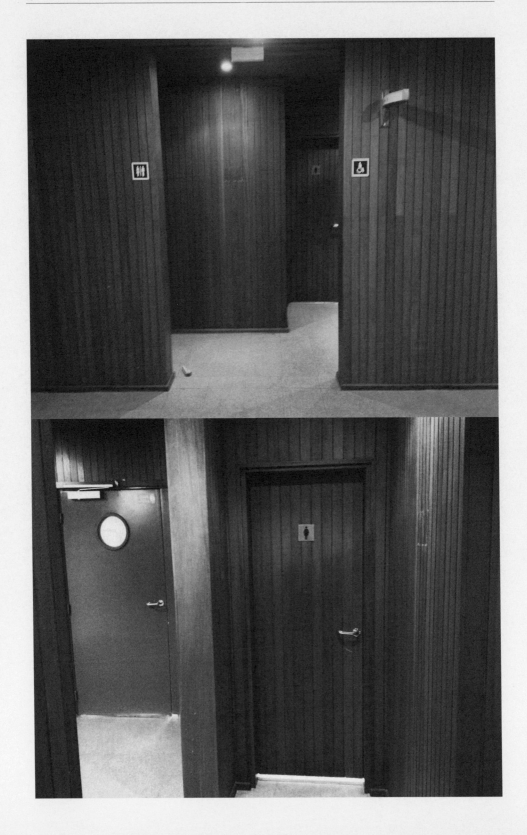

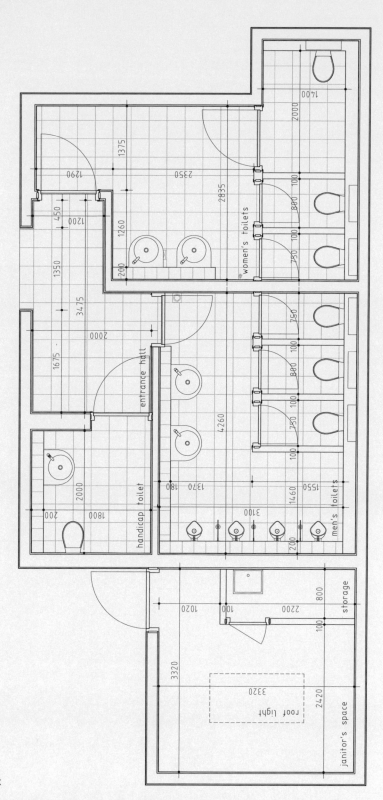

UNESCO, *Paris*, 2013
Courtesy of Superflex

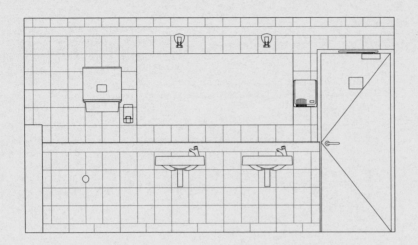

UNESCO, *Paris*, 2013
Courtesy of Superflex

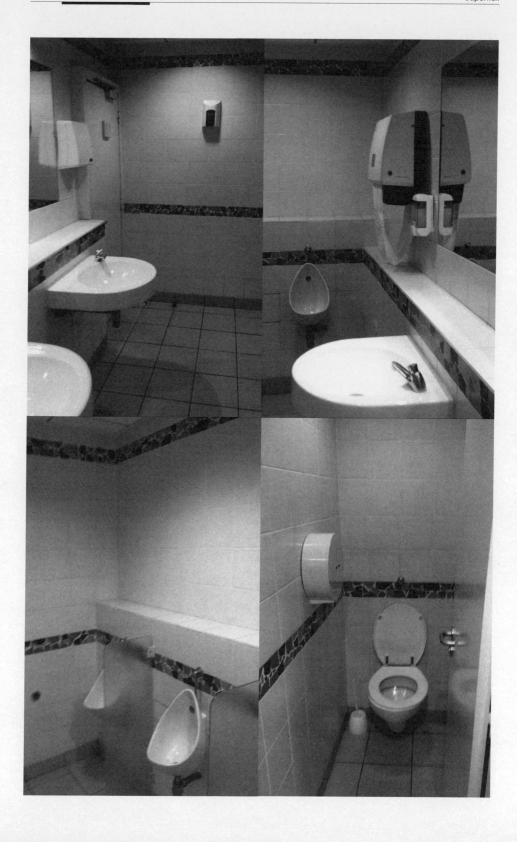

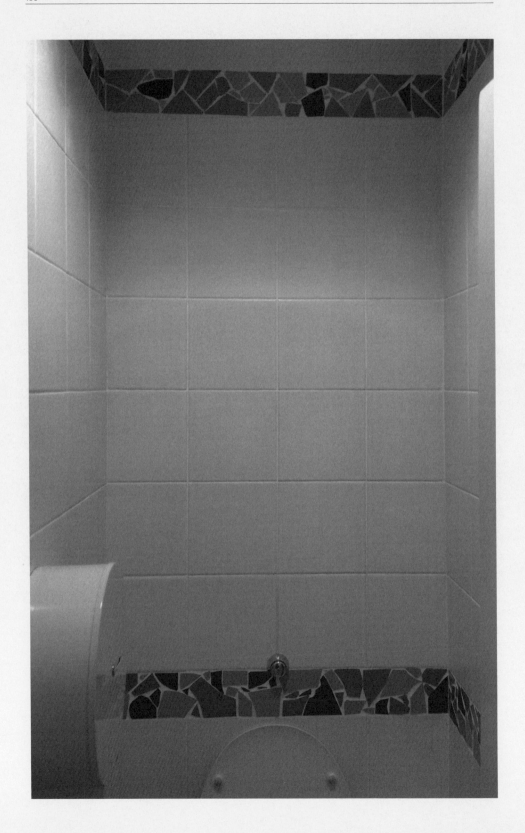

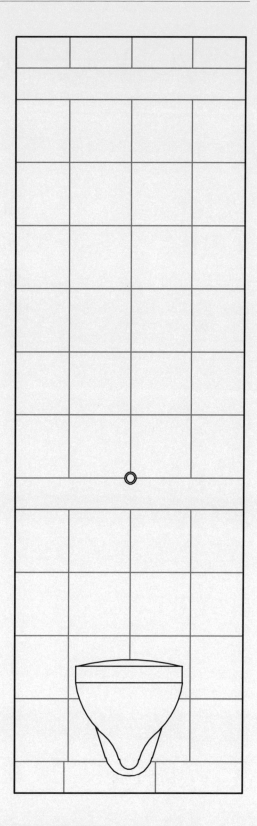

UNESCO, *Paris*, 2013
Courtesy of Superflex

Psychogeography

Peter
Carl

Civic Monuments,
Garden Follies,
and Orientation
in History

As the Gwangju Follies make reference to the May 1980 protests, they would appear to be monuments rather than the follies customarily found in the English Garden. That a southern Korean city might be considered a species of English Garden invites the question: have garden and city recovered an ancient reciprocity or have all distinctions become reduced to "form," absorbed into the infinitely promiscuous "space"? If the issue converges with what is frequently called object-and-context, the substance points to whether distinctions of this kind matter, and thence to the scope and depth of the urban imagination, otherwise free to roam through "public space." Walter Benjamin's morality was unable to make sense of the blizzard of open-ended references thrown up by metropolitan capitalism, resulting in the unresolved fragments of the *Arcades Project*. James Joyce, by contrast, was not bothered by this phenomenon, realizing that the European City as receptacle of European culture relied precisely on folk who only partially understood or misunderstood, were variously reflective beyond their immediate needs and desires, were angels or prostitutes or both, were bigoted or generous, fought with words as well as with fists, walked the streets and alleys encountering other Dubliners or rode through the population in an omnibus, a funeral carriage or, even more remotely, in a viceregal carriage.

The viceroy's carriage and comportment carry many of the connotations expected of a civic monument. Those of Catherine the Great in Odessa, or of the Place de la Concorde in Paris, are sober, remote, dignified hunks of stone and bronze

Postcard of the Place de la Concorde, Paris, France, ca. 1890–1900. Wiki Media Commons

positioned so that traffic, troops, tourists, and townsfolk flow past them. Rulers and popes were once similarly expected to mediate between eternity and history; but now that eternity itself is history, such works are stranded in a vague respect for art and heritage, when not deemed emblematic of pomposity and oppression. Conversely, the two obelisks of Bernini in Rome, at Sta Maria sopra Minerva (positioned on an elephant) and in Piazza Navona (positioned upon a four-quartered grotto attempting reconcile four geographical rivers with the four rivers of paradise) offer a greater generosity of imaginative participation, not to mention a dense metaphoricity and iconography. The *acutezza* and *ingegno* of Bernini's monuments remain within the authority of an official discourse that, by the late nineteenth century, had decayed to the lugubrious moral didacticism of civic monuments, and of monumental planning (moral engineering to complement the physical engineering of the new sewers, piped gas, and metro lines). It was these didactic theaters that De Chirico, stimulated by Nietzsche's disdain for "values," so effectively subverted in his paintings. Although the culture that sustained Bernini is lost to us, his monuments still communicate a wit and sobriety absent from the agony of the Vittorio Emanuele monument, also in Rome. However, even the Vittorio Emanuele does not inspire the ridicule provoked by Saddam Hussein's crossed swords or the monument to Peter the Great in Moscow.

Rising thirty-three stories from the Moskva River—therefore from natural surroundings if not an English garden—perhaps the monument to Peter the Great may serve as a transition from the urban monument to the garden folly. Other than its size, it exhibits the characteristics of quirky extravagance and oneiric strangeness characteristic of garden follies. The turn to monuments and to follies happened to-

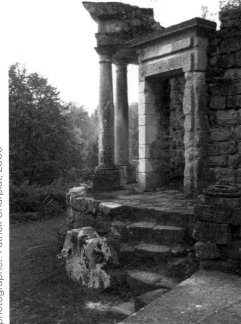

Temple to Philosophy at Ermenonville. Wiki Media Commons, photographer: Patrick Charpiat, 2006

gether historically, alongside the transformations of cultures, religions, and languages into concepts and attributes which could be studied comparatively in great tomes and museums. The *Grand Tour* of (mostly southern) Europe was mirrored in *petit tours* of English Gardens, processing individually or in small groups through a succession of poignant lessons in history or life, perhaps pausing for refreshment in an "oriental" tea-house or *laiterie*. The supposedly "natural" disposition of the greenery and the attendant didactic melancholy served to convince these tour-ists that they were traversing a landscape of Culture and History. The pro-

grams of many of the English follies, or the French *fabriques*, occasionally aspired to profundity, such as René de Girardin's intentionally incomplete Temple to Philosophy at Ermenonville (the first of these gardens in France, inspired by and dedicated to Rousseau, who died there and was entombed on an island in the garden). From the evidence of later experiments in the genre, most compelling was the melancholia of Rousseau's death, and of the "ruin" as an incarnation of history as loss, rather than any inspiration to "philosophy." Certainly the general run of *laiteries* and *ermitages* were courtly *divertissements* contemptuous of actual farmers or hermits. It is therefore somewhat surprising that the imagery and iconography of these rather fey constructions were deployed by architects of shrines to the Supreme Being or to Reason in the aftermath of a Revolution organized to dispose of the aristocracy. Despite the irony, it is possible to see similar aspirations in the Gwangju Follies.

These shrines were, of course, short-lived. Post-Schinkel Berlin came to exemplify a city able to balance its civic ideals with urban gardening. The sequence from the Tiergarten via the Brandenburger Tor, down Unter den Linden to what is now Museum Island developed a subtle play between a well-tended natural order and a civic order of cultural and imperial institutions, themselves deemed to have monumental value. The importance of views in the achievement of this enterprise (as with the "picturesque" aspects of the English Garden) was supported by laboriously researched, nostalgic reconstructions of such exemplary settings as ancient Athens or medieval cathedrals. This testified to a conception of culture as a project possible to fulfill in an idealized picture. It was an early manifestation of the strangely persistent Romantic experience of a fallen culture that could be renewed through projects.

The ardent desire to rescue Culture from History fuelled the vast panorama of moral engineering that was Vienna's Ringstrasse. Under these conditions, the city becomes a background for encounters with monuments, as the places where significant meaning resides. The twin generalizations of the English Garden and of the perspectival machine of nineteenth-century planning easily combined to make up this background—landscape and cityscape—for monuments. Le Corbusier's crystalline housing disposed as patterns across an English Garden testify to the progressive flattening of the available meanings to a contest between technological mastery and individual psychologism in a conception of history that discards the past for the ever-deferred future redemption. The monument and the individual began to converge (most vividly in late nineteenth-century cemeteries): from Lequeu's entire corpus to Robbe-Grillet's *Project for a Revolution in New York*, we find emotional, even lurid attempts to capture meaning set within abstract frameworks of "order"—much as industrialization helped to create conditions fruitful for the Gothic Novel. This conception of poignant moments set in a conceptual structure is, in any case, a fair description of Bernard Tschumi's Parc de La Villette scheme, in which the point-grid is perhaps the most *folie* aspect of the proposition.

In such contexts—where, for example, archaeologists and art historians use the term "monument" to refer to any object of research, no matter what period or culture—one appreciates André Breton's discovery of phenomena embedded in urban life, such as the brasserie named La Nouvelle France, or the "luminous Maz-da sign," or the Saint-Ouen flea market, or a canopy in the Place Dauphine, which allude to the remains of myth, or perhaps new ones. Similarly, Louis Aragon's exploration of the Passage de l'Opéra opens an urban depth fruitful for analogy, reverie, opportunities for encounters, found meanings arising from *objets trouvés*. The broad corpus of works that go under the term "psychogeography"—an unfortunate coinage that sounds like touring an English Garden—cultivate similar ground. We are, of course, in the domain of ephemeral fragments—and the Benjamin / Joyce dilemma—rather than orchestrated lessons or insights; but these fragments have a communicable accuracy and arise from the processes of civic life, both good and evil, and, at least according to Joyce, carry viscerally the leg-

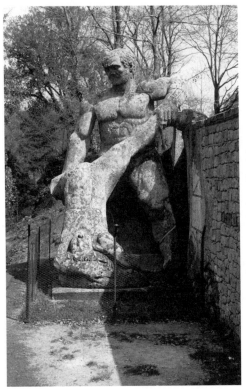

A giant at the Garden of Bomarzo. © Horst Bredekamp

acy of the European City. They might seem fragile by comparison to the numbing effect of the topographies of consumerism—from Randy's Donuts in L.A. (surely an urban folly) to malls to Via Sant'Andrea, Milan—but they require involvement in the deeper processes of a city, and are in fact more durable and rich than the stimulation of a pretty body looming from a billboard.

They also bear comparison to the urban sculptures of Bernini, mentioned earlier, in their capacity to animate the continuum of the city, rather than to stand apart, lecturing us, as do monuments. To be sure, the elevated discourse of the Baroque city and the capacity to trace meanings to shared levels of profundity have become more obscure, perhaps requiring the wit and generosity of a Joyce to retain credibility; but even the inhabitants of the most arduous urban slums do not believe life is meaningless. More directly to the point, the republican rhetoric of the apologists for the English Garden—briefly, that nature subjected to geometry is emblematic of tyranny—is manifestly absurd. The Renaissance and Baroque gardens were "rooms" like those in the city—*piazze*, streets, *cortili*, *saloni*, etc.—in which took place the *agon* of everyday life, from conflict to negotiation to accommodation to collaboration, and from reflection to ceremony to games to murder.

Certainly the population of a villa garden was more exclusive than that of a city; but by comparison to the English Garden's melancholy tour of didactic follies, the collective life of the Renaissance and Baroque gardens seems important to acknowledge.

Even Bomarzo's giants, dragons, and Mouth of Hell, hewn from live *tufa* in the depths of its *bosco,* would not have been called follies, because the continuum between natural and civic orders prevailed at a more primordial level. The clearest example is the grotesque vault which preserves its celestial luminosity whilst its ornament traces a progressive metamorphosis from calligraphy to hybrid figures to fully worked-out frescoes and stucco relief. As often observed, the Surrealists share this capacity to discover analogies within a metamorphic articulation of the given conditions, which are re-affirmed in the transformation. This is not simply a material transformation—and, again the Surrealist analogies can only indirectly draw upon the comprehensive framework of meaning available to the earlier cultures—but is itself an affirmation of renewal with respect to primordial conditions.

Unlike the didactic landscape of the English Garden, the city considered as a receptacle of metamorphosis recovers a proper affinity with nature. The conception of History as successive epochs, as a moving frontier of newness that consumes the past—as historicism—is absent here; and this is the most significant difference from the thinking in terms of monuments. The archetypal "landscapes" of stones— the Neolithic menhirs, alignments, barrows, quoits, henges subtly disposed with respect to movements of the land, the horizons, and celestial orientations—were produced by a culture whose fragile houses and equipment have utterly vanished. Precisely for this reason, the weathered stones testify to what is always at stake in the articulation of place: finding structures of mediation between the finitude of practical life and the primordial conditions, for which the deepest respect is held.

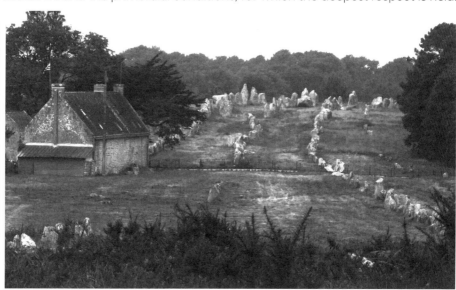

Carnac, Alignement de Manio, vue W. © Peter Carl, 2012

Quixotic

Nancy
Adajania

The Quixotic
Heroism of
"Follying"

Typically, an architectural folly is not meant to serve a purpose. It *is* its own phantasmagoric purpose. It shoots out like a twisted creeper from a crevice, producing a schism in the architecture of normality. A quixotic dream, it conjures up images of a doorless doorway in a sublime landscape, a cathedral with its roof blown off, a staircase that travels into the clouds, or a faux ruin that erupts like a fungus. Such idiosyncratic articulations of whimsy populated the private estates of eighteenth-century England but also of France, where the Désert de Retz, with its Broken Column House, Chinese pavilion, and Egyptian pyramid was one of the most famous examples of the genre.

The Broken Column House at Désert de Retz. © Michael Kenna, 1993

On some occasions, however, follies have embodied more than the pastiche fantasies of those driven by a desire to consume the Oriental Other. There was a time when follies served the needs of those who would have gone hungry without them. During the potato blight in mid-nineteenth-century Ireland, starving farmers were employed to build "famine follies," roads that led from nowhere to nowhere and walls that began and ended as abruptly as a snatch of music whistled in the night. Eccentric as this measure of relief may appear, it saved a number of Irish farmers and their families from an agonizing death, long before the Keynesian welfare state adopted such measures.

Crane no. 85. © 노순택 NOH Suntag, 2011

Closer in time, it would be useful to test the relevance of an urban folly project in a neo-liberal economy with its harsh cutbacks and even harsher asymmetries. Tracing the ancestry of the folly back to the Irish famine rather than the Désert de Retz, I shall—in an appropriately idiosyncratic gesture—nominate Crane No. 85 as a "folly." Until recently, it stood in a shipyard in the coastal Korean city of Pusan. This crane was not commissioned as a folly by a non-governmental organization or the State, or more significantly by any of Korea's *chaebols* or family-owned business conglomerates for the purpose of urban embellishment. And yet, its baffling presence, poised monumentally between dereliction and grandeur, challenged

the business-as-usual fabric of normality. Why? In January 2011, Kim Jin-Suk, a trade-union activist and South Korea's first female welder, climbed to the top of Crane No. 85 to protest against the unjust labor policies pursued by the Hanjin Heavy Industries and Construction (HHIC). The immediate provocations for her protest were a massive layoff of workers and low wages. Like pilgrims, people from neighboring cities came to Pusan to visit this 115-foot-high symbol of desperate, heroic resistance.

Some eight years earlier, Kim Jin-Suk's colleague, Kim Joo-Ik, who was also a trade-union activist, had plunged to his death from the same crane. In a letter from her sit-in on top of the crane, Jin-Suk wrote on 12 January 2011: "… a tall man [once] came here quietly … anxiously looked down, wandering around like an animal locked in a cage, wondering how many colleagues would gather around that day. It was Crane No. 85 where he balanced himself dangerously for 129 days between life and death: life when many colleagues came to support, leaning towards death when few colleagues came. It was [here] that he wrote his suicide note, watching union colleagues turning back with steps heavier than the ship they sent out

Hope Bus campaign, protest march, "Making the world without temporary workers!" © 노순택 NOH Suntag, 2011

from the dock that day. And I will surely do the thing that Joo-Ik could not do against his will: I will climb down the crane with my own legs."

The poet Song Kyung-dong crafted the Hope Bus campaign[1] to show solidarity with the workers' cause. Thousands of people were mobilized via social networking media. They travelled together in hundreds of buses—teachers, students, nuns, migrants, sexual minorities, physically challenged people, and the youth at large—in the hope of sharing the workers' predicament which could, given the worsening economic situation, just as well become their own. The protestors were sprayed with water cannons laced with tear gas. People with disabilities at the forefront of the protests were injured in scuffles with the police. But the buses kept coming over the months, and thousands more joined the protest.

Kim Jin-Suk's "aerial occupation" of Crane No. 85 turned into a trope of civic resistance. The crane, both as metaphor and reality, lies at the heart of Korea's urban development projects. In Gwangju (nearly 200 km from Pusan) where the Folly Project takes place, the crane has played an important role in the construction of its new urban centers. Gwangju is home to the May 18, 1980 people's uprising, which was brutally put down by the military but heralded the fall of the dictatorship and the democratization of Korea. One of Gwangju's new urban centers, Sangmu Sindosim, was the site of the former military garrison where hundreds of innocent people were detained, tortured, and killed under martial law during the

1980 uprising. In an insightful essay for the catalogue of the 2002 Gwangju Bien-
nale,[2] Jeong Ho-gi has written about the systematic erasure of the traces of the
uprising (the Sangmudae detention center, as well as the court and military police
buildings were relocated and replicated) and the subsequent official "institution-
alization" of collective memory and trauma.[3]

How does a folly project unfold in a city where the uprising has been turned into
a fetish? How do we negotiate between the official and the civic imaginations,
when the former is presented monopolistically as popular articulation and the
latter is relegated to oral history and evaporating memories of individuals? Where
contested public spaces and sites of historic resistance are being paved over,
domesticated, and appropriated for the mythography of an ambitious, burgeon-
ing *urbs*?

Crane No. 85 *was* a folly standing in a shipyard in Pusan. After 309 days of protest,
Kim Jin-Suk descended the crane, having valiantly survived heat waves, typhoons,
and snowstorms. On the recommendations of the National Assembly, HHIC was
supposed to reinstate ninety-four laid-off employees within a year's time.[4] Crane
No. 85 was smashed to pieces. It remains a memory of a critical rupture, a pause
in the mythologizing of the transitional city and its postindustrial imaginaries. But
then again, I wonder if the smashed folly did not liberate the ghosts of Kim Joo-Ik
and countless other victims of the old martial-law dictatorship and the new order
of neoliberalism? In a neoliberal economy, Kim Jin-Suk's form of protest embodies
the quixotic heroism of "follying," the architectural noun verbed into a perfor-
mance: a last stand against the forces of oppression, but also a renewal of the
civic imagination as it tries to emancipate itself from its official surrogate.

When you walk through Gwangju, remember there is a third who walks with you.
Did you say the air is thick with ghosts?

[1] As co-artistic director of the Ninth Gwangju
Biennale, 2012, I conceived the discursive event
Workstation 1, where cultural theorist Taek
Gwang Lee analysed the Hope Bus campaign
which dynamized the contemporary Korean
public sphere. See Nancy Adajania, "Logging In
and Out of Collectivity," in *ROUNDTABLE:
Gwangju Biennale, 2012* (Gwangju, 2012), pp.
18–33.
[2] The genesis of the Gwangju Biennale lies in
the May 18, 1980 Uprising.
[3] See Jeong Ho-gi, "The History and the
Changes in Placeness of a Military Space: Sang-
mu Sindosim" in *Project 3-Stay of Execution:
Gwangju Biennale 2002-P_A_U_S_E* (Gwangju,
2002), pp.42–53. Conceived by artistic director
Wan-kyung Sung, the exhibition *Stay of Execu-*

tion took place at the May 18 Liberty Park with
site-specific works installed in the Court House,
the Main Office of the Military Police, the Watch
Tower and so forth. Intended as a probe into the
Uprising and its re-enactment through the act
of memorializing, it exposed the effects of a
sanitized history in everyday life.
[4] This applies to ninety-three of the ninety-four
employees, one of them being already of retire-
ment age. However, the contract between em-
ployer and employee is weighted against the
former. HHIC re-evaluated the damages, chang-
ing the figures from 5 billion won to 15.8 billion
won, blaming the increase on the strike, yet an-
other tactic aimed at destroying the workers'
union.

Roundabout Revolution

Eyal Weizman with Samaneh Moafi

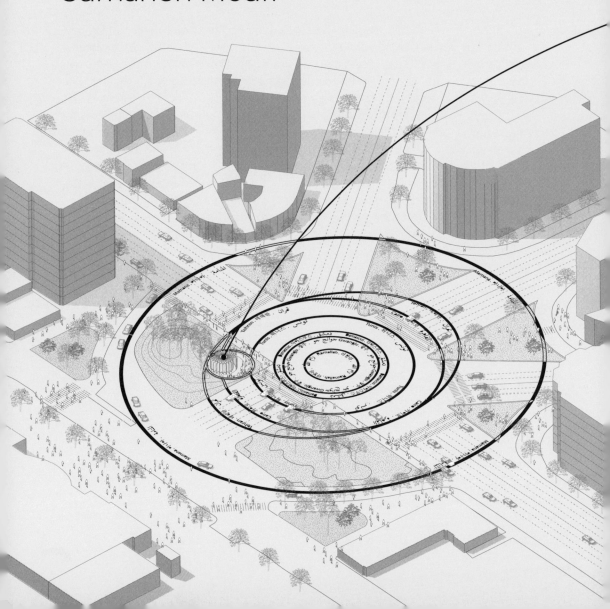

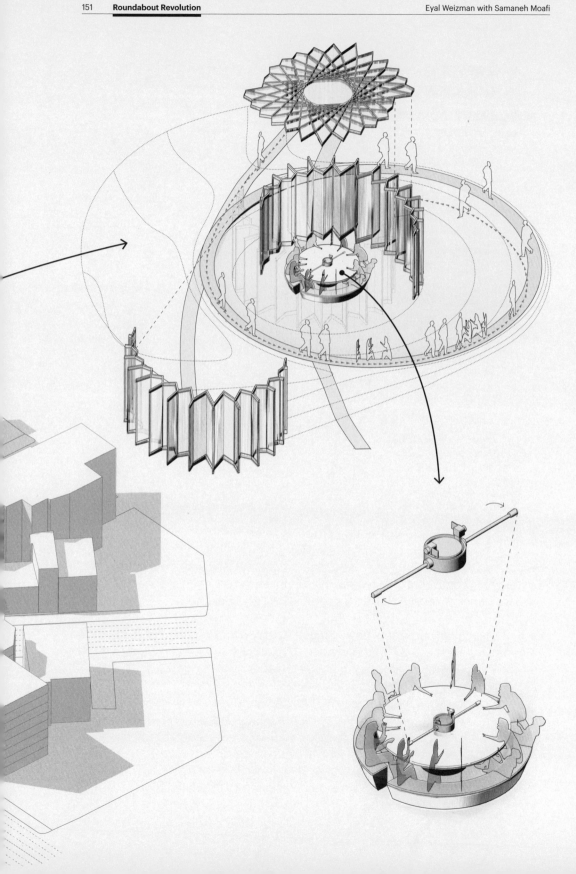

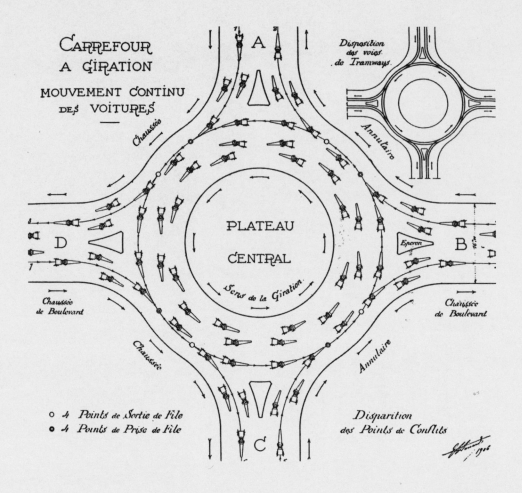

It is through the political power of the roundabout that we seek to establish a relation between the events of May 1980 in Gwangju and the recent political protests and revolutions that have shaken the Middle East and beyond.

Each of these political events has a unique history and a complex actuality. The outcomes of each are still in the making. (Asked about the significance of the French Revolution, Mao famously said that it was too early to know…)

One of their common features is not political but rather architectural: many of these events erupted around inner-city roundabouts. These roundabouts—many of them now the symbols of their respective revolutions—stood at the center of complex political vortices through which history passed.

Therein lies a cruel paradox: an apparatus designed to regulate urban order has become the loci for its undoing.

Developed from the Roman circus (the site sometimes used as a venue for chariot races), the modern roundabout emerged at the start of the twentieth century together with two other inventions: motorized traffic and the moving image (film). To a certain extent, the roundabout combines these two principles in producing a contemporary forum.

Roundabouts are the twentieth-century solution to the problem posed by the straight boulevards that cut through the fabric of the nineteenth-century city: when cars started moving along these routes, it was necessary to control the flow arriving from different trajectories without stopping it or slowing it too far down.

Roundabouts were conceived as a demonstration of the era's optimistic faith in "self-regulation," when the principles of self-regulation became prominent in political theory and the economics of liberalism. Its promise unfulfilled, like that of deregulated capitalism, was to optimize traffic with minimum top-down intervention. What it did manage to achieve, however, is a circular movement that resequences the perception of the urban scene. It is no coincidence that the roundabout at Piccadilly Circus is also the site of what used to have been the largest illuminated commercial billboard in the world. Herein lies the power of the roundabout: it is both a physical and a cinematic apparatus.

The traffic circle in Tahrir Square was built in 1919 in the context of Khedive Ismail's lavish plan to create a "Paris on the Nile." Soon thereafter, it became the feature of every plan that endeavored to discipline the oriental city—with fast boulevards cutting diagonals through urban fabric across North Africa and the Middle East. But it is also in this context that it has become a representative space. Monuments to the regime are widely visible here but certainly beyond the access of the governed.

Usually, the islands within roundabouts are inaccessible, circumscribed by an invisible city border, "a wall of speed." Highly visible, however, they are not only used to display the monuments of a regime, but also, increasingly, corporate advertisements.

When taken over by crowds of people, the meaning of these monuments is detoured. This transition demonstrates the difference between a *public space*—which is always mediated by a regime—and a *commons*—which is an immanent form of collectivity. This is also the reason why the roundabout revolutions differ from the protests that take place in urban squares. The urban square is designed as a site of gathering. The roundabout, however, must be occupied—and to do so generates blockage.

The paradox returns: the urban apparatus intended to discipline the chaotic flow through these otherwise serpentine and dense oriental cities has provided the nodes for their undoing. Every public space within the center of a roundabout is a *commons in potentia*, waiting to erupt.

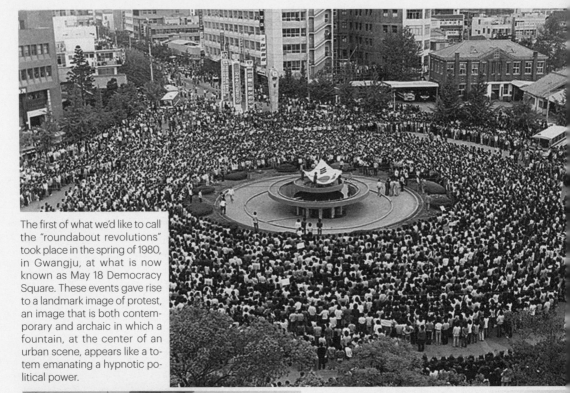

The first of what we'd like to call the "roundabout revolutions" took place in the spring of 1980, in Gwangju, at what is now known as May 18 Democracy Square. These events gave rise to a landmark image of protest, an image that is both contemporary and archaic in which a fountain, at the center of an urban scene, appears like a totem emanating a hypnotic political power.

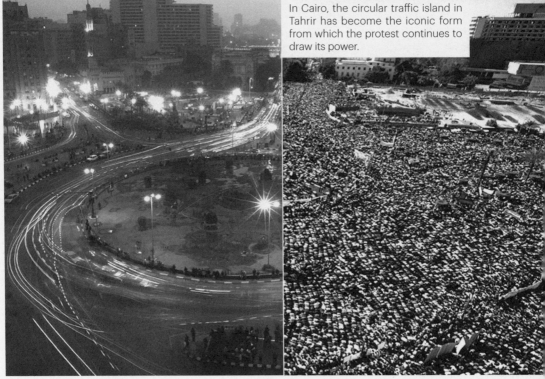

In Cairo, the circular traffic island in Tahrir has become the iconic form from which the protest continues to draw its power.

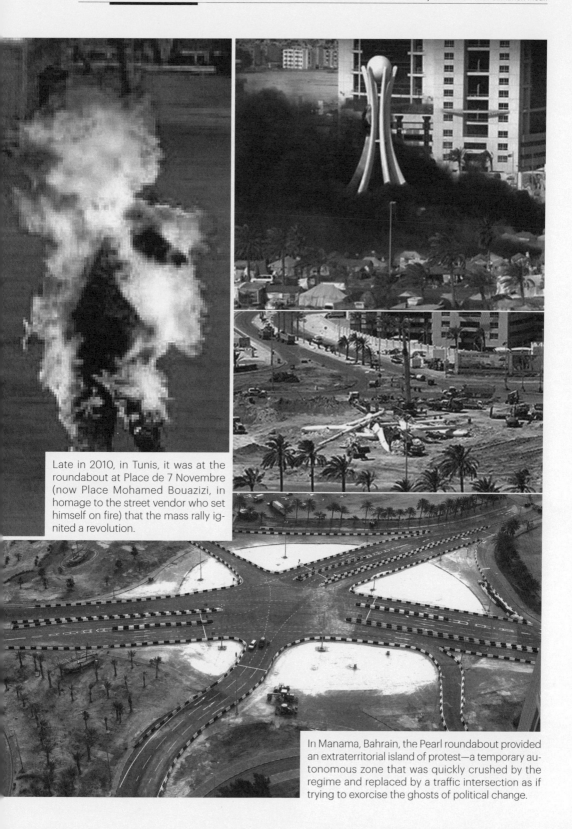

Late in 2010, in Tunis, it was at the roundabout at Place de 7 Novembre (now Place Mohamed Bouazizi, in homage to the street vendor who set himself on fire) that the mass rally ignited a revolution.

In Manama, Bahrain, the Pearl roundabout provided an extraterritorial island of protest—a temporary autonomous zone that was quickly crushed by the regime and replaced by a traffic intersection as if trying to exorcise the ghosts of political change.

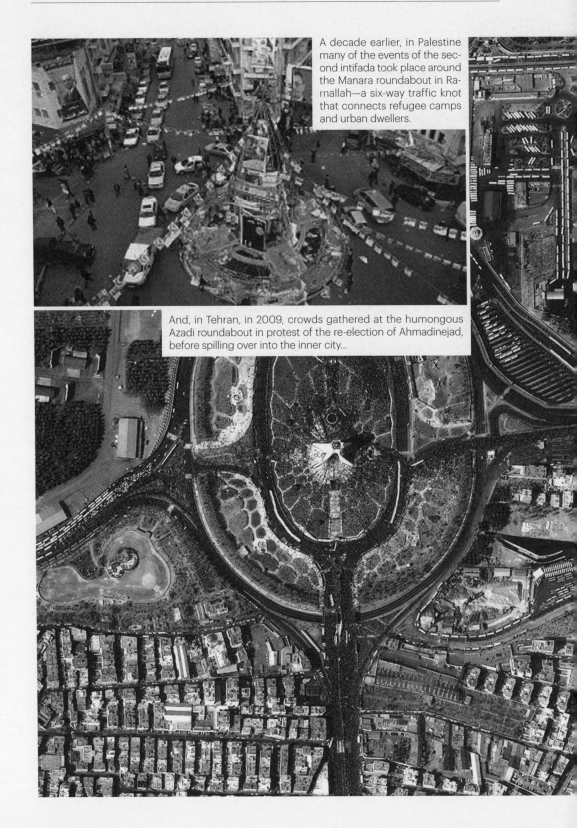

A decade earlier, in Palestine many of the events of the second intifada took place around the Manara roundabout in Ramallah—a six-way traffic knot that connects refugee camps and urban dwellers.

And, in Tehran, in 2009, crowds gathered at the humongous Azadi roundabout in protest of the re-election of Ahmadinejad, before spilling over into the inner city...

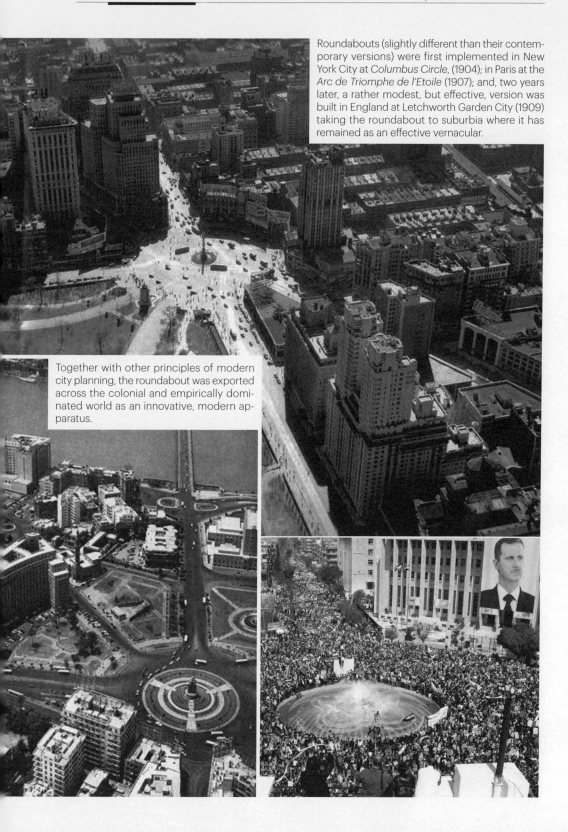

Roundabouts (slightly different than their contemporary versions) were first implemented in New York City at *Columbus Circle*, (1904); in Paris at the *Arc de Triomphe de l'Etoile* (1907); and, two years later, a rather modest, but effective, version was built in England at Letchworth Garden City (1909) taking the roundabout to suburbia where it has remained as an effective vernacular.

Together with other principles of modern city planning, the roundabout was exported across the colonial and empirically dominated world as an innovative, modern apparatus.

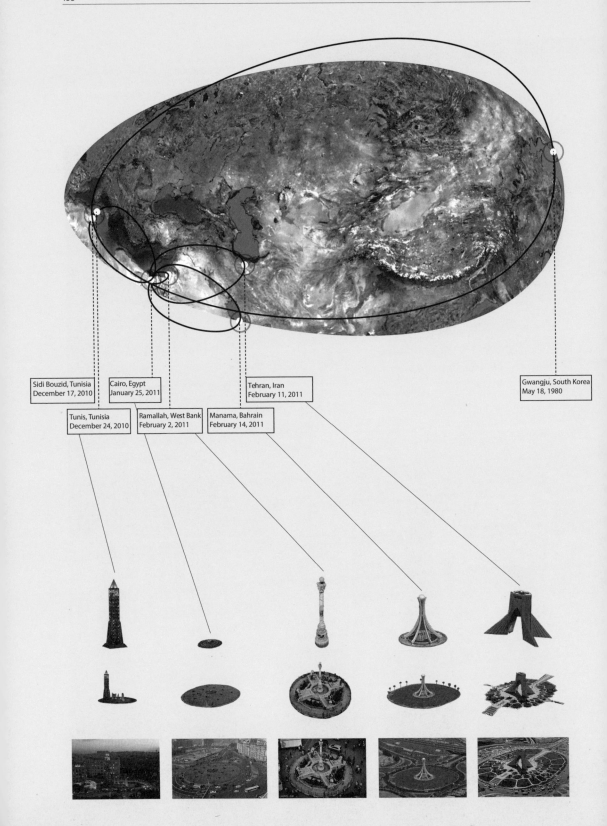

Sidi Bouzid, Tunisia
December 17, 2010

Tunis, Tunisia
December 24, 2010

Cairo, Egypt
January 25, 2011

Ramallah, West Bank
February 2, 2011

Manama, Bahrain
February 14, 2011

Tehran, Iran
February 11, 2011

Gwangju, South Korea
May 18, 1980

In the morning after revolutions, hard decisions must be made, and public action must be superseded by claims for power.

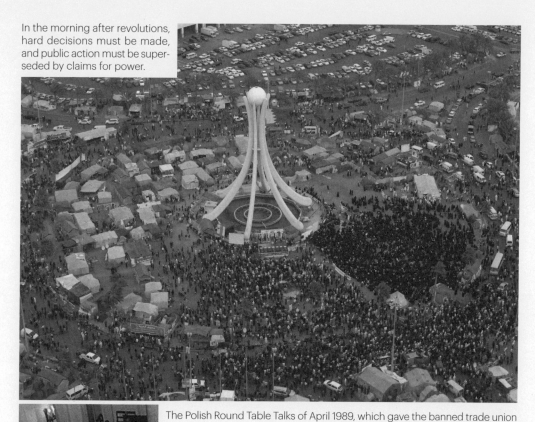

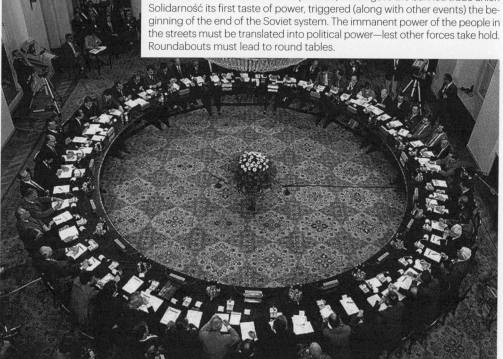

The Polish Round Table Talks of April 1989, which gave the banned trade union Solidarność its first taste of power, triggered (along with other events) the beginning of the end of the Soviet system. The immanent power of the people in the streets must be translated into political power—lest other forces take hold. Roundabouts must lead to round tables.

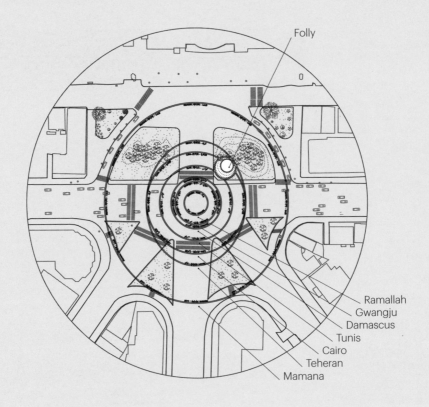

Folly

Ramallah
Gwangju
Damascus
Tunis
Cairo
Teheran
Mamana

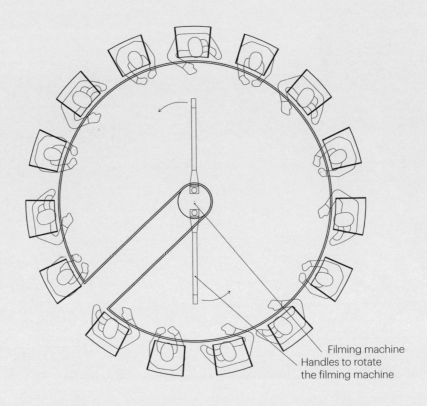

Filming machine
Handles to rotate
the filming machine

We located the pavilion on a traffic island within the traffic circle in front of the Gwangju Central Station. In the spring of 1980, this was one of the sites where the protests first gathered.

We have drawn a series circles over the site marking the exact size of the roundabouts in other places: Ramallah, Cairo, Manama, Tehran, and Tunis. On the roadways, we have drawn the circles in black. On the traffic islands, we have carved out the outlines of these roundabouts as paths. The name and place of each roundabout, and the date for the beginning of revolutionary events is to be labeled in Korean, English, and Farsi.

The folly itself has been organized around a round table. The table is bottom lit and is made of "white board" material—the kind of plexiglass on which one can easily draw and erase. At the center of the round table there is a rotating device on which two cameras are affixed. Long handles allow the participants to turn the cameras around as the conversation evolves. Participants in the discussion can attach their own cameras onto the device. This turns the pavilion into a recording studio or a place to stage a press conference.

The envelope of the pavilion is made of dozens of rotating doors cladded with mirrors facing the inside. When the lights are on, the mirrors pointing at each other create an endless reflection—multiplying the image of the participants into an infinite crowd, somewhat referring to the iconic image of the May 18 events.

For the opening, we invited activists from each of the revolutionary hotspots for a round-table summit. This session has been recorded to inaugurate the website, which also hosts film we produced about the "roundabout revolutions." Additionally, streaming and recordings of the events that take place around the Gwangju round table are uploaded to create an archive.

Staircase for Scarface

Bernard Tschumi

Broadway Follies

I initiated the *Twentieth-Century Follies* series in 1979 in New York with a construction in the open courtyard of Castle Clinton near Wall Street. Entitled *A Staircase for Scarface,* it was the first in a set of ephemeral constructions whose role was that of a critical laboratory for architecture. The word "follies" was meant to be ironical, playing with the concepts of uselessness and excess generally associated with the built meaning and with its other, primarily French definition meaning madness (*la folie*). Under no circumstances were these *Twentieth-Century Follies* meant to be the support of an historicist or private commentary. On the contrary, they were immediate and contemporary, a public place of experiment where theoretical issues, incompletely explored in texts and drawings, could be tested with real materials, real spaces, and real actors. Like *The Manhattan Transcripts,*[1] the *Twentieth-Century Follies* were aimed at exploring the inevitable disjunction between form and use, space and event.

Other follies were built in London, England, and Middleburg, Holland, and projects were made for Kassel, Germany, and Toronto, Canada. However, most were built in New York City:

Bernard Tschumi in front of his Staircase for Scarface folly in New York City, 1979

at the corner of Forty-seventh Street and Second Avenue, life-size figures (a film from Amos Poe) occasionally were projected on a large shroud veiling its frame; at Wave Hill, construction took the form of a gate intersected by a ramp project-ing red flags. All the objects were built of black painted plywood, steel profiles, or sheet metal, generally on very low budgets. In 1983, I won the international com-petition for a 125-acre twenty-first-century urban park in La Villette in Paris, which is to be a second generation of over thirty of these architectural and social labo-ratories. This time they will be made of permanent materials and are to be struc-tures in the master plan of this future *Parc des Folies*.

All *Twentieth-Century Follies* systematically explore spatial organizations or related objects and seek new forms of urbanism. Five basic relationships have been tested:

- Single object: a finite object whose rules of transformation are specific and internal to that object, a form of freeze-frame, an arrested moment of archi-tecture with the event that occurs within it.
- Pair of objects: the pairing-up according to the rules of reciprocity, conflict, or indifference; for example, Middleburg's set of ordered architectural ele-ments (columns, stairs, gables, etc.) matched against a similar set, in disorder.
- Linear sequence of objects ("The Broadway Follies"): a transformational se-quence coupled with an actual sequence of spaces. This sequence is planned to be located along Broadway at intersections from the Custom House to the Bronx. The initial element is the absolute cube, which is then ruptured, conflicting with stairs, walls, columns, windows, or elements spe-cific to architecture. Devices not unlike those found in the early days of film—repetition, distortion, superimposition, and fading—are used. These devices allow for formal contradictions and functional paradoxes. They suggest new relations between body and language.
- Randomly scattered objects: based on an aerial photograph of the Kassel Town Hall, showing the deconstruction of the photographed walls and roofs and their recomposition in different relations and geometries. These are placed at random throughout the city in an indifferent and interchangeable manner.
- Objects on a point grid (La Villette): a transformational sequence moving from representation to abstraction, with exceptions inserted according to pro-grammatic or symbolic requirements.

In madness equilibrium is established, but it masks that equilibrium beneath the cloud of illusion, beneath feigned disorder; the rigor of the architecture is con-cealed beneath the cunning arrangement of these disordered violences.[2]

[1] Bernard Tschumi, *The Manhattan Transcripts: Theoretical Projects*, (New York and London, 1981).

[2] Michel Foucault, *Madness and Civilization: A History of Insanity in the Age of Reason*, (London, 1967).

Sugar Loaf

Barbara
Jones

Mad Jack
Fuller's Follies

The atmosphere of the follies is beyond dispute, but, alas, also beyond analysis. At Barwick the unfamiliar shapes of the follies seem responsible, but Mad Jack Fuller's follies in Sussex immediately confound so simple an answer. True, he had no grotto, but he had a cone, a pyramid tomb, an obelisk, and a hermit's tower, as well as such more normal adornments to an estate as an observatory, and a rotunda, and yet it is all jolly, one cheerful piece of nonsense after another, quite without alarm. The cone is called the Sugar Loaf: one night after dinner John

Mad Jack Fuller's faked church spire, England.
© Barbara Jones, 1974

Fuller said that the spire of Dallington church could be seen from his dining-room. Next morning in daylight, he saw that he was wrong, and also that it was something easily set right. Dallington has rather a cobby steeple, and Fuller copied it with a cobby cone just behind the skyline from the dining-room window. It is very friendly and pleasant, solitary in a field, about forty feet high...

A folly for the cows of Barwick Park, England.
© Barbara Jones, 1974

Transfer

Erik
Göngrich

Urban Planning Concerns Us All! calls on us to engage with urban issues. It even sounds like an order commanding us all to become co-authors of city planning, resounding with the futuristic optimism of Germany's 1960s economic boom. It was a time in which it was enough to put up a vitrine in order to inform citizens

Budapester Straße, Berlin
Photo credit: Landesarchiv Berlin
Photo: Horst Siegmann, 1956

about changes in their city. And so it was that the future of West Berlin could be seen in vitrines in front of the Zoo Palace cinema and across the street from the Café Kranzler.

Respectfully, inhabitants stood in front of this white city model as if waiting for Snow White to wake up. I found one of these vitrines, but search, still, for the other.

At the end of the 1950s, one of the vitrines was placed in front of the Tiergarten Town Hall, which I put to use for an exhibition called "Urban Sculpture Concerns

Urban Sculpture Concerns Us All! Exhibition in the vitrine in front of the Tiergarten Town Hall in Moabit, Berlin.
Photo: Erik Göngrich, 2009

Us All!" (Kunstverein Tiergarten, 2009). I placed several posters into this vitrine as part of a campaign to demolish the Town Hall building, which was constructed by the National Socialists in 1935/36 as an elephantine, fascist administrative structure that also included a balcony for the Führer.

It occupies a prominent site in front of the market hall and was designed to end the political activities of this "red" city district. Thus: Free the Arminius Platz—Let's finally tear that Town Hall down!

Trespassing

Cultural Agencies

On September 29, 2010, the Gülsuyu-Gülensu Dükkanı closed after almost twenty months of intense activities during which the former garage and then shop was turned into a micro art institution. In twenty-five square meters, no bigger than a tiny two-car garage, the full spectrum of an institutional model was implemented: exhibitions, an archive, administration, a library, and events. The space acquired a new interior which was used as a stage and seating for presentations and discussions between residents and guests. A new front terrace was poured to raise the pavement and provide additional space for the crowded interior, which was happily appropriated as a market stall during the weekly market day. The pitched roof now houses a clock made from a recycled satellite dish.[1] The planned additions

were collaborative efforts responding to the evolving needs of project activities, negotiating between artists as external authors and local residents. Users of the Dükkanı (Turkish for "store"), local children, and passersby became co-producers by adding their own additions such as a poem, some drawings, and furniture. This condition of "open production" transcended the problematic relationship pattern between "external experts" and locals who

Cultural Agencies, axonometric drawing, 2009

were assigned the role of informants. The Dükkanı became a laboratory between organic and structural, between informal and formal practices, which underline the ambivalence between agency and institution.

The project also stepped across established lines, which had eyed cultural work outside the cultural bubble of Istanbul, up until then, with suspicion. At times, mainly external observers felt the need to assume hidden agendas: is the project spearheading gentrification, perhaps even gathering data on local residents? Are sources of funding being hidden?

Trespassing, the active violation of established and all-too-comfortable boundaries—be it social, cultural, political, or artistic—remained at the heart of the project: this applies to Istanbul's cultural bubble as much as to the fortress Gülsuyu-Gülensu as seen by some of the most radical local political activists. By deliberately introducing the contested typology of a "neutral cultural space" the project became more than a comment on institutional critique. It created a space in which new, hitherto unlikely collaborations became possible, a space of negotiation in which persistent questions assumed certainties of artistic practice, and residents' views on cultural projects and urban transformation or the "good and bad" divisions of local political activists became the defining parameters of the project itself. The laboratory of the Dükkanı neither set out to deliver certainties nor certain services. It remained a more uncomfortable arena claiming an autonomy that resists the temptation to fall under the "protection" of local fractions or the agenda of outsiders.

Cultural Agencies, Istanbul, 2010

Cultural Agencies is a project by Nikolaus Hirsch, Philipp Misselwitz, and Oda Projesi (Özge Açıkkol, Güneş Savaş, Seçil Yersel).
[1] As of May 2009, the artist residencies supported by SALT Istanbul, Allianz Kulturstiftung and Rhyzom led to a series of physical interventions realized with local residents. Artists involved included: Etcetera, Burak Delier, YNKB, Giorgio Giusti, Oliver Heizenberger, Danny Kerschen, Martin Kirchner, Shane Munro, Kirsten Reibold, among others.

Typofolly

Sunah Choi & Markus Weisbeck

Equalization of Typeface

Font characters are graphical illustrations. The respective characteristics of their form hold a specific meaning and therefore a potential function in the context of each languages individual phoneme inventory. In the Latin alphabet, words are formed linearly. In the Korean alphabet Hangul, single consonants and vowels are combined horizontally and vertically in a logographical form of imaginative squares. In both language systems these graphemes as modules depict the language of the written word.

The word "Folly" consists of five letters arranged in a horizontal line. In the adopted Korean pronunciation of these two syllables, "폴리" sounds similar to "Polly." As

the Korean language doesn't have a consonant that exactly corresponds to the Latin "F," a Korean consonant is selected, which sounds more like a "P." In this case an exact transference of the English is impossible and it becomes obvious that this detour is an agreement, within a framework, that allows conventions of language to be practiced. In both systems the arrangement and therefore the sequence of the prescribed reading play a crucial role in the understanding of the word.

The known difficulty in juxtaposing two languages is the tendency to create systems of power. In the visual composition of the book cover neither alphabet should take priority. Beyond the line weight, the form of the typographical character should be visually well balanced to construct a hybrid of two languages. To confront this, we decided to design two separate catalogues for the Gwangju Folly II, one in English and the other in Korean. The content is the same in each, however, it results in two differently constructed books, as each follows the alphabetical order of the Folly lexicon in its corresponding language.

All the while, the key visual of the Gwangju Folly II confronts the matter of democratizing the typeface via this diversion through architecture. The key visual looks for its reference not in the western or Korean typographic system. As typographical folly,

it refers to the wooden lattice windows and doors of traditional Korean Hanok Houses. Based on geometrical ornament, these lattices in the Asian architectural tradition regulate incoming light and air using refined methods. Additionally the logograms are partly derived from Chinese characters, alluding to an additional but related design element: typographical characters from a further language. Such design is less useful for distinct and fast readability, but rather for the delay of their individual decryption. This corresponds to the intentional indistinctness fundamental to the idea of architectural follies; their ambiguous function and architectural form.

Unreason

Shumon
Basar

I'm Building
a Folly
for Michel
Foucault

I'm building a folly for Michel Foucault, there. You don't know it's for you. You are not alive, but neither are you dead. I'm building a folly, *pour toi*.

I'm building a folly for Michel Foucault. But first I have to archeology the word. "Folly." Do I choose Old French—"folie"—or Middle English—"folie"? Madness. Madness. The madness of the word, which, it is said, has an older incarnation: "delight" and "favorite abode."

I'm building a folly for Michel Foucault. Specifically your book, *Histoire de la folie*, which entered the world the year Adolf Eichmann went on trial, Yuri Gagarin into space, and Joseph Stalin was moved from Lenin's mausoleum, after Lenin spoke from the dead, from his own mausoleum-folly, in a dream to Dora Abramovna Lazurkina. No one said she was mad. It was 1961.

I'm building a folly for Michel Foucault. You said, "Madness exists only in society. It does not exist outside the forms of sensibility that isolate it, and the forms of repulsion that expel it or capture it."

I'm building a folly for Michel Foucault. You spoke of the "sovereign enterprise of unreason." You described the confinement of *la folie*—madness—in asylums, and that even in the liberation of madness, it would lead to further confinement, ending with the figure of the psychiatrist, whose practice is "a certain moral tactic contemporary with the end of the eighteenth century, preserved in the rites of the asylum life, and overlaid by the myths of positivism."

I'm building a folly for Michel Foucault. A building without function. A sovereign enterprise of unreason.

I'm building a folly for Michel Foucault. In the future, some may claim that *la folie*—the madness—is in me, the builder. Others will accuse the specific moment in time of this delirium. The truth, as you know, is exactly halfway between words and things.

I'm building a folly for Michel Foucault. I take the risk it will be a misunderstood structure. This misunderstanding will be the hearth and heart of the folly. Madness and civilization. We identify with civilization's discontents. Don't we?

I'm building a folly for Michel Foucault. Borrowing forms from Roman temples, ruined Gothic abbeys, Egyptian pyramids. Because history itself suffered from its own *folie*: not knowing what time is—even though history is compelled to tell the story of time. History is, despite its malady of chrono-madness. Despite the pervasions of sanity.

I'm building a folly for Michel Foucault, here.

Vote

Rem Koolhaas &
Ingo Niermann

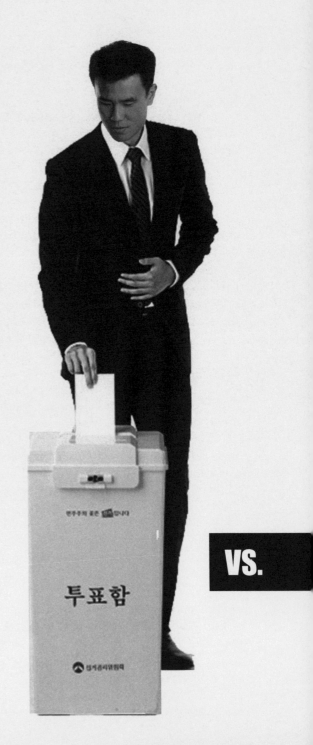

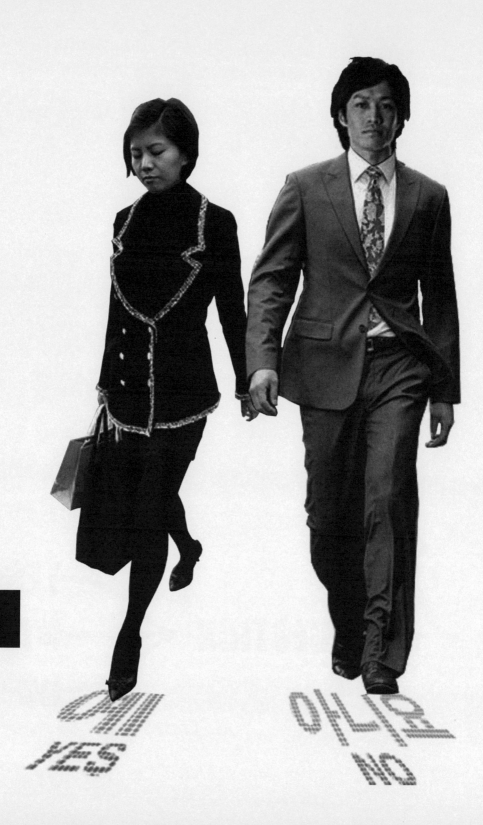

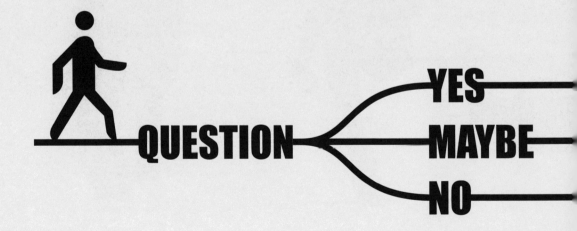

ONLINE ARCHIVE

ANSWER

ON SITE ARCHIVE

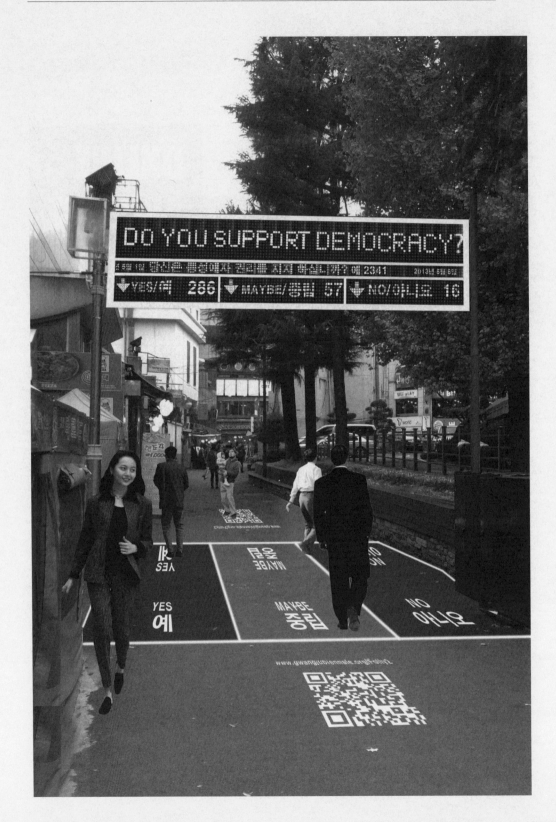

When democracy began taking shape in Athens some 2500 years ago, its citizens were asked to gather once a month to openly vote on laws and decrees, elect officials, and try political crimes. Since then, democracy has become more and more diluted. Bigger states with even greater populations made it all but impossible for all citizens to gather at one place at a time. Even in Athens, the direct vote was only viable as no more than ten to fifteen per cent of the population counted as citizens (women, children, slaves, criminals, and foreigners were excluded). Hereupon, representative democracy was introduced in which every few years citizens would elect a manageable number of representatives. The liberal

democracy, familiar to us since the eighteenth century, is even more diluted. In a process of further specialization, it expects politicians not only to be professionals but also to submit themselves more or less to the mandates of a political party.

Liberal democracy defeated monarchy worldwide in less than a hundred and fifty years, and its next big threat—totalitarism—was pretty much extinct in another seventy years. Still, liberal democracy doesn't appear to be the big winner, but rather to be slowly deteriorating. On the one hand, autocratic regimes have gained enough expertise and pragmatism to rule countries like companies—expanding capitalism beyond a liberal setting. On the other hand, supranational institutions have gained in power, and even when most countries are now considered democracies—as are all of the member states of the European Union—the people's vote is for the most part merely symbolic. After having been and still being indoctrinated with nationalism by almost all political parties, the people are mistrusted by exactly those parties for their inability to grasp the long-term necessities that go along with globalization. Likewise, the people regard politicians as elitist, manipulative, and corrupt. Society has become more complex than simple ideological dictates can encompass, and people find their opinions less and less congruent with any one single party.

Modern telecommunication could enable all citizens to participate in political debates and to vote with short notice on an unlimited number of questions. To not overburden them, decisions about questions of minor interest could be restricted to a randomly selected group of people (like jurors at court) or each citizen could only be allowed to vote a limited number of times per year (as recently proposed by Martti Kalliala, Jenna Sutela, and Tuomas Toivonen[1]). Instead, plebiscites are often limited to elementary constitutional questions and need to be initiated with a petition that is signed by a large number of citizens. The plebiscite is regarded as a last resort in saving rather than an actual exercise in democracy.

As it stands now, the only thing ordinary people can do to directly influence politics in between elections is to hold a demonstration where the secret ballot is foregone, and instead one is left to vouch for their opinion in public. Each demonstration has to be individually promoted so that it is never just about a specific topic but about sympathy with its organizers. Banners have to be painted, trucks rented, loudspeakers installed. Then all participants have to gather at a specific place at a specific time—no matter if it's hot, freezing cold or raining. No matter how many people turn up, all that really matters is the media coverage. If the demonstration doesn't make it into the evening news, it is as if it never happened.

The Occupy movement has tried to overcome these obstacles by installing a permanent demonstration that avoided representing specific interests. Its newness yielded extensive coverage by the media, but after a couple of weeks or months most participants lost interest in endless public discussions and the movement disappeared—at least from the streets and the news.

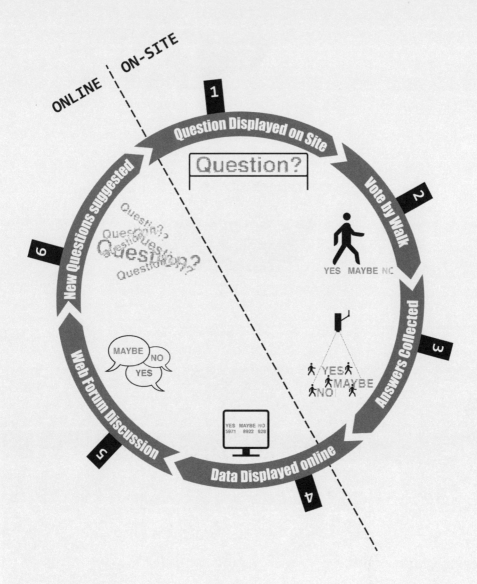

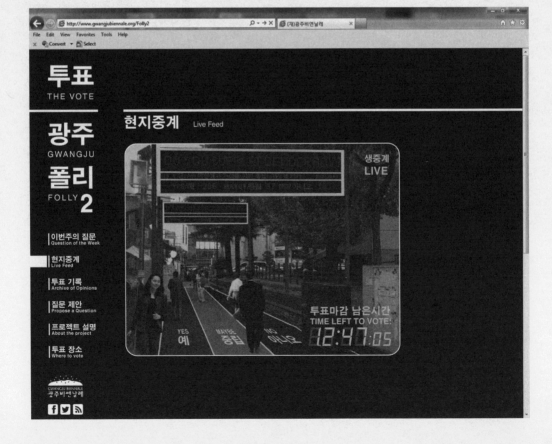

What is missing is a new mode of demonstrating that is both easy-going and last-ing. Something that can be done as quickly and casually as a virtual "I like" but still works as a distinctive physical gesture in the real public space. You are going somewhere and along the way you choose one of several passages to express approval, disapproval or indifference to a specific question. As with the division of the assembly you don't have to raise a hand or push a button, but to spatially separate.

Just like streaming a TV program or a movie online, it is no longer necessary to attend demonstrations at a specific time. Demonstrations can go on for days, weeks, months, and though they may lose visual size, they can take on new spec-tacular phenomena. The participants are no longer lost in the crowd but instead expose themselves, one after another, and can use their moment of decision as an individual performance. Traditional demonstrations can be transformed into telegenic endless queues in front of the yes, no, or maybe passages.

Each person stepping or rolling through this device we call simply the "Vote" is counted electronically so that the typical disputes about the actual number of participants are eliminated. The results of the issues are archived online to satisfy an ever-growing demand for quantification and ranking. This growing demand is often interpreted as the result of a progressive commodification. Placing a num-ber on something is only a short step away from pricing it. But democracy is about counting too, and it is no coincidence that standardized coins were invented around the same time.

As basic counting technology makes no distinction between voters, you would have the chance to vote several times on the same question. You might even go back and forth endlessly, for days or months on end, assembling thousands of votes. Social monitoring would admonish or even applaud you for such an extraor-dinary engagement. The Vote thus becomes a model study in grassroots democ-racy, or at least a playful experiment. How to deal with this new public tool has yet to be developed and might vary extremely from place to place.

In Gwangju, the Vote is positioned in the middle of a busy shopping and entertain-ment district that is mainly frequented by teenagers. A narrow street is divided into three pedestrian lanes marked "Yes," "No," and "Maybe." A delegation of the Gwangju Youth Center has been commissioned to detect the most urgent issues teenagers and other citizens of Gwangju should vote on in the midst of streets lined with clothing shops, tarot reading stalls, Karaoke bars, and cafés. Previously existing street furniture invites these "walk-through" voters to relax, contemplate, and discuss.

[1] Martti Kalliala with Jenna Sutela and Tuomas Toivonen, "The Vote Economy," in *Solution 239-* *246—Finland: The Welfare Game*, ed. Ingo Nier-mann (Berlin, 2011), p. 45–48.

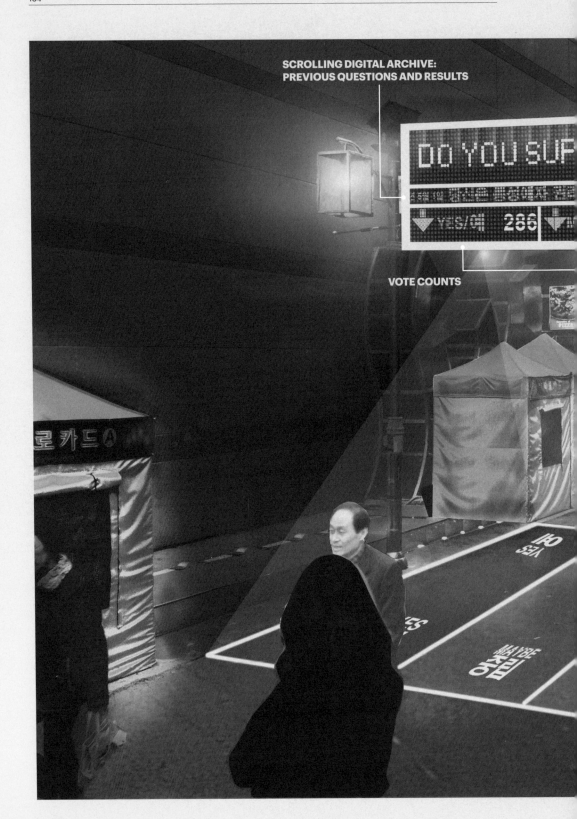

SCROLLING DIGITAL ARCHIVE:
PREVIOUS QUESTIONS AND RESULTS

VOTE COUNTS

QUESTION OF THE WEEK

Watershed

Mike Bouchet

This is a full-scale, two-story contemporary American house in Venice, Italy. Flush with the sea surface, this empty house floats on water. Its vinyl-siding exterior, asphalt shingle roof, traditional windows, white interior walls, nighttime lights, and two-car garage door are no different than what you would find in a suburb. Contrasting sharply with the historic Venetian surroundings, the house takes on the appearance of a mirage: American suburbia in the midst of medieval Venice, the water effectively functioning as a pedestal for a house.

The suburban home has been a subject of heated discussion for the last forty years in academia. This almost universal object of desire, it would seem, hides a host of issues. On one hand, this house is the very real embodiment of the dream of autonomy, security, expansion, privacy, family, and, above all, equity. On the other hand, it represents environmental destruction, willful ignorance, isolationism, bizarre modern cowboy fantasies, failed communities, and, more recently, the basis of the largest financial crisis in modern history.

Formally, the distinction between a typical suburban house and a film set is next to nothing. The structure itself is identical. Considering the development of architecture in the last one hundred years, not only in design, but also materials, the typical US suburban home is basically a conservative, cheaply built wood structure, with a thin plastic coating. The general typology of this "western ranch house" has not changed much in 150 years. The main difference now is that this particular design probably reflects better the increased interest in indoor activities—such as watching TV—than those that take place outside—like playing in the yard.

Mike Bouchet's *Watershed* at the Venice Biennale.
© Mike Bouchet, 2009

One doesn't just visit the sea; one visits an image of the sea. The house subverts the exclusivity and "escape" that waterfront property represents. The concept of "urban sprawl" is in reality "suburban sprawl." Where will it end? The coastline or the planet? With the first glance out of the living room window, one can visualize the sea view from the Cote d'Azur or Malibu—or further houses, even a flotilla of homes in the middle of Venice, of a new type of suburban sprawl, complete with floating supermarkets, tanning salons, and kindergartens. The notion of the aquatic suburb reorders the mental aerial view of our coastlines and population density maps. With global warming and its impact on sea levels, this artwork also reminds us of the dream the suburban house, how it remains a stronghold between the realities of natural catastrophe and the perverted ingenuity of housing developers.

As an American, having grown up in and around suburban homes and sprawl, my interest is in not just sparking this strangely politicized object through re-contextualization. But rather by placing the house in such a highly unlikely scenario (on water, and in one of the most famous historic sites in the world) I want to simply reveal how visually and culturally unsettling this commonly recognized object is.

Press Release

Beautiful, newly built, custom estate home on large secluded lagoon. Very private setting. This 3+ den, double-garage home has 240 square meters of living area. Located in the harbor of the Darsena Grande of Venice, Italy. Close to shopping and the Arsenale. Very secure area. Features all-weather vinyl siding, four-meter-high columns on a stately porch. Thirty-year asphalt roof shingles. This charming two-floor home, with 360-degree sea views, includes French doors, decorative front window details, and a cultured stone base. Includes exterior molding and solar outdoor lighting. Slight water damage.
Viewing is essential. Please call for further details, +491636958871.

Contributor Biographies

Nancy Adajania is a Bombay-based cultural theorist and independent curator. She was co-artistic director of the 9th Gwangju Biennale, 2012.

David Adjaye is an architect and the founder and principal of London- and New York-based Adjaye Associates.

Ai Weiwei is an artist, curator, architectural designer, cultural commentator, and political activist based in Beijing, China.

Can Altay is an artist living in Istanbul and teaches at Istanbul Bilgi University Faculty of Architecture, and is founding editor of *Ahali: a journal for setting a setting*.

Shumon Basar is a writer.

Franco "Bifo" Berardi is a writer and media-activist based in Bologna, Italy.

Barry Bergdoll is Professor of Architectural History in the Department of Art History and Archaeology at Columbia University and the Philip Johnson Chief Curator of Architecture and Design at the Museum of Modern Art in New York City.

Mike Bouchet is an American, Frankfurt-based artist who produces objects, paintings, videos, and installations. His work *Watershed* was shown at the Venice Biennale in 2009.

Horst Bredekamp is Professor for Art History at the Humboldt University and Permanent Fellow of the Institute for Advanced Study, Berlin.

Peter Carl teaches Diploma Design and runs the PhD Programme in Architecture at the Sir John Cass Faculty of Art, Architecture, and Design, London Metropolitan University.

Caruso St John, Adam Caruso and Peter St John, are architects based in London and Zurich. They have been collaborating with Thomas Demand since 2000.

Eui Young Chun, curator of Gwangju Folly II, is a professor of Graduate School of Architecture at Kyonggi University, and director of Seoul Design Olympiad 2009.

Minsuk Cho is a Seoul-based architect and the founder and principal of Mass Studies. He was also a curator for the 4th Gwangju Design Biennale, 2011.

Sunah Choi is an artist based in Berlin.

Thomas Demand is an artist who lives in Berlin and Los Angeles.

Joan Didion is an American novelist and essayist who lives in Sacramento, California.

Etcetera is a collective founded by Loreto Garin Guzman, and Federico Zukerfeld in Buenos Aires who work across multiple categories including poetry, theater, and visual art.

Seok-hong Go and **Mihee Kim** are based in Seoul and won the Gwangju Folly II competition for emerging Korean architects.

Erik Göngrich is a Berlin-based artist who is interested in a rough, direct, spontaneous, drawn, architectural, colourful, subjective, documentary, and sculptural production that activates the public.

Nikolaus Hirsch, Director of Gwangju Folly II, is an architect, curator, and the Director of the Städelschule and Portikus Kunsthalle in Frankfurt.

Hans Hollein is an architect, urban planner, designer, and artist who lives in Vienna.

Hu Fang is a fiction writer, art critic, and curator. He is the co-founder and artistic director of Vitamin Creative Space in Guangzhou and the Pavilion in Beijing.

Sam Jacob is a director of FAT Architecture, professor of Architecture at UIC and Director of Night School at the Architectural Association in London.

Barbara Jones (1912–1978) penned a pioneering survey of the unexpected and picturesque grottoes, hermitages, labyrinths, and follies of England in 1953. She was also an artist and mural painter.

Rem Koolhaas is an architect and the founding partner of OMA.

April Lamm, assistant curator of Gwangju Folly II, is an American writer and editor based in Berlin.

Yongwoo Lee is the President of the Gwangju Biennale Foundation, and founding director of the biennale, and also editor and publisher of the critical art journal *NOON*.

Markus Miessen is an architect and writer. In 2007, he founded the Winter School Middle East. He is currently a professor for Critical Spatial Practice at the Städelschule in Frankfurt and visiting professor at USC, Los Angeles.

Philipp Misselwitz, curator of Gwangju Folly II, is the Chair of Habitat Unit at the Institute of Architecture of the Technical University Berlin.

Samaneh Moafi is an Iranian architect based in Sydney.

Naeem Mohaiemen is a New York- and Dhaka-based writer and visual artist whose work addresses histories of the international left, utopia-dystopia slippage, as well as borders and belonging in South Asia.

Ingo Niermann is a novelist and editor of the book series *Solution* who lives in Berlin and New York.

Hans Ulrich Obrist is co-director of the Serpentine Gallery in London.

Marion von Osten is an artist, author, and exhibition maker and member of Labor k3000 Zurich, kleines post-fordistisches Drama (kpD), and the Center for Post-Colonial Knowledge and Culture Berlin (CPKC).

Raqs Media Collective (Monica Narula, Jeebesh Bagchi, Shuddhabrata Sengupta) enjoy playing a plurality of roles: often artists, occasionally curators, and, more often than not, philosophical agent provocateurs. They are based in New Delhi.

Kyong Park was the founding director of StoreFront for Art & Architecture in New York and a curator of Gwangju Biennale in 1997. He currently lives in San Diego.

Felicity D. Scott is Associate Professor at Columbia University in New York and founding director of the program in Critical, Curatorial, and Conceptual Practices in Architecture.

Taiye Selasi is an author, photographer, and screenwriter based in Rome.

Cassim Shepard, founding editor of The Architectural League's *Urban Omnibus*, writes and makes films about architecture and urbanism and is based in New York.

Stephen Squibb is artistic co-director of Woodshed Collective, writes regularly for artforum.com, art-agenda, and n+1, where he edits a series of essays about American cities with Keith Gessen.

Do Ho Suh is an artist based in London, New York, and Seoul.

Eulho Suh is an architect based in Seoul and the founder of SUH Architects.

Superflex is a Danish artists' group founded in 1993 by Jakob Fenger, Rasmus Nielsen, and Bjørnstjerne Christiansen. Superflex describe their projects as *Tools*.

Bernard Tschumi is an architect based in New York and Paris. His most recent book is *Architecture Concepts: Red is Not a Color*, a comprehensive collection of his conceptual and built projects.

Phillip Ursprung is Professor of the History of Art and Architecture at ETH Zürich.

Anthony Vidler, a historian and critic of modern and contemporary architecture, specializing in French architecture from the Enlightenment to the present, is Dean of The Cooper Union in New York.

Markus Weisbeck is Professor of Graphic Design at the Bauhaus University Weimar and founder of the design studio Surface Gesellschaft für Gestaltung in Frankfurt and Berlin.

Eyal Weizman is an architect and professor of spatial and visual cultures at Goldsmiths, University of London, and Director of the Centre for Research Architecture.

Credits

Autodidact's Transport by Raqs Media Collective

Project team:
Raqs Media Collective (Jeebesh Bagchi, Monica Narula, and Shuddhabrata Sengupta)

Design: Mansoor Ali Makrani; Amitabh Kumar
Programmer: Suraj Rai

Local Architects: Gitaek Sun
(Architects Office HS Group)

Local partner for program management:
Gwangju Metropolitan Rapid Transit Corporation

Citizen Supporters: Gwonseob Kim, local expert; Sanghoon Lee, local student

Local Cooperator: Jihyun Kim
Video Production: Jihyun Kim
Performers: Suk-Ju Kim, Jung-A Kim
Mi-Lim Kim

Cubic Meter Food Cart by Ai Weiwei

Project team:
Ai Weiwei Studio

Local Architects & Collaborators:
Philseo Kang (Space Dongin Architects Office)

Local partner for program management:
Gwangju Greenway

Citizen Supporters:
Daebong Yeom and Kyounghee Lee, region experts; Jangryul Choi, pojangmacha association; Sammin Yang, representative of residents; Bomi Kim, local student; Jinyoung Choi, local student

Additional thanks to the staff of the Gwangju Biennale for their patience and assistance. Thanks to the vendors and management of Gwangju Park and vendors by the Student Memorial Hall who allowed us to photograph and interview them at work.

Gwangju River Reading Room by David Adjaye & Taiye Selasi

Project team:
David Adjaye, Yohannes Bereket, Fiona Gueunet, Emanuel Afonso Rebelo, Francisco Tojal

Local Architects & Collaborators:
Dongyoung Kang (Raum Architects Office), Wonil Lee (EL Architects Office), Youngseok Lee (Urbanindex-lab)

Local partner for program management:
Gyeol

Citizen Supporters:
Si Hun Park, Byoungdo Kim, Bongnam Jeong, region expert; Sooyeon Lim, representative of residents; Seonghyun Park, Seulki Park, local students

Additional thanks to Cassim Shepard

In-between Hotel by Do Ho Suh & Suh Architects

Project team:
Do Ho Suh, Suh Architects, Studio WY + Urbanindex.lab, Kia Motors, Imagebakery, Design A-Works, RACHEL

Local partner for program management:
Ramada Hotel

Additional thanks to Sunjung Kim, Claudia Pestana, Lehmann Maupin Gallery, New York and Hong Kong, Soyeong Moon, Stephanie Solomon, Sunghee Lee, Jeon, Taegsu, and the Gwangju Biennale Foundation

Memory Box by Seok-Hong Go & Mihee Kim

Project team:
Seok-hong Go and Mihee Kim

Local Architects & Collaborators:
Guiseong Kim (ID design)

Local partner for program management:
Gwangju YMCA

Citizen Supporters:
Mijeong Ahn, Daehyun Kim, region experts;
Younggi Moon, Youngseon Kim, representatives
of residents; Yiseul Jeon, local student

Additional thanks to Du won Seo, Do young
Ahn, Jae hee Ryu and iArc architects

Power Toilets / UNESCO by Superflex

Project team:
Jakob Fenger, Rasmus Nielsen, and
Bjørnstjerne Christiansen in collaboration with
Skafte Aymo-Boot and Yukiko Nezu, NEZU
AYMO architects

Local Architects & Collaborators:
Soonme Lee (Migaon Architects Office),
Woosang Yoo

Local partner for program management:
Sangsoo Shin

Citizen Supporters:
Bongik Choi, region expert; Sammin Yang,
representative of residents; Hwanseok Jeong,
Soohyun Kang, local students

Roundabout Revolution by Eyal Weizman with Samaneh Moafi

Project team:
Eyal Weizman with Samaneh Moafi

Local Architects & Collaborators:
Doosang Cho (Plus Engineering & Architects
Co.,Ltd.), Youngseok Lee (Urbanindex-lab)

Local partner for program management:
Korea Youth Rights Center

Citizen Supporters:
Gilsoo Kim, region expert; Moonja Yoo,
Seongi Yoon, representatives of residents

Additional thanks to Blake Fisher for his
assistance on research.

Vote by Rem Koolhaas & Ingo Niermann

Project team:
Rem Koolhaas, Ingo Niermann
Grace H. Cho, Alexander Giarlis, Victor Nyman,
Jihyun Woo

Local Architects & Collaborators:
Sojung Lee, Sangjoon Kwak (OBBA),
Sangbong Sim

Local partner for program management:
Gwangju Youth Center

Citizen Supporters:
Mincheol Lee, Seonghoon Kim, region experts;
Hwancheol Jeong, representative of residents;
Noori Han, local student

Urban Research Team

Chonnam University
Department of Architectural Engineering of
the Graduate Schools, students: Inseong Cho,
Yong Kim, Seongwook Park, Yongseop Kim,
Hyunjun Lee
Department of Architecture, students: Segyu
Oh, Gwisoon Myeong, Jihyun Kim

Chosun University
Department of Architectural Engineering of
the Graduate Schools: Kyungho Kim, student
School of Architecture: Daebong Yeom,
Assistant Professor; Sungjin Park, Adjunct
Professor; students: Yeolhong Cheon,
Hangmin Lee, Junyoung Kim, Mincheol Park,
Haegang Jo

POLGASA
Seonyoung Park, Professor, School of
Architecture of Chonnam University; Sunghyun
Park, Professor School of Architecture of
Chonnam University; Jeongseon Wi, Graduate
School of Honam University; Soonme Lee,
CEO of Migaon Architecture firm

Text Sources

"History of the Folly" by Anthony Vidler first
appeared in *Follies: Architecture for the Late-
Twentieth Century Landscape*, ed. B.J. Archer,
(New York, 1983), p.10–13. Reprinted by per-
mission of the author.

"Entering Bomarzo," trans. Gerrit Jackson, in
The Garden of Forking Paths, Ed. Heike Munder,
(Zürich, 2011), p. 55-61, originally in Horst
Bredekamp, *Vicino Orsini und der Heilige Wald
von Bomarzo: Ein Fuerst als Kuenstler und
Anarchist*. Worms, 1985. Reprinted by permis-
sion of the author.

"Many Mansions" from *The White Album* by
Joan Didion. Copyright © 1979 by Joan Didion.
Reprinted by permission of Farrar, Straus and
Giroux, LLC.

"The Picturesque and the Landscape Garden"
from Barry Bergdoll, *European Architecture
1750-1890* (New York, 2000), p. 75. Reprinted
by permission of the author.

"Broadway Follies" by Bernard Tschumi first
appeared in *Follies: Architecture for the Late-
Twentieth-Century Landscape*, ed. B.J. Archer,
(New York, 1983), p.42. Reprinted by permission
of the author.

The excerpt titled "Mad Jack's Follies" is taken
from Barbara Jones, *Follies and Grottoes*,
(London, 1974), p.230. Reprinted by permission
of Constable.

Image Credits

Antagonists
An example of Ledoux's "phallic planned brothels," the Oikema, an integral part of the Ideal City of Chaux, ca. 1780.
Ledoux's Quarters for the Rural Caretakers, with plans for three floors, ca. 1780. Engraving after Ledoux by Van Maëlle.

Art Alone?
Bird's eye view of the Garden of Bomarzo. Lucio Luise, Manfredo Manfredi, Ildo Manfroncelli and Salvatore Marino, *Quaderni dell'Istituto di Storia dell'Architettura*, 1955, April, No. 7-9, p. 32.
Orcus, god of the underworld, on whose upper lip is inscribed, "All thoughts fly," in the Garden of Bomarzo. © Horst Bredekamp, 1985.
Leaning tower in the Garden of Bomarzo. © Horst Bredekamp, 1985.

Autodidact's Transport
All images courtesy of Raqs Media Collective.

Backslash
David Hammons's *House of the Future*. © Sandy Lang, 2008.
Backside of David Hammons's *House of the Future*. © Sandy Lang, 2008.

Barricade
Street barricade in Dakha, Bangladesh. Courtesy of Naeem Mohaiemen.

Cannibalism
Street folly © Athar Abidi.
Os Filhos de Pindorama. Cannibalism in Brazil in 1557, as imagined by Hans Staden.

Cubic Meter Food Cart
All images courtesy of Studio Ai Weiwei.

Dogged
Wu Ping and Yang Wu's house in Chongqing, China, 2007. © EyePress, Hong Kong.
Illustration by Martin Mörck of the Nagelhaus, an aborted project for Escher Wyss Platz, Zurich, by Thomas Demand and Caruso St. John. © Martin Mörck.

Emancipation
Images of May 18, 1981, Gwangju. © 5.18 Memorial Foundation

Form, Follies, Function
Original graphic from Hans Hollein, 1983.

Gwangju River Reading Room
All images courtesy of David Adjaye, 2012.

Haircut versus Wig
Baroque stage set instructions, "How to make ships or galleys seem to move over the sea" from *The Renaissance Stage: Documents of Serlio, Sabbattini and Furttenbach*. Edited by Barnard Hewitt. Copyright © 1958.

Hameau
Claude Louis Chatelet, *Vue du hameau prise en avant de l'étang*, 1786.

Horizon
Gordon Matta-Clark, *Tree Dance*, Vassar College, 1971; *Open House*, New York, 1972; *Splitting*, Englewood, NJ, 1974. Courtesy of the Estate of Gordon Matta-Clark and David Zwirner, New York.

In-between Hotel
Conceptual renderings © Suh Architects, 2012.

Instant Monuments
Minsuk Cho's "Flower Cushion" in Bucheon, Korea. © Kyungsub Shin, 2012.

Interrogation
Philip Johnson peering out from his "dwarf-scaled pavilion" in the garden of the Glass House estate in New Canaan, Connecticut. © Saul Leiter, 1963. Courtesy Howard Greenberg Gallery.

Magnet
Cedric Price's "Perspective sketch: Magnet," 1995. Reprinted by permission of Cedric Price Fonds and Collection Centre Canadien d'Architecture/Canadian Centre for Architecture, Montréal.

Memory Box
Architectural renderings. Courtesy of Seok-hong Go & Mihee Kim, 2012.

Misplaced
"Nomadic House," 2000–2005. Courtesy of Kyong Park.

Parade
Etcetera's parade, Istanbul. Courtesy Cultural Agencies, 2010.

Participation
Occupy Frankfurt. Courtesy Armin Linke, 2011.

Pedestal
The exedra of Protogenes, Kaunos. © Cengiz Isik. Courtesy of Can Altay.

Picturesque
Palladian bridge, Stowe gardens.
© John Hubble, 2012. Courtesy of the National
Trust Photographic Library.

Power Toilets/UNESCO
UNESCO Headquarters in Paris. Photograph by
Michel Ravassard. Courtesy of UNESCO.
UNESCO democracy archive sign. Courtesy of
Superflex.
Inside the executive toilets of UNESCO, Paris,
2013. Courtesy of Superflex.
Architectual renderings, plan, wall elevations of
the toilets in UNESCO installed in Gwangju.
Courtesy of Superflex and NEZU AYMO
architects.

Psychogeography
Postcard of the Place de la Concorde, Paris,
France, ca. 1890–1900. Wiki Media Commons.
Temple to Philosophy at Ermenonville.
Wiki Media Commons, photographer:
Patrick Charpiat, 2006.
A giant at the Garden of Bomarzo.
© Horst Bredekamp, 1985.
Carnac, Alignement de Manio, vue W.
© Peter Carl, 2012.

Quixotic
The Broken Column House at Le Désert de
Retz, Study 9. © Michael Kenna, 1988.
Crane no. 85. © 노순택 NOH Suntag, 2011.
Hope Bus campaign, protest march, "Making
the world without temporary workers!"
© 노순택 NOH Suntag, 2011.

Roundabout Revolution
Architectural renderings and photographic
essay, 2012. Courtesy of Eyal Weizman and
Samaneh Moafi.

Staircase for Scarface
Bernard Tschumi in front of his Staircase for
Scarface folly in New York City, 1979. Courtesy
of Bernard Tschumi.

Sugar Loaf
Mad Jack Fuller's faked church spire, England.
© Barbara Jones, 1974. A folly for the cows of
Barwick Park, England. © Barbara Jones, 1974.
Courtesy of Constable.

Transfer
Breitscheidplatz (Charlottenburg);
Stadtplanung. Neugestaltung des Zoo-Viertels;
Vitrine mit dem Modell zur Besichtigung durch
die Bevölkerung. Copyright © 1956 by Horst
Siegmann. Reprinted by permission of the
Landesarchiv Berlin.
"Urban Sculpture Concerns Us All!" exhibition
in the vitrine in front of the Tiergarten Town
Hall, Moabit, Berlin. Courtesy of Erik Göngrich,
2009.

Trespassing
Axonometric drawing, 2009, and photograph,
2010. Courtesy of Cultural Agencies.

Typofolly
Images of the English and Korean book covers.
Courtesy of Sunah Choi and Markus Weisbeck,
2013.

Vote
Collage image courtesy of Alexander Giarlis.
All other images and graphics courtesy of Rem
Koolhaas and Ingo Niermann.

Watershed
Mike Bouchet's Watershed at the Venice
Biennale. Courtesy of Mike Bouchet, 2009.

Editors: Nikolaus Hirsch,
Philipp Misselwitz, Eui Young Chun
Associate editor: April Lamm
Korean translations editor: Suki Kim

Translations from the English into Korean:
Jeong Hye Kim (Ai, Bergdoll, Cho, Go and
Kim, Jones, Obrist, Raqs, Tschumi, Vidler)
Suki Kim (Hirsch, Misselwitz, Chun)
Suk-Jun Kim (Berardi)
Jay Lee (Didion)
Sunghee Lee (Suh)
Sungmin Lee (Jacob)
Hyejin Moon (Basar, Scott with Jihoi Lee)
Jaeyong Park (Altay, Bredekamp, Carl, Cultural
Agencies, Etcetera, Göngrich, Mohaiemen,
Miessen, Niermann, Park, Selasi, Squibb,
Superflex, Weizman)
Meejeong Uhm (Adajania, Lamm, von Osten,
Ursprung)

Translation from the Korean into English:
Ji Young Park (Yongwoo Lee)

Translation from the Chinese into English:
Michelle Lim (Hu)

Design: Surface, Max Nestor
Typesetting Korean: Sunah Choi
Visual identity: Markus Weisbeck & Sunah Choi
Typeface: Graphik
Reproductions: Surface Gesellschaft für
Gestaltung, Berlin
Production: Julia Günther, Hatje Cantz
Paper: Tauro Offset, 120 g/m²; Artic White,
130 g/m²
Printing and binding: Kösel GmbH & Co. KG,
Altusried

Thanks to Beatriz Colomina, Martina Cooper,
Okwui Enwezor, Joseph Grima, Sunjung Kim,
Jonas Leihener, Ruth Ur, Malte Wittenberg

Published by

The Gwangju Biennale Foundation
111, Biennale-ro Buk-gu
Gwangju 500-845
South Korea
Tel. +82 (0)62 608-4114
Fax +82 (0)62 608-4219
www.gwangjubiennale.org
www.gwangjufolly.org
President: Yongwoo Lee

and

Hatje Cantz Verlag
Zeppelinstrasse 32
73760 Ostfildern
Germany
Tel. +49 711 4405-200
Fax +49 711 4405-220
www.hatjecantz.com
A Ganske Publishing company

Hatje Cantz books are available internationally
at selected bookstores. For more information
about our distribution partners, please visit our
website at www.hatjecantz.com.

ISBN 978-3-7757-3553-7